SOUTH AFRICA
PRIVATE WORLDS

Photography by
SØLVI DOS SANTOS

Text by
DESMOND COLBORNE

conran
OCTOPUS

CONTENTS

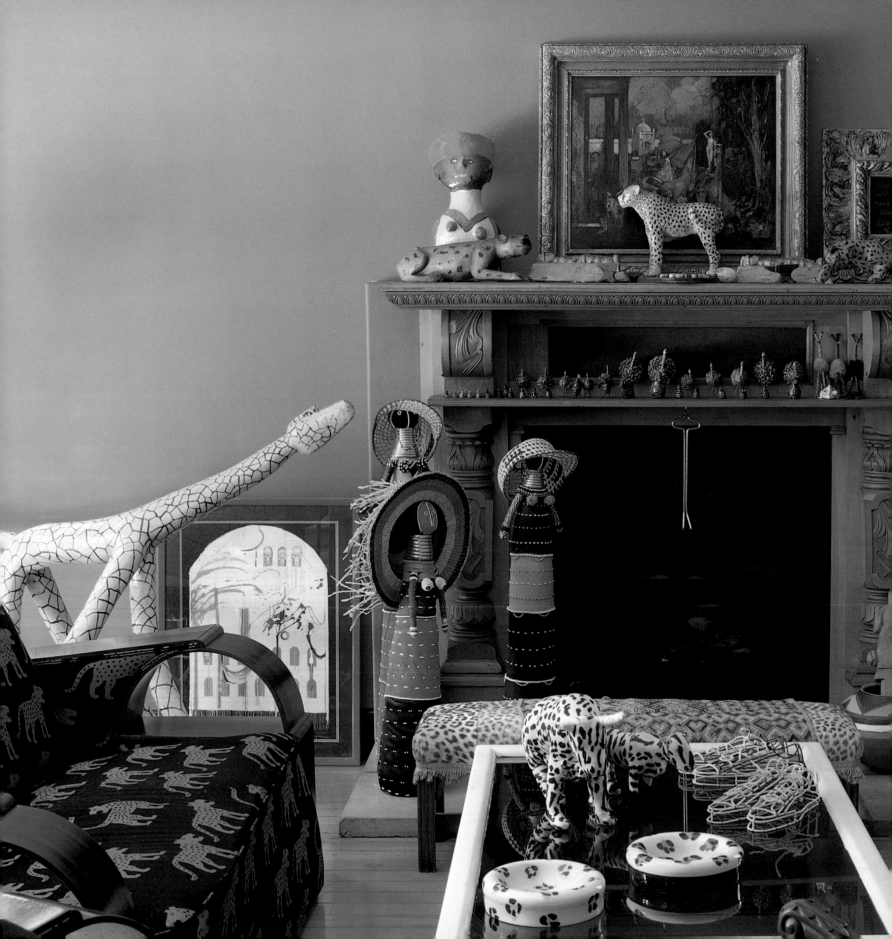

FOREWORD

SØLVI DOS SANTOS

It was with high expectations that I made my first trip to South Africa to research this book, and I certainly wasn't disappointed. The landscape is stunning: the picturesque coastline stretches from the bracing Atlantic to the warm Indian Ocean; the mountains are breathtaking, the vegetation rich, the Karoo arid but graphic, the bush vast with an incredible wildlife. And, in its midst, a rich cultural mix of people.

On arriving in Cape Town, my immediate challenge was to search out unique and creative homes to photograph. But how would I be able to infiltrate the private worlds that foreign visitors never usually get to see? Gillian Stoltzman, the energetic and knowledgeable manager of Vineyard Ventures, was the answer. It was through Gillian, her friends and their network of friends that I found everything I was looking for.

The homes featured here represent an impressive array of architectural styles: the classic Cape Dutch wine estates and the Victorian houses, with their traditional, colonial-style interiors, that seem to belong to very different worlds from the exuberant and eclectic homes of artists and designers. Yet, all the interiors reflect the different personalities, tastes and lifestyles of their owners, all of whom have defied convention and indulged their imaginations. It was left to me to document them all with my camera.

The unique African identity is revealed through its tribal art, and it is fortunate that the new South Africans value their rich heritage. In the homes I visited I could admire collections not only of traditional local art but of the continent as a whole. The expressiveness of this art defies time and personal taste; it is eternal and universal and an important part of our global heritage.

The contemporary art scene in South Africa incorporates a huge range of interesting art forms, including painting, sculpture, ceramics, metalwork, many of which have a graphic edge inspired by tribal art. Recycled art is a particularly exciting development, with amazing creations made with whatever is available, such as wire, tins, even safety pins.

It is clear to see that creative and artistic expression is well and truly thriving in South Africa – and it is more than worthy of our attention.

INTRODUCTION

There are two things that strike most first-time visitors to South Africa: its dazzling beauty and its confusing but fascinating complexity – it both pleases the eye and teases the mind. It is a kaleidoscope with an ever-changing pattern that is difficult to describe in any analytical sense. This book, however, does not even attempt analysis. Instead, it is concerned with visual impact – that of the world of interiors.

In a country of so much political change, it comes as no surprise that many South Africans are revealing their personal enthusiasm for change through their homes. Homes that are not of recent design have been reshaped, restyled, altered or adapted in some way to suit modern lifestyles. Several of those photographed for this book seemed to be in a state of flux, with their interiors changing drastically between two closely timed visits – an indication of the restless creativity of their owners.

Although the homes featured here express a response to global trends, such as minimalism and eclecticism, they have all moved away from a distinct Eurocentric view of things towards a more Afrocentric one. Admittedly, many South African homes still look as if they would rather be in the English Home Counties, the Mediterranean, even California, but many more are now taking on a pronounced local colour. Increasingly, interiors reveal a much stronger appreciation of the home-grown, displaying a widening range of ethnic, tribal and outsider art and artefacts.

Even the most modern of homes are full of references to the past. As elsewhere in the world, people in South Africa used to live in caves. And the rock art in those caves, the so-called Bushmen paintings, are today national treasures. There are about 15,000 sites, with the oldest reckoned to be 27,000 years old. The Bushmen, now referred to as San, were nomadic, with the classic nomad's view: 'Life is a bridge. Cross over it, but build no house on it.' When necessary, they put up rudimentary shelters of sticks sometimes covered with reed mats. A related people, the pastoral Khoi, formerly called Hottentots, moved around less and built settlements of beehive-shaped huts.

The beehive shape was also the preferred domestic design of the Nguni peoples, including the Zulus and Xhosas. Nelson Mandela described how, in the 1920s, he and his family, local Xhosa nobility, lived in beehive-shaped huts with mud walls, just as their

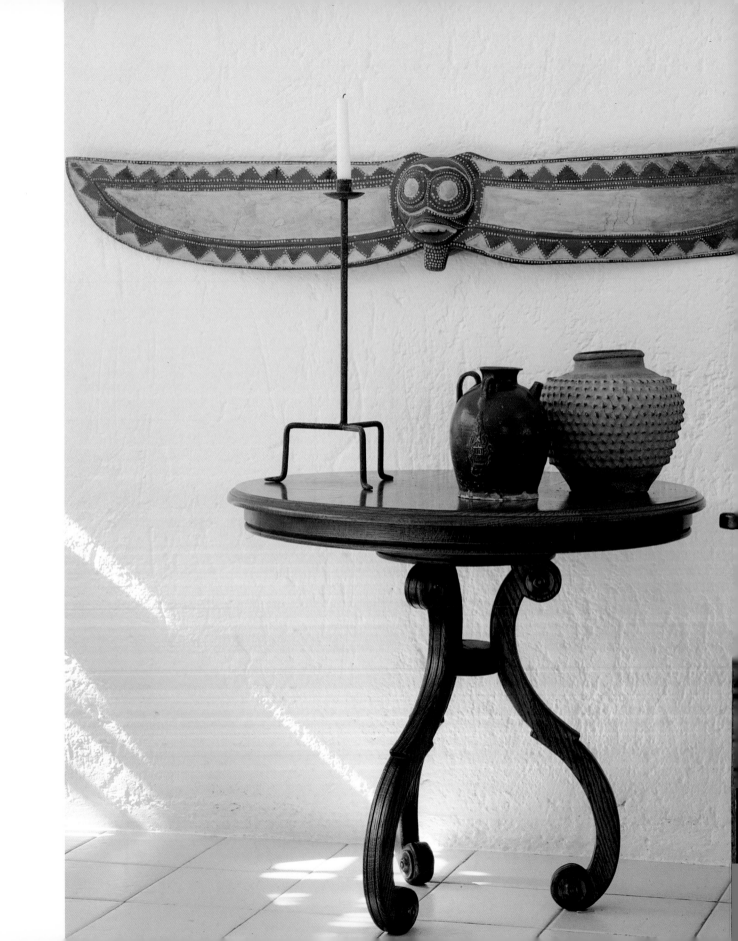

ancestors had done. A wooden pole in the centre held up a peaked grass roof, while the earth floor was kept smooth by smearing it regularly with fresh cow dung.

Western-style structures were first introduced to South Africa by the founders of the world's first multi-national company, the Dutch East India Company which, during the seventeenth century, established trading stations all over the world. At approximately the same time as the Dutch founded New York, they established its sister city in Africa – Cape Town. Some of the buildings, as well as the furniture from those times, are still well preserved – in Cape Town Castle, Constantia, Vergelegen and Meerlust, which appears in this book. The Dutch colonists developed an indigenous 'Cape Dutch' style with curving gables, characteristic floor plans and front *stoeps*, or verandas. Following on from the Bushmen shelters and beehive-shaped Xhosa and Zulu huts, Cape Dutch joined South Africa's grammar of traditional styles.

As the Cape was a half-way house to the Indies, it was obviously influenced by the East in terms of architecture, food and music. And for hundreds of years there has been a sizeable community of Cape Muslims. When Rudyard Kipling first came to the Cape, he was reminded of his childhood in India and enchanted by the 'colour, light and half-oriental manners'.

Before Kipling's time, a simplification in lifestyle took place among the Dutch and French Huguenot settlers of the Cape who moved into the rural hinterland. During the eighteenth century, in the Karoo and other remote parts, a white African people evolved, with its own home-grown language and culture. Originally called Boers, meaning peasants or farmers, they are now referred to as Afrikaners. Adopting local know-how and

survival techniques from the Khoi, or Hottentots, as well as a semi-nomadic lifestyle based on moving on or 'trekking' – a key word, coined in South Africa – they went in search of the promised land in covered wagons drawn by oxen.

And then Britain colonized the Cape, and the Boer trekkers moved away, clashing violently with the tribes in the interior, notably the powerful Zulus. A series of struggles for control then followed – frontier wars, Zulu wars, Boer wars, British wars.

Meanwhile, colonial homes in South Africa were built in Georgian, Victorian and Edwardian styles. With diamonds, gold and other resources, South Africa was the British Empire's Eldorado. Its wealth financed a series of building booms. The architects of New Delhi – Sir Edwin Lutyens and Sir Herbert Baker – erected similar monuments to empire in South Africa, as well as more modest everyday buildings and bungalows. There was stylistic cross-fertilization. While the anti-British Boer leader Paul Kruger lived in Pretoria in an English-style colonial villa, his political enemies, the imperialists Kipling and Cecil Rhodes, opted for the Cape Dutch style. Kipling described his house at the Cape as 'a perfect Dutch house full of old Dutch things'. Rhodes' home, Groote Schuur, built by Baker, is the most celebrated neo-Dutch house in the country. Lived in successively by British imperialists and Afrikaner nationalists, it is now the official residence of Nelson Mandela. This is a sign, one hopes, that South Africans of different origins can be comfortable in one another's homes.

The story of South Africa has not only been one of conflict but also of cross-fertilization, co-operation and a shared heritage, all of which are assets in forging a new common identity as well as a new South African style.

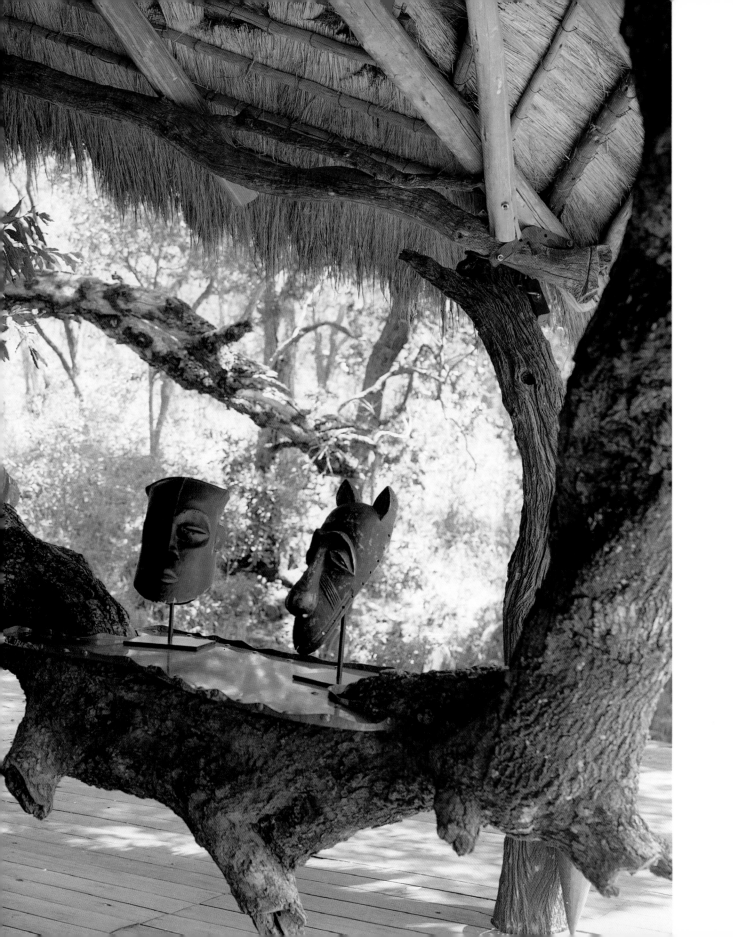

CLASSIC

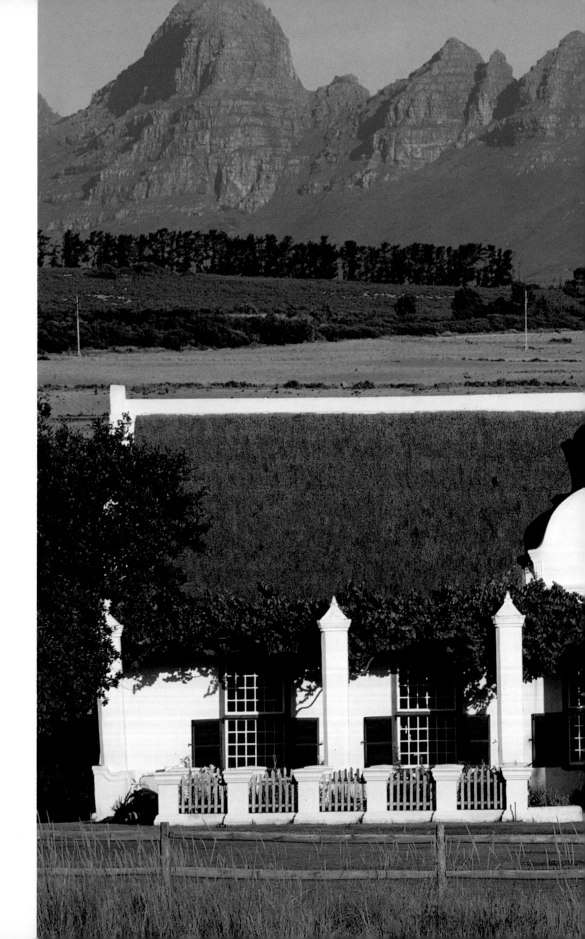

Of all the classic
architectural styles
in South Africa, the
most celebrated is
Cape Dutch, which
goes back more than
three hundred years.
A showpiece
example of this
home-grown style,
epitomized by its
white-walled beauty,
is the Meerlust wine
estate, shown here.
Like the other
classic-style homes
featured in this
chapter, it is
sensitive to historic
tradition as well as
perfectly in tune with
modern lifestyles.

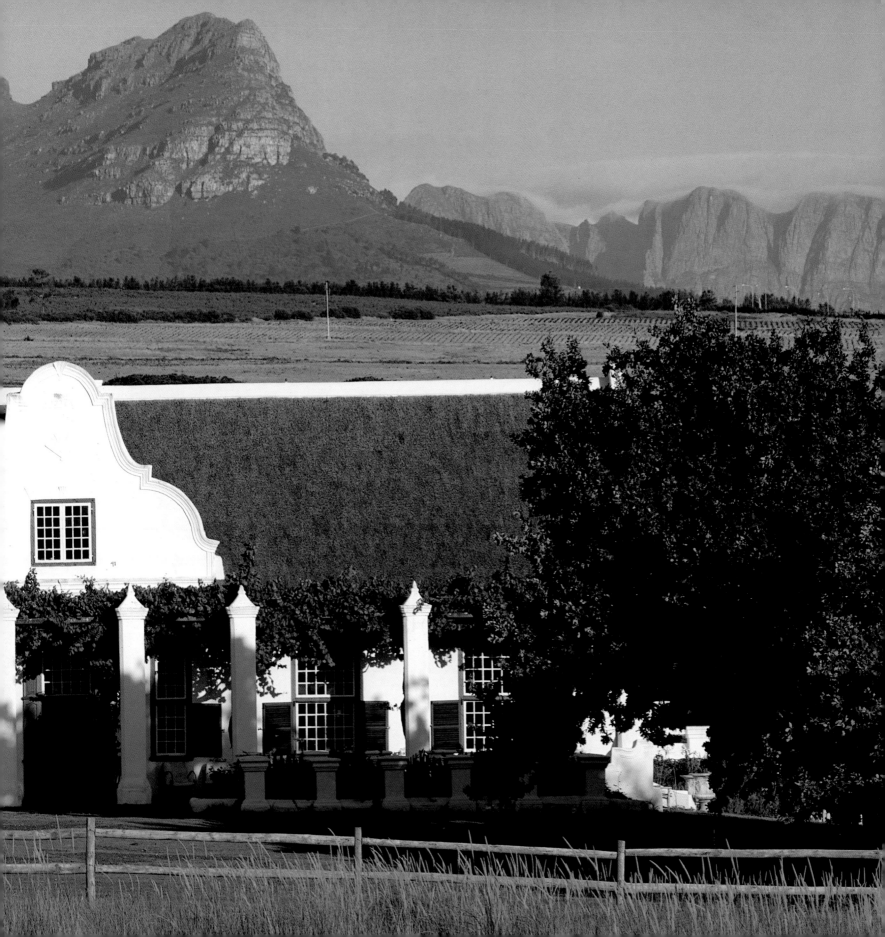

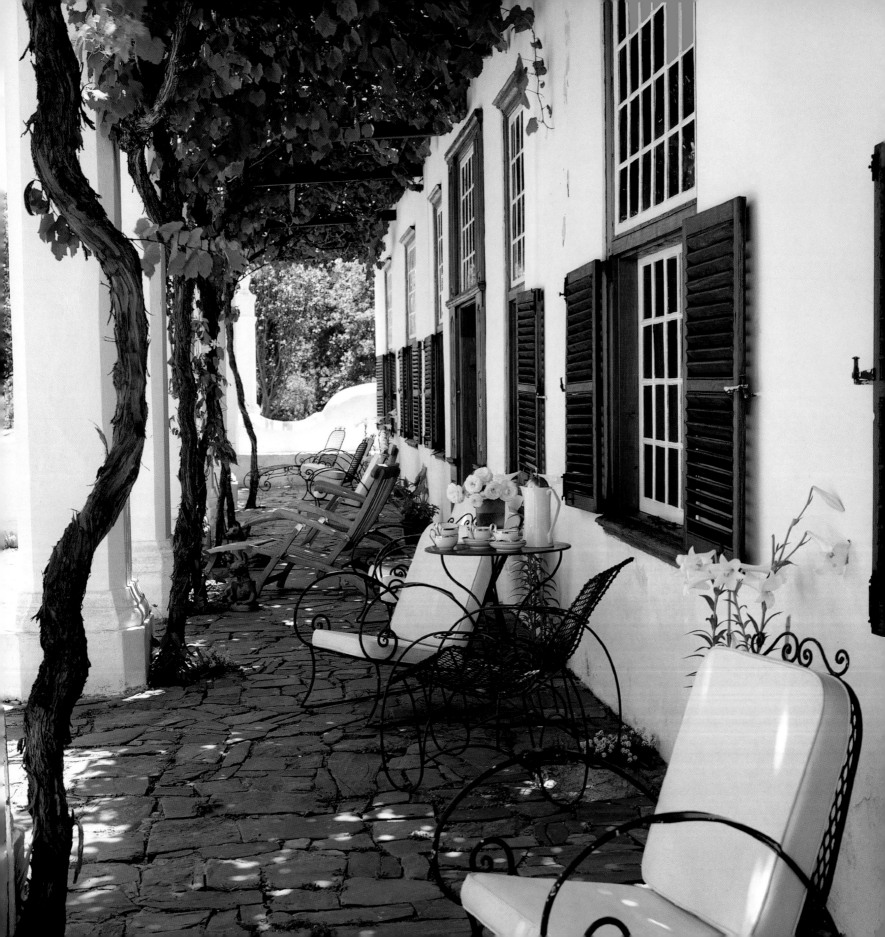

HISTORY IN THE MAKING

Meerlust is probably the most famous estate in the Cape winelands – renowned for the quality of its wines, the charm of its setting and its colourful history – and it epitomizes the white-walled beauty of Cape Dutch architecture. Seven generations of the Myburgh family have lived here, and in all respects it is the country's closest equivalent to a European country house that has been handed down through the generations. However the current owner, Hannes Myburgh, takes a cheerfully unstuffy view of all its heritage.

Even so, it is still something of an event to drive through the vineyards, up the long alley of alternating palm and plane trees, past an old family graveyard, some wine cellars and outhouses, towards the main house with its gable and *stoep*, or veranda. The walk through reception rooms filled with period furniture, scrolled documents and old pictures of the property is equally impressive. But nostalgia at Meerlust has a multi-cultural flavour. A sculpted relief on one of the outhouses, the work of a Cape Muslim craftsman, features cockfighting – a once-popular sport brought to the region from the East Indies.

Hannes doesn't use the house as it was originally intended, but in a 'back-to-front' way, having shifted the focus from the historic reception rooms in the front to the enlarged, convivial kitchen at the back. This has a maplewood table, large enough to cope with the generous portions of country cooking. Around it are grouped a dozen club chairs, originally from a company boardroom and sold off at auction. In a more classical vein, there is a rare, early Cape grocery cupboard made of stinkwood and yellow-wood of a type now greatly sought after by collectors. An imposing shelving and storage unit, which Hannes salvaged from an up-country bar-room, serves as a kitchen dresser.

Hannes has also rejuvenated the other living spaces throughout the thirteen-roomed house. The upstairs rooms, under exposed wooden beams and sloping thatching, have a rugged feel in complete contrast to the elegance downstairs, and are furnished with oak Arts and Crafts chairs and well-worn leather armchairs. In the bedrooms, the mood is set not by riding boots, as you might expect, but by sports shoes. Hannes' study and den are particularly youthful in feeling, decorated with a collage of posters and memorabilia picked up during his travels in Europe.

Hannes points out that every generation has put its own stamp on Meerlust. He has, too, discreetly updating it but without disturbing the friendly family ghosts who also live here.

LEFT **The curved roof gable over the *stoep* – a terraced veranda linking the indoors with the outdoors – is a distinctive feature of Cape Dutch architecture and of the region. The view from the *stoep* extends over the vineyards towards Table Mountain and the sea; the name 'Meerlust' means a longing for the sea.** ABOVE **In the garden, a flower border is planted with white agapanthus, the African lily, one of the Cape floral kingdom's many indigenous species.**

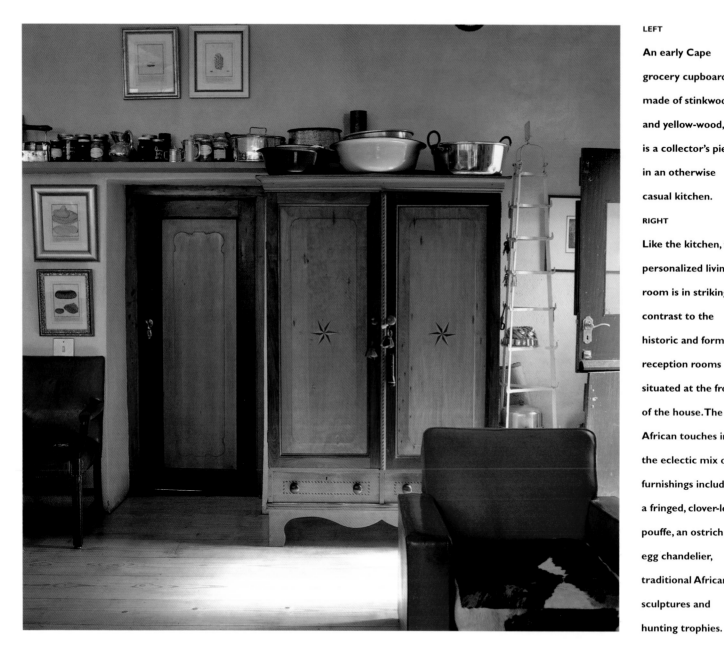

LEFT

An early Cape grocery cupboard, made of stinkwood and yellow-wood, is a collector's piece in an otherwise casual kitchen.

RIGHT

Like the kitchen, this personalized living room is in striking contrast to the historic and formal reception rooms situated at the front of the house. The African touches in the eclectic mix of furnishings include a fringed, clover-leaf pouffe, an ostrich egg chandelier, traditional African sculptures and hunting trophies.

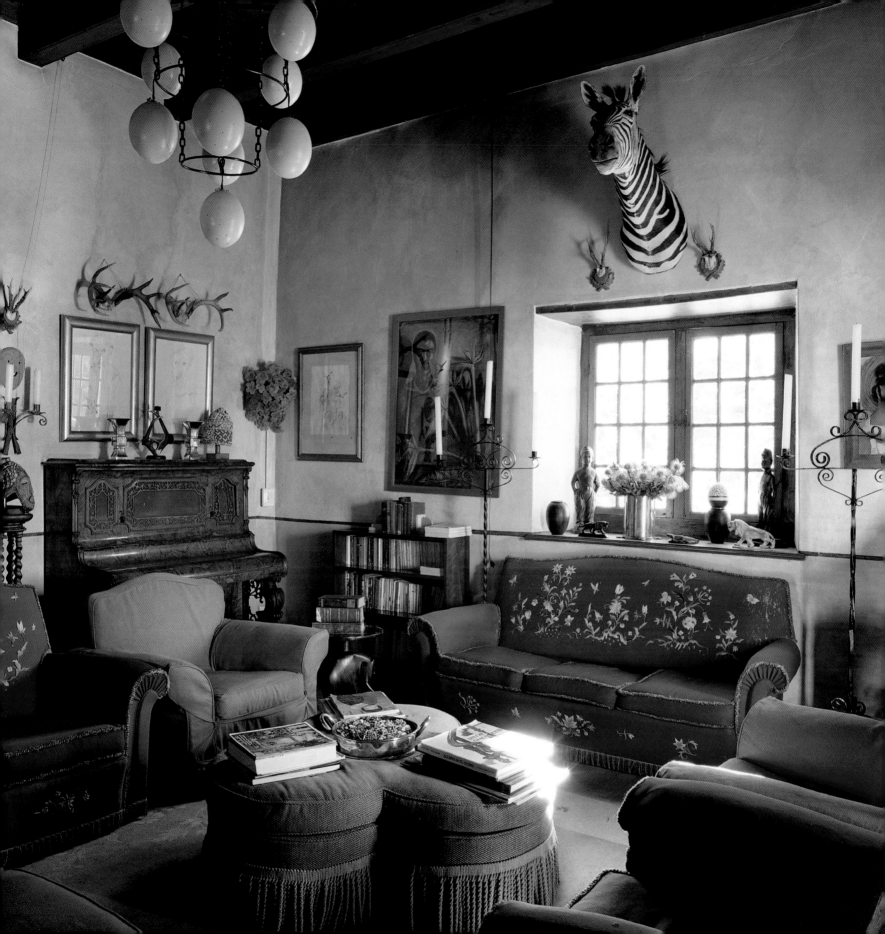

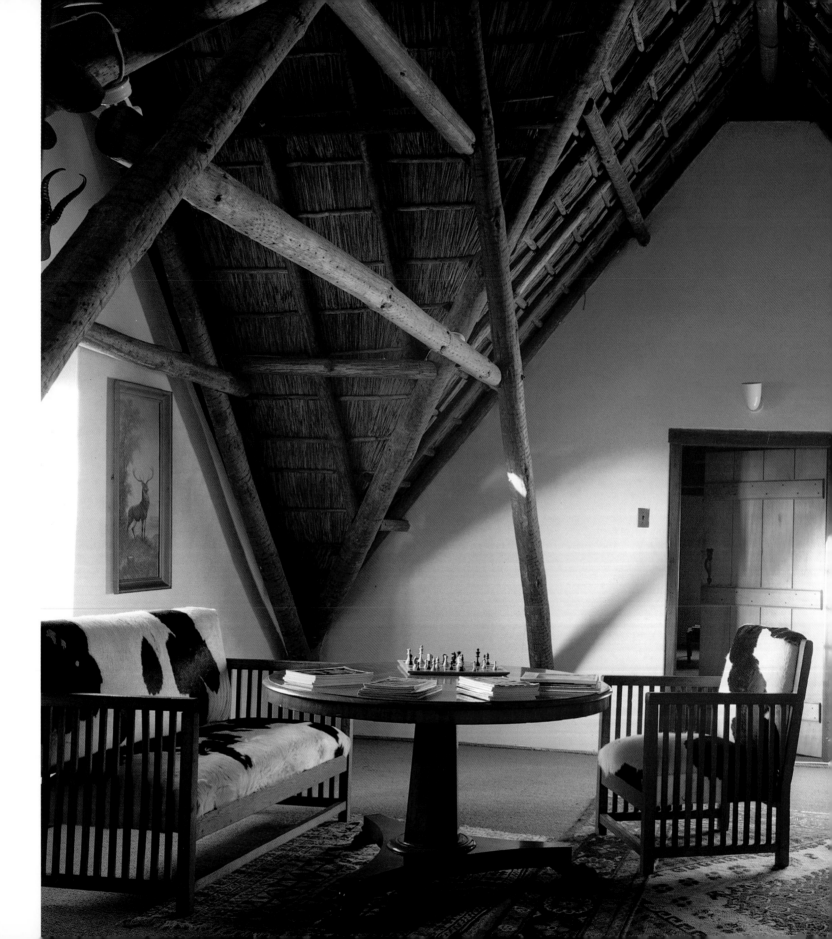

LEFT

The thatched roof and well-worn furniture of the upstairs rooms are a rustic counterpoint to the historic elegance downstairs at Meerlust. This games room features William Morris chairs covered in animal hide and comfortable leather club chairs.

RIGHT ABOVE

The broad-brimmed Boer-style hat and British colonial pith-helmet on the hatstand represent the country's various cultural traditions.

RIGHT BELOW

Shop-window dummies have been 'Africanized' with colourful beaded tribal headdresses.

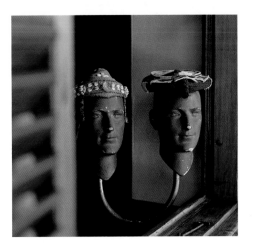

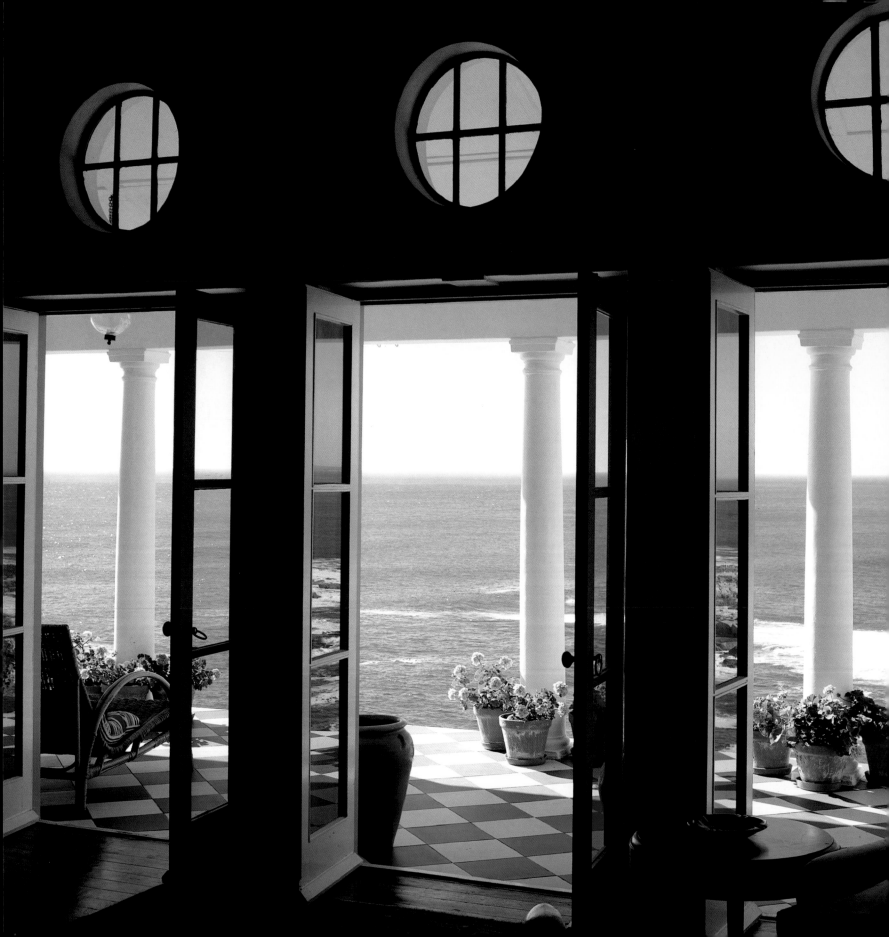

NOSTALGIA UPDATED

Graham Viney is one of South Africa's best-known decorators, responsible for restyling and updating some of its grandest institutions – the Mount Nelson Hotel and Vergelegen manor house and wine estate among them. The former is what you might call a *grande dame*, favoured by Kipling and generations of British and other refugees from the northern winters; the latter is, perhaps, the nearest equivalent to Versailles at the Cape, favoured as a reception venue for Queen Elizabeth II, President Clinton and other distinguished visitors from abroad.

Viney's house is in complete contrast to these grand residences: 'When some of my more opulent clients visit my home, they ask, "Is that all?"', he says with a laugh. He lives in a post-First World War seaside villa at Bantry Bay at the Cape, spoilt during the fifties but rehabilitated by Viney ten years ago. He opened up the veranda that faces the sea and created a dropped ledge without railings to interrupt the view, like 'a kind of ha-ha in the sky', a reference to the English country house device of using a ditch to separate the garden from farmland without spoiling the outlook. Inside, he knocked a number of smaller rooms together and enhanced an interestingly curved ceiling by incorporating bulls-eye windows that open towards the sea.

The furnishings reflect Viney's desire to update and recycle the styles of the past. From his years of studying at Oxford and working in London, he brought back some English country house-style classical busts and a large portrait of Sir John Vanbrugh, probably the most baroque of British architects. There are also echoes of the country house in the fireplace and in some of the graphics of Sir Herbert Baker, the protégé of Cecil Rhodes and the most influential architect who ever worked in South Africa.

The Anglo-Indian furniture is an additional imperial touch and a reminder that Viney's reputation is also based on his highly regarded book, *Colonial Houses of South Africa*. From this period of history, Viney has collected woodcuts of Rhodes, Jameson and others, which decorate the walls, as do pictures of Cape scenery by Gwelo Goodman and portraits of tribal people by Neville Lewis.

In his decoration projects, which have extended outside South Africa to the Victoria Falls Hotel in Zimbabwe as well as London, New York and Madeira, Viney, ever respectful of the past, believes firmly that 'you have to understand and work with your house'. With his own home, he has had a much freer hand, and has brought nostalgia right up to date.

LEFT The dropped ledge creating the 'ha-ha in the sky' gives the living room and veranda an unobstructed view over Bantry Bay and the Atlantic coastline. From here one can see the toing-and-froing of ships rounding the Cape of Good Hope. The columns and bull's-eye windows are features of the classic style that Viney has used in his own compact home as well as in important decorating commissions. ABOVE Silvester, the cat, also seems to enjoy the view.

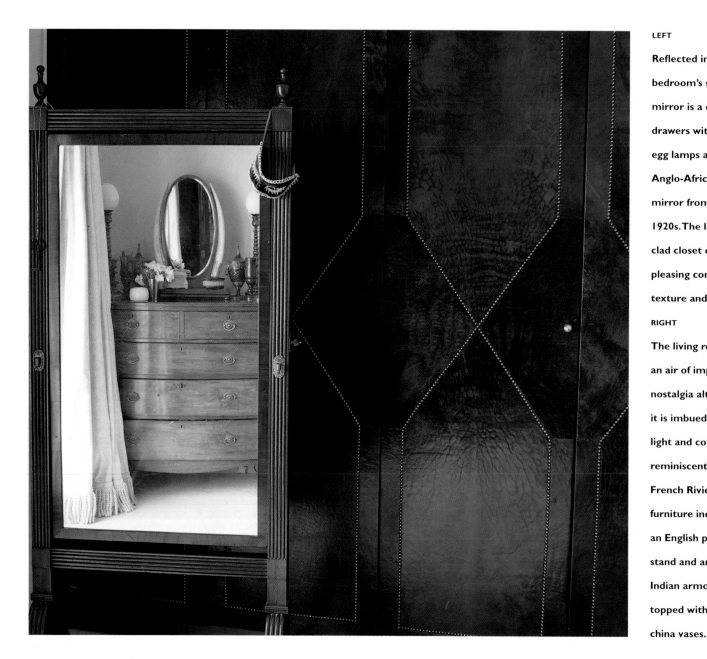

Reflected in the bedroom's swivel mirror is a chest of drawers with ostrich egg lamps and an Anglo-African tusk mirror from the 1920s. The leather-clad closet creates a pleasing contrast of texture and colour.

RIGHT

The living room has an air of imperial nostalgia although it is imbued with the light and colours reminiscent of the French Riviera. The furniture includes an English portfolio stand and an Anglo-Indian armoire topped with antique china vases.

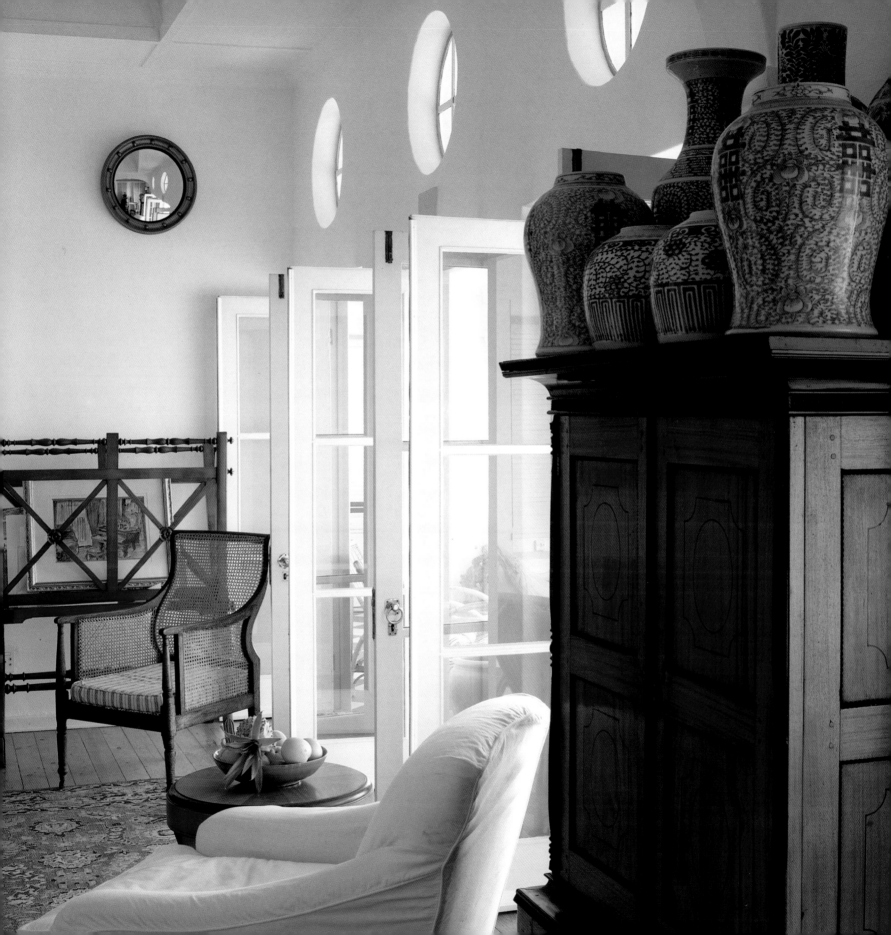

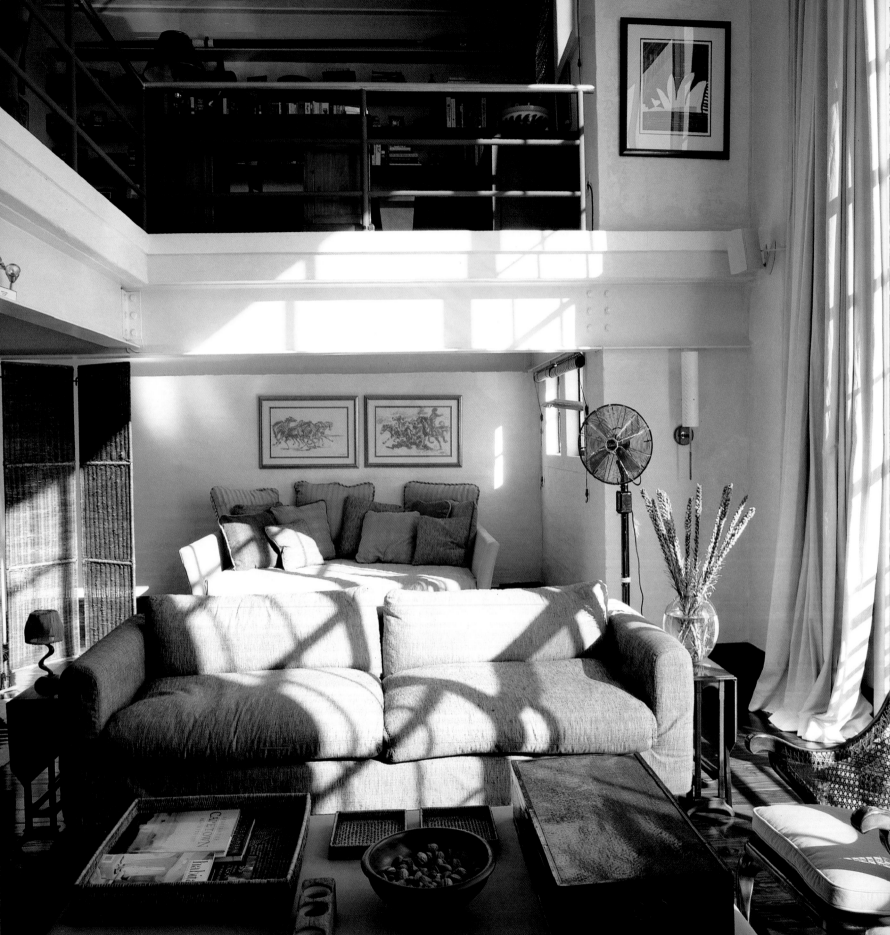

CITY-CENTRE LIVING

Unlike most of his business contemporaries, Ian Douglas, a senior executive for a leading hotel and entertainment company, chose to live in the very heart of Cape Town. Perhaps because he is young and single, a sprawling, gentrified house set in large grounds outside the city held little appeal for him, but he still wanted the spaciousness that a suburban home would offer. The obvious solution was city-centre living in a loft apartment.

Views from the floor-to-ceiling windows extend beyond the business district, over the ships in the busy port and the hugely successful Waterfront entertainment and shopping area. Most conveniently of all, Ian's office, also visible from the apartment, is just a few blocks down the street.

Inside the duplex, which has been decorated by the interior designer Jayne Wunder, space appears to flow through both the upper and lower levels, with the entire apartment in effect open plan yet clearly demarcated by function. Elegant minimalist steps lead upstairs, where the mezzanine floor is bordered by a shipboard-style railing. The more private areas on this upper level include the bedroom, study, spacious dressing room and stunning bathroom, where the brown woodwork makes a striking contrast with the white enamel and acid-washed marble.

Everything in the apartment has its place; there is not a hint of clutter anywhere. Clothes and shoes are tidied away in the dressing room, while Ian's books and papers, together with a few discreet mementoes of his university days at Oxford and of his travels abroad, are secreted away in the study.

In spite of such orderliness, Ian has created a home that is undeniably warm and sociable in atmosphere. Downstairs, the kitchen and dining area are combined – Ian lays special emphasis on this convivial space. Grouped around a long, high table are bar stools from Innovation, pioneers of modern design in Cape Town. There is ample cupboard space, kitchen equipment worthy of a master chef, and wine bottles are stored in a handsome Chinese cupboard.

In the living area, which flows on from the dining area, the gleaming dark wooden floor is set off by a zebra skin. Around an ottoman, there is a choice of chairs and sofas in different styles. Oriental touches include a wicker screen, a cabinet from Burma and a chair from Indonesia, reminding one that Cape Town's port has always been a half-way house to the exotic East. Still, the oriental influence is discreet and understated, absorbed seamlessly into a comfortable and relaxed contemporary home.

LEFT Cape light floods through large windows into two levels of lofty space. Upstairs, behind the ship-style railings, is the bedroom and study; downstairs, the kitchen, dining and living areas. The couches were custom-made, as was the large ottoman in the foreground, which is used as a table. The wickerwork screen serves as a divider to turn the niche at the far end of the living area into an improvised guest room. ABOVE This Victorian chair has been covered in West African ikat cloth.

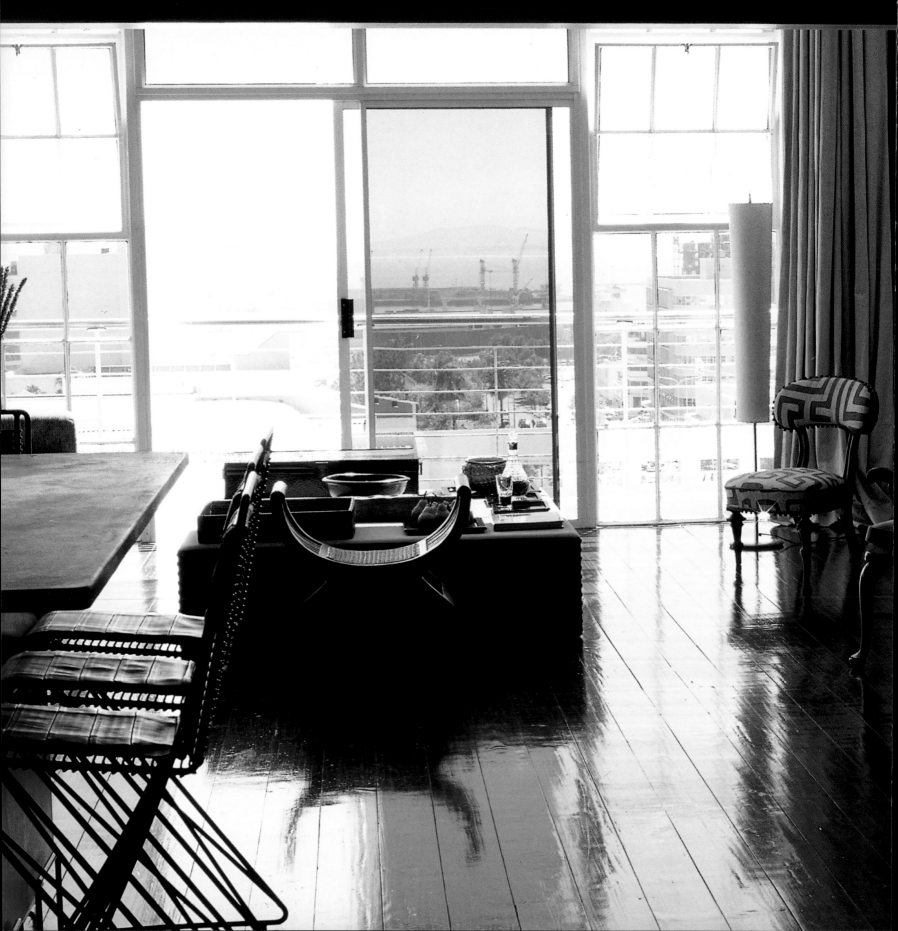

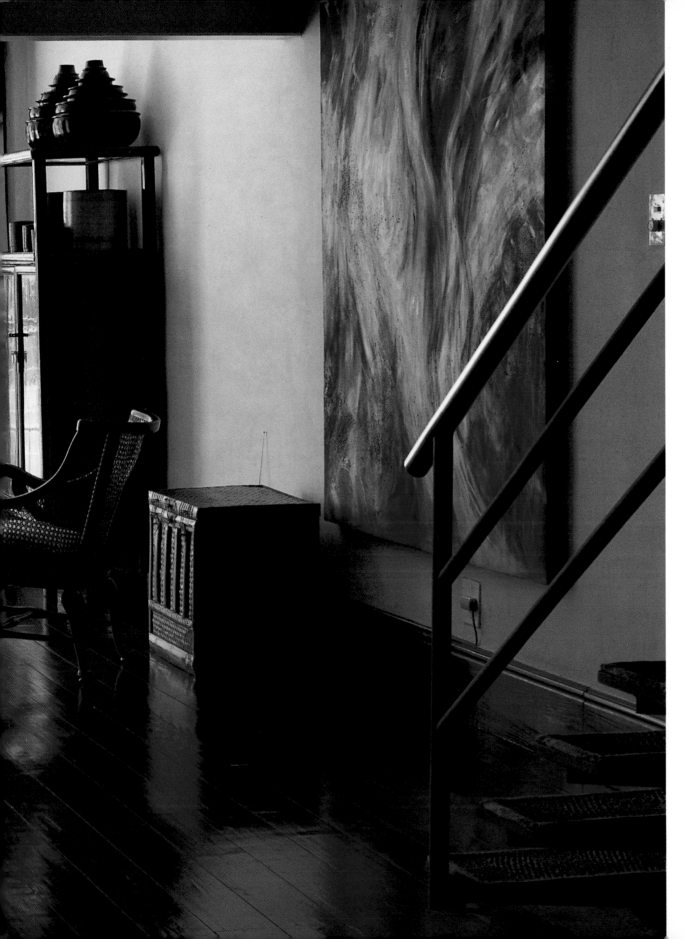

LEFT

Floor-to-ceiling windows in the kitchen-dining area give panoramic views of Cape Town habour. The gleaming wooden floor, reflecting the light, adds greatly to the atmosphere of tranquillity. Against the wall is a lacquered cabinet from Indonesia. Other Eastern touches, such as the cane and wickerwork furniture, convey an almost oriental sense of calm.

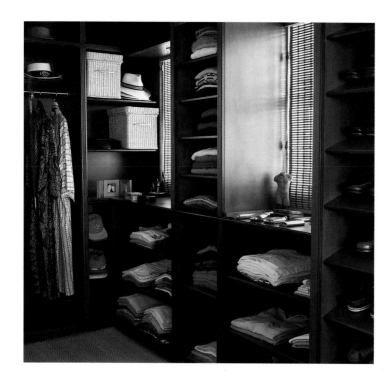

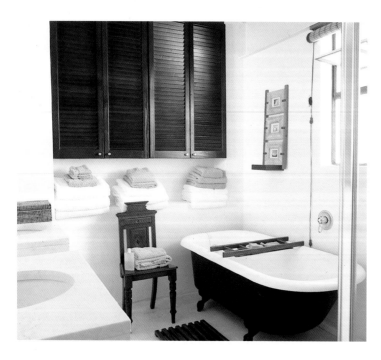

LEFT ABOVE

Open storage shelves in the dressing room are practical and pleasing to the eye.

LEFT BELOW

The orderliness of the dressing room is carried through into the adjoining bathroom.

RIGHT

A small office area has been created in a well-lit corner of the bedroom upstairs, a few steps back from the balcony. The solid pieces of furniture, including the large sleigh bed, help to make a secluded and cosy atmosphere. Personal touches include a sculpture of Ian's grandmother on top of the chest of drawers and an oar from his Oxford university days.

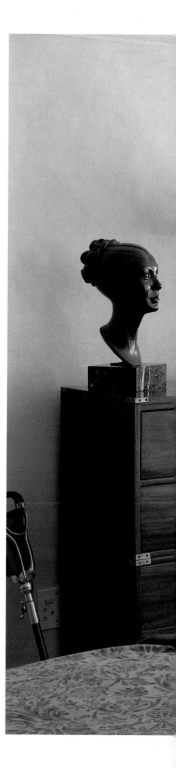

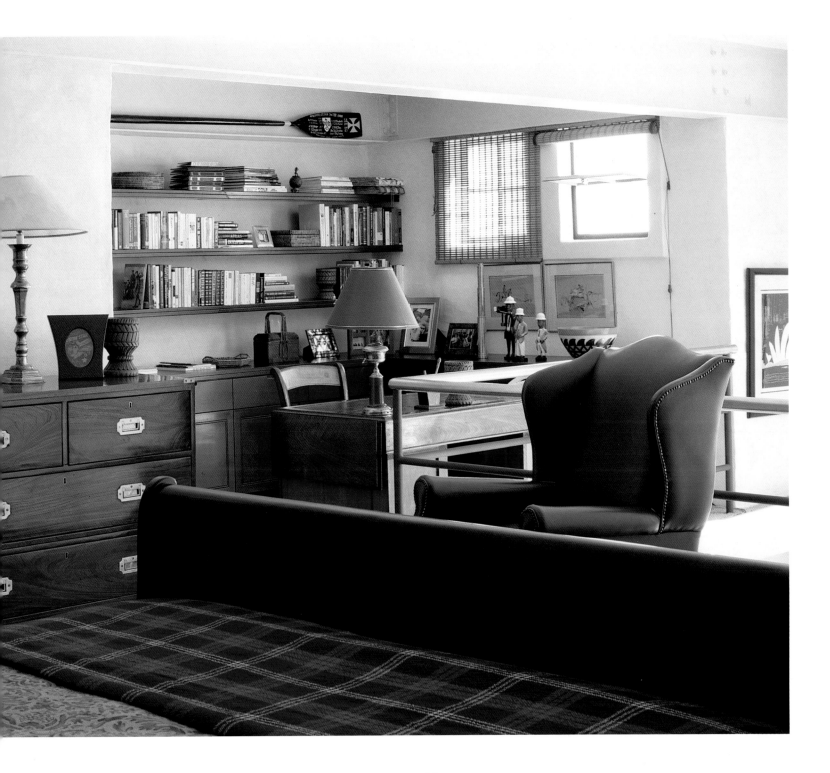

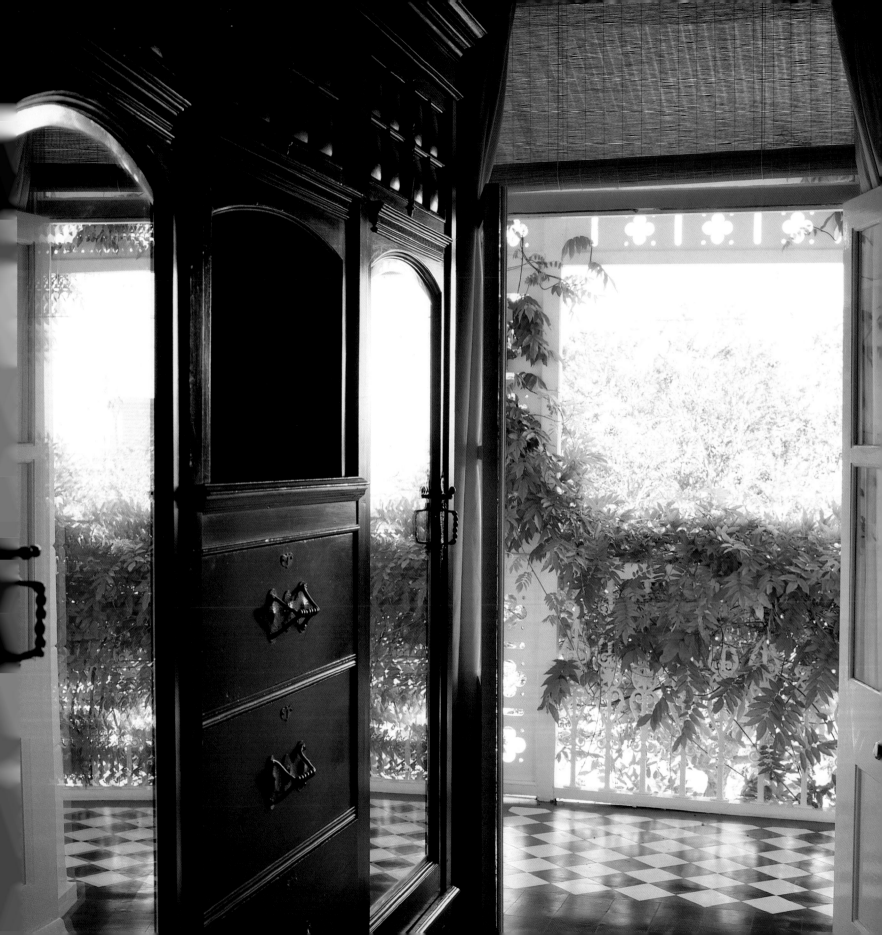

LIGHT ENTERTAINMENT

Although a popular souvenir for many overseas visitors, ostrich eggs, particularly the painted ones, have been considered by most South Africans to be rather kitsch and passé. That is, until Trevor Dykman came along and reinvented them as the centrepieces of stylish and modern light fittings. Lamps and various other furnishings are, in fact, Trevor's business; he designs and sells them to retail outlets and interior decorators. He admits to having always been fascinated by light and shadow, and the effects they can create. Needless to say, his work plays a prominent role in the home he redesigned for himself quite recently, as well as in some of the other homes that are featured in this book.

Trevor's house lies in the shadow of Table Mountain, in Orangezicht in Cape Town. Here, many properties date back to the days of the Dutch East India Company, although most of them, including Trevor's, were later Victorianized, with verandas and frilly ironwork added on to the exteriors.

Although he has retained some of the original features, Trevor has introduced much more light into the house and given it a relaxed feel that is both contemporary and comfortable. By knocking down the interior walls downstairs, he has opened up a flow of space from the front to the back of the house, incorporating an outside courtyard, complete with a hundred-year-old fig tree and a corrugated iron porch. Upstairs, the rooms lead onto the veranda, with splendid views over the city.

Inside, Trevor has mixed mirrors and fixtures of his own design with comfortable sofas and chairs; one particularly handsome piece is an Art Deco Indonesian recliner. Victorian touches include a range of vintage hunting trophies: big buffalo heads and kudu heads with their impressive spreading horns, reminders, perhaps, of past years when South Africa was a paradise for hunters, before it took a lead in game conservation.

It must be said that Trevor himself is no Victorian, and certainly not a hunting, riding and fishing Hemingway-type figure. He is, in fact, a supremely sociable man; the description he applies to himself is that of a hedonist with the belief that 'living well is the best approach to life'. Although he has spent several years working in Los Angeles, he finds that Cape Town has just as much to offer socially. He is extremely fond of entertaining and makes full use of the outside courtyard, while the guest rooms play an important role in preventing post-party drunken driving. 'This is hardly a family home,' he says frankly, 'more of a honey-pot for all my friends.'

LEFT On the slopes of Table Mountain, with views of Table Bay further down the hill, Trevor Dykman's old house in Orangezicht, one of Cape Town's oldest suburbs, has been completely transformed, but only on the inside. On the outside and in the entrance hall he has kept up Victorian appearances. ABOVE Nothing could be more typical of Victorian colonial architecture than a balcony set off by decorative cast-iron railings like this one.

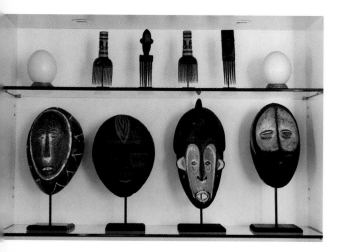

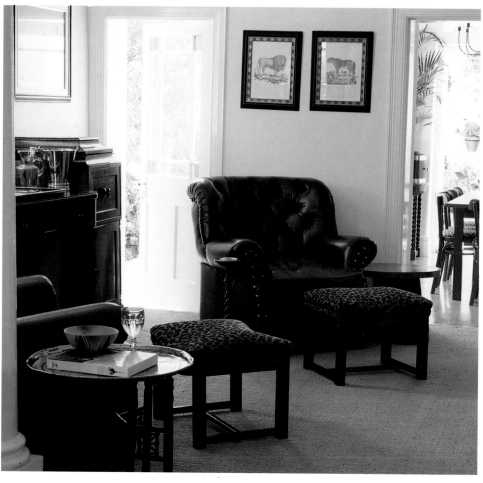

ABOVE

Contemporary glass
shelves make an
unobtrusive display
case for ostrich eggs
and wooden tribal
combs and masks
from central Africa.

BELOW RIGHT

Ndebele patterns
have been burnt and
carved into these
wooden bowls. The
Ndebele's artistic
traditions are the
most widely valued
of all the South
African tribes.

ABOVE

In the living room,
which looks out onto
the inner courtyard,
a ponderous leather
armchair offers
Victorian-style ease
and comfort.

RIGHT

Tribal Africa exists
in the decorative
details. On the
bedroom window sill,
Trevor has displayed
traditional African
hunting knives.

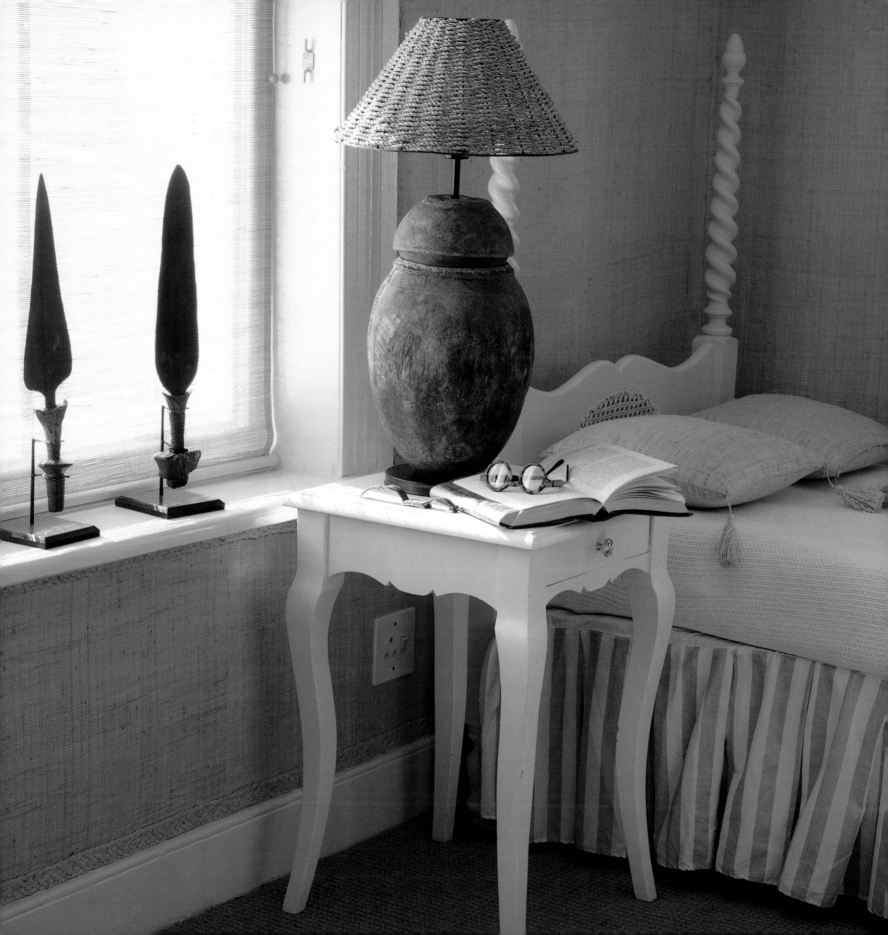

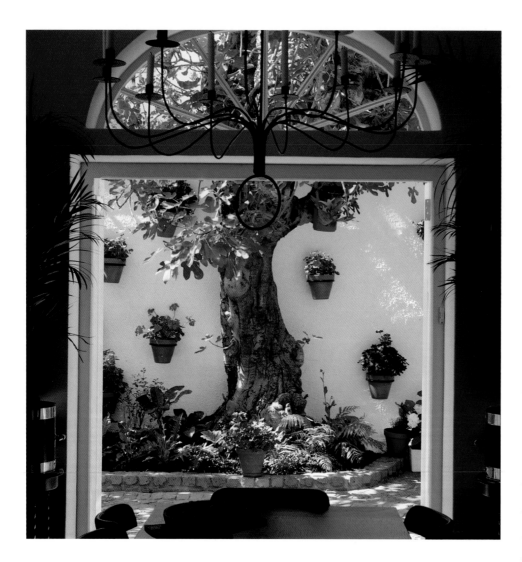

LEFT

Viewed from the dining area through double doors, the magnificent fig tree is one hundred years old, the same age as the house. Terracotta pots of pelargoniums add splashes of colour to the whitewashed walls of the courtyard.

RIGHT

The bold striped fabric on the colonial wicker sofa brings a contemporary note to an otherwise Victorian-style veranda. The painted corrugated iron roof, which provides welcome shade, together with the fancy ironwork on top of the pillars, are typical examples of South Africana.

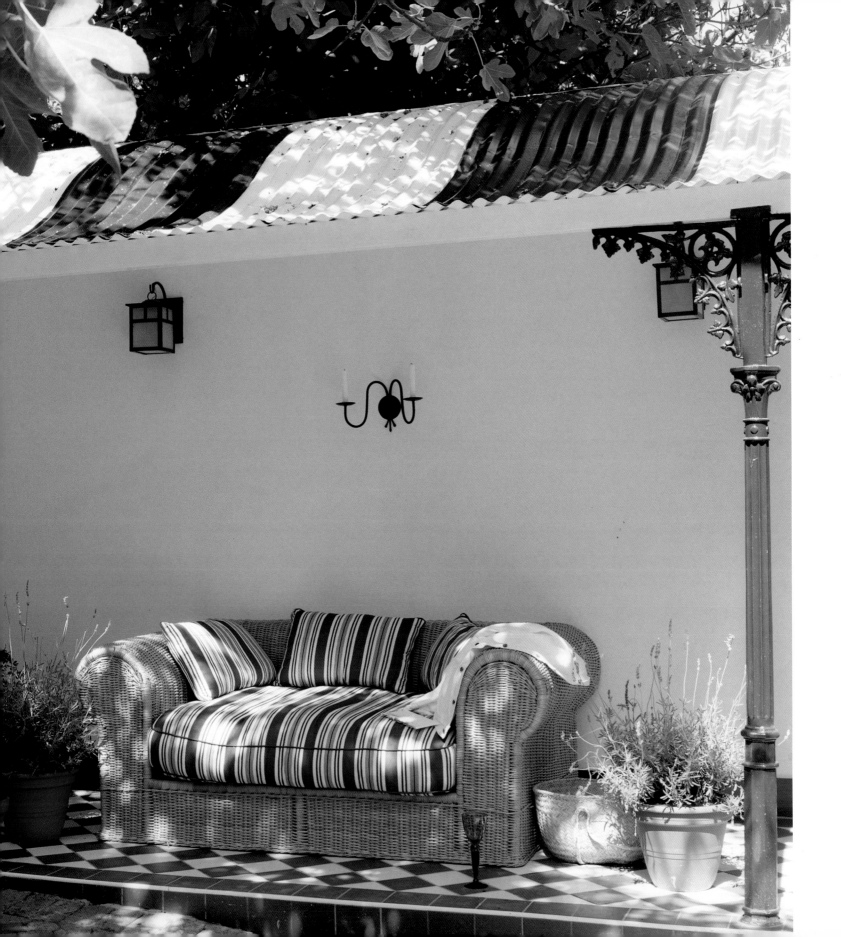

ECLECTIC

With its driftwood-
draped fireplace,
teacup-shaped coffee
table, ostrich egg
chandelier, Art Deco
furniture, modern
paintings and garden
gnomes, Marianne
Fassler's living room
is on the far frontier
of eclecticism. The
diverse traditions in
South Africa – Zulu,
Xhosa, colonial, East
Indian, frontier – have
allowed eclecticism
to flourish, reflected
in the mixing and
matching of
decorating styles.

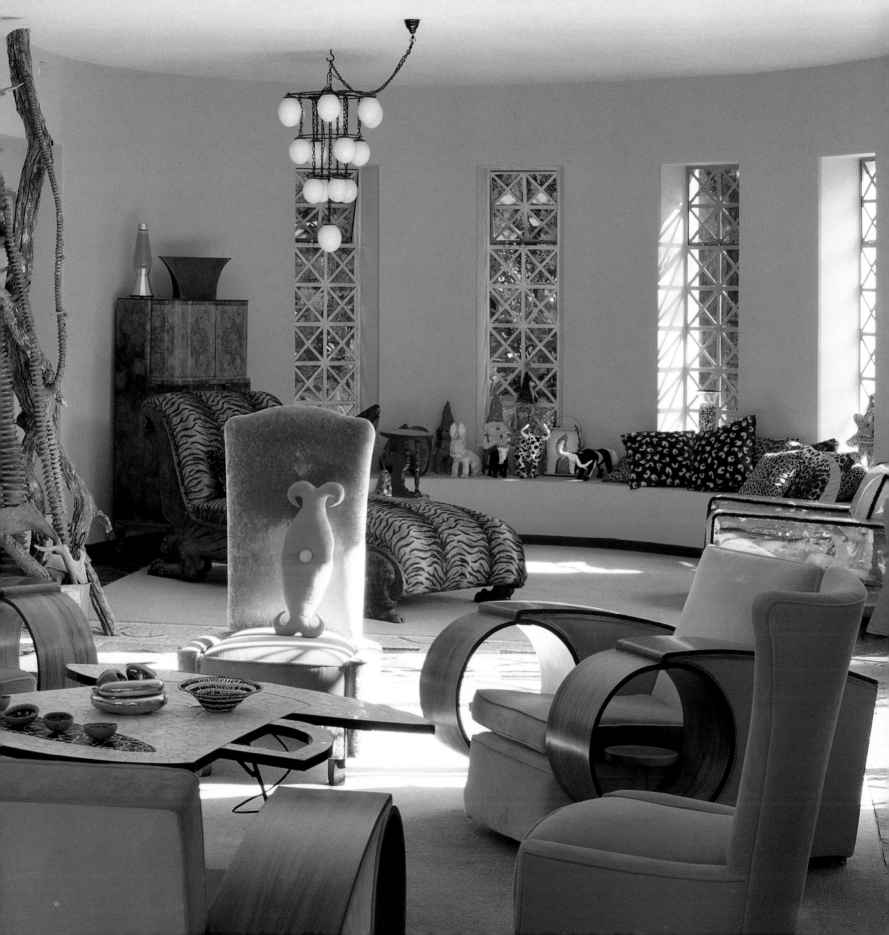

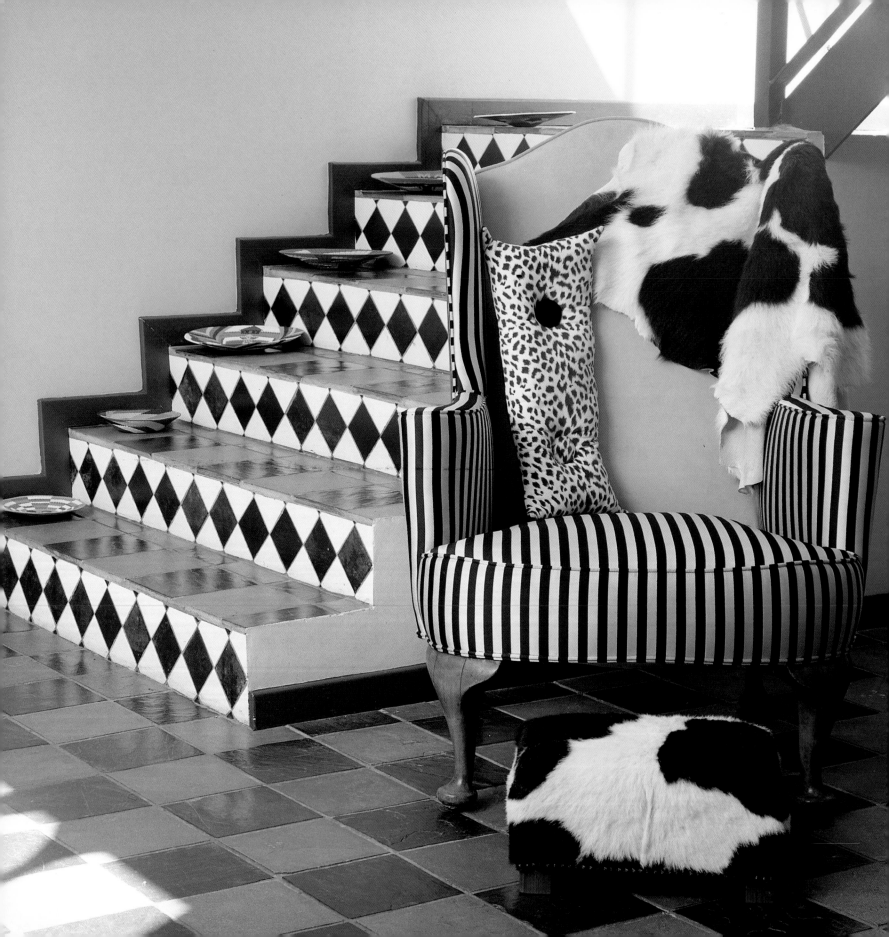

FASHION STATEMENT

Designer Marianne Fassler has been described as 'South African fashion's most flaming free spirit'. She is, she says, 'determined to grow old disgracefully, and convinced that eccentricity is what keeps you young, open-minded and alive'. Her home in the leafy Saxonwold section of Johannesburg, where suburban-style houses stand in large grounds, is no doubt seen as decidedly eccentric, if not disgraceful, by at least some of her neighbours.

Built in the 1920s, the house was given a complete makeover by Marianne. The approach to the house was Africanized with a *boma*, a kind of winding stockade made from knobbly branches, and by piling up river pebbles on the ground. Continuing the African theme, she has erected a parking sign in the shape of a leopard; Marianne uses leopard skin in a playful way in many of her designs, referring to it as her 'reluctant corporate image'. The addition of a large, double-storeyed structure with crenellations and enormous ecclesiastical-style windows to the front of the house gives it the appearance of a neo-gothic castle chapel. But, once inside, the 'chapel' reveals itself as the main living room. Its theatricality and eclecticism are appropriate for a space that occasionally serves as a stage for Marianne's fashion collections as well as a room for entertaining.

Marianne has decorated the inside of her home in what could be called an eclectic and neo-Surrealist way. Leaning against the fireplace is a tangle of what looks like driftwood, lit up by small red lights. There's an ostrich egg chandelier, a mosaic coffee table in the shape of a tea cup, a Regency-style *chaise-longue* with a tiger skin covering, pictures by well-known South African artists such as Karel Nel, and a community of garden gnomes. Seating is provided by a see-through plastic aquarium chair with fake fish swimming inside, and Art Deco armchairs, re-covered in vibrantly coloured fabrics. African accents include a leaping Swazi leopard sculpture, Zulu wire baskets and builders' hard hats, cut and reworked into fantastic shapes; these are the kind of objects that Marianne picks up in scruffy downtown markets – places that she loves for their vitality.

Most of the other rooms in the large house are just as exciting as the living room, even the bathrooms: one has a sumptuous baroque mirror, another a multi-coloured, whirling mosaic. Marianne obviously thrives on living in a kaleidoscope, with her programme for growing old disgracefully well on track. Still, she had to be reassured recently that the colour she had chosen for the dining room was definitely not in good taste!

LEFT At the foot of the tiled staircase leading up to the main bedroom is a wing chair, its canary yellow and black-and-white fabric complementing the decor perfectly. The post-modernist chair is draped with an animal skin and made more comfortable with a rectangular cushion in Marianne's trademark leopard-skin design. ABOVE The shallow bowls placed along one edge of the staircase are colourful Zulu designs made from telephone wire.

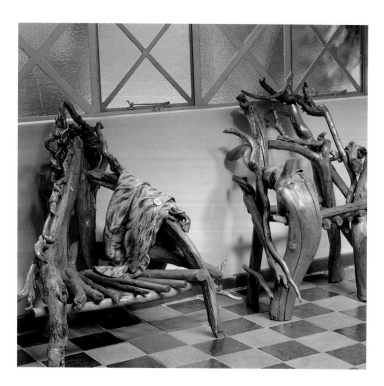

LEFT

Marianne's weakness for 'born-again' hats manifests itself in her 'mad hatter' chandelier, textured with African beads and draped with a selection of hats. Elsewhere, she displays builders' hard hats that have been restyled in outlandish shapes.

LEFT

In the extension to the entrance hall, light filters through coloured glass panes onto a pair of organic wooden thrones. Marianne has mixed up various styles: rough with smooth, ethnic – Mexican, West African and local – with Art Deco, Art Nouveau, kitsch and modern.

BELOW

Suspended from a hook on a wire grid, this container for kitchen utensils is made from an oil canister decorated with bottle tops.

RIGHT

Yellow walls are the perfect foil for the black-lacquered Mackintosh chairs in the dining room. The chickens by the fireplace are made out of plastic bags.

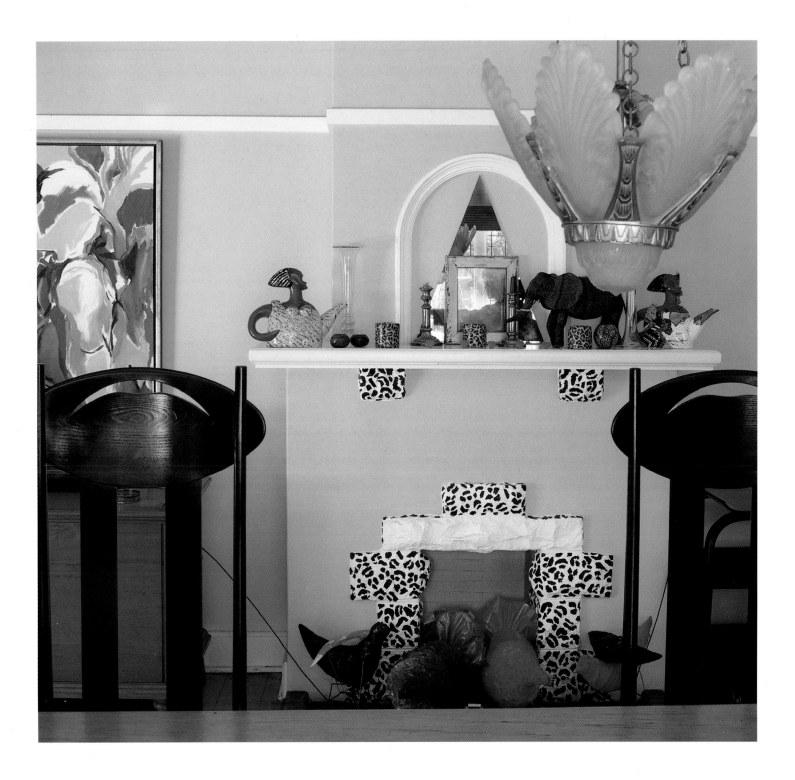

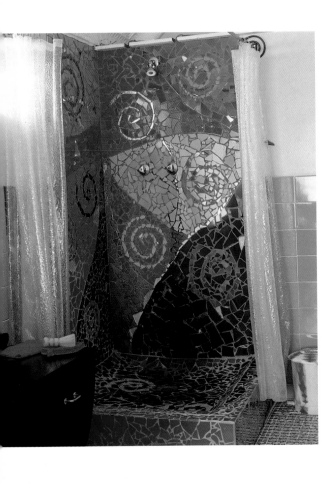
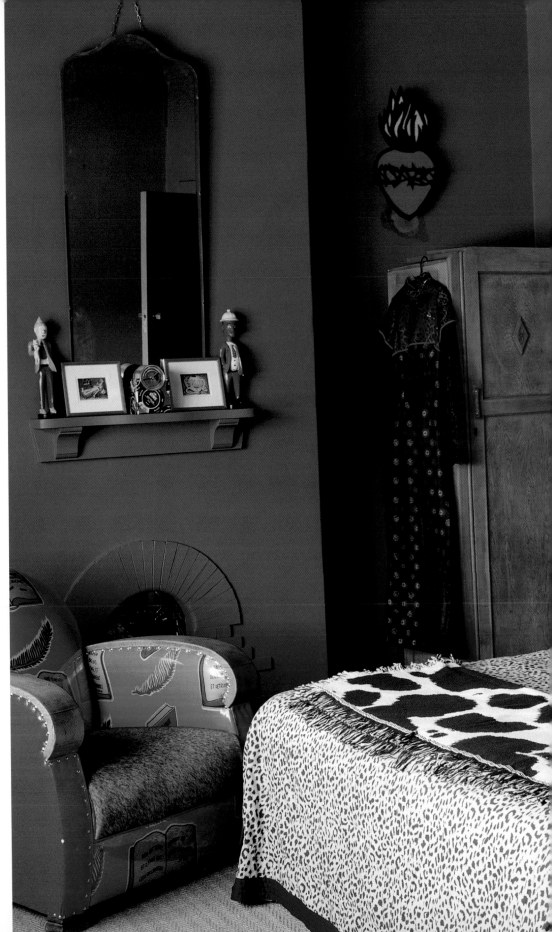

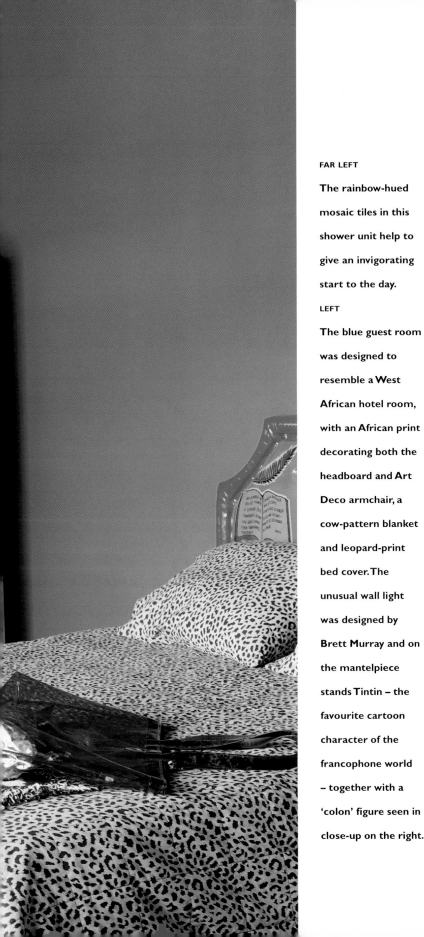

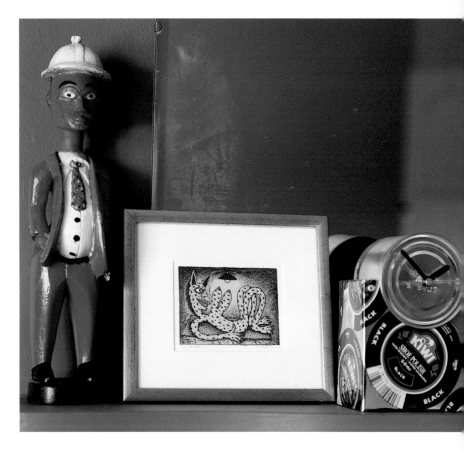

FAR LEFT

The rainbow-hued mosaic tiles in this shower unit help to give an invigorating start to the day.

LEFT

The blue guest room was designed to resemble a West African hotel room, with an African print decorating both the headboard and Art Deco armchair, a cow-pattern blanket and leopard-print bed cover. The unusual wall light was designed by Brett Murray and on the mantelpiece stands Tintin – the favourite cartoon character of the francophone world – together with a 'colon' figure seen in close-up on the right.

ABOVE

The 'colon' figure – a European colonist in tie and pith-helmet – was carved by a local African artist. The painting is by Norman Catherine, the clock made from shoe-polish tins.

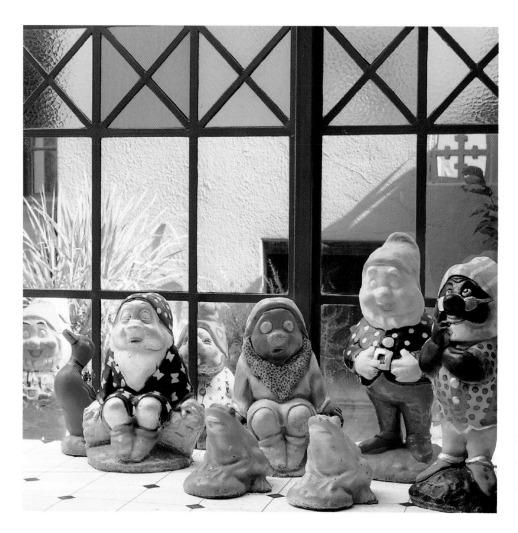

LEFT

Kitsch with clout in the kitchen: Marianne has a soft spot for garden gnomes, which have colonized her kitchen as well as her living room. This humorous group has been repainted by the well-known artist Karel Nel, whose home also features in this book.

RIGHT

Kitsch persists in the pink guest room with its glittering lamp and fake leopardskin covering the chair and bed. Elsewhere in the room there is a bead curtain from the Seychelles and a mat made out of grass and sweet wrappers from Swaziland.

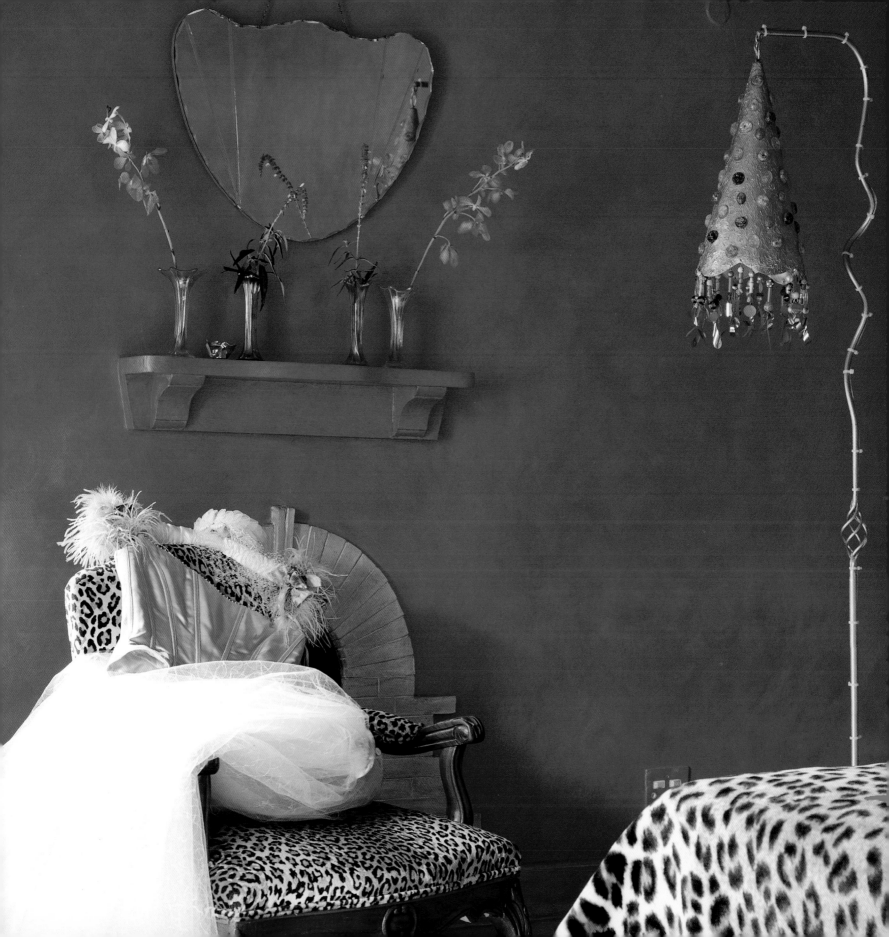

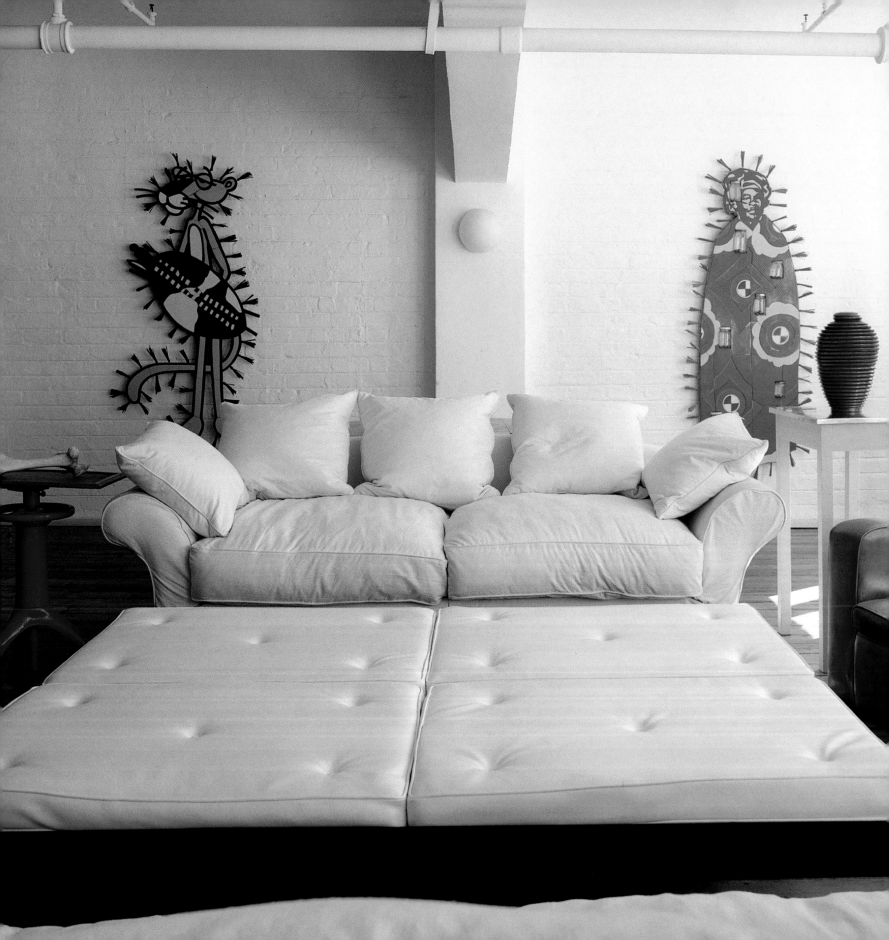

LOFT PIONEER

In a country where the tradition of the pioneer persists, Craig Port, a young clothes designer, can claim to be something of an urban pioneer. He has converted a vast loft situated in the centre of Cape Town, formerly a warehouse and then a printer's workshop, into a room with a view – and what a view, inside as well as out. The loft is one long vista of living space, punctuated by an ensemble of furnishings and objects that are easy-going, humorous, eyecatching and, what's more, most of them quite inexpensive.

The suburban tradition is very strong in South Africa and loft-living has just recently caught on. It is only in the last few years that the warehouses and commercial buildings in city centres have been converted into loft apartments, with such success that developers have even started to construct so-called 'authentic' lofts from scratch.

Craig's loft, a real one, was first purged of previous uses, cleaned up and emptied out. Then, with so much space to play with, he started filling it up again. He has some expensive pieces, by the likes of Le Corbusier and Philippe Starck, as well as pictures by young, relatively unknown South African artists – a pop art pink panther with a Zulu shield is particularly striking. But one of Craig's main sources for fitting out the loft is practically next door:

the antique and design stores of Church Street, and, even more enticing, the country's biggest concentration of bric-à-brac in Long Street. 'It's the old story of being able to resist anything but temptation,' admits Craig, 'and cheap temptation at that, right on my doorstep.' From here, he has acquired all manner of 1950s kitsch, such as diner chairs, a milk shake machine, a juke-box and a late Art Deco display cabinet. He also has a knack for picking up institutional and commercial furniture at auctions and elsewhere. These include a shop display cabinet, a pasta-drying rack from an Italian restaurant, hospital patient trolleys and a bed from Groote Schuur hospital.

Because he has the space to do so, Craig moves his possessions around continually. Although the apartment has clearly demarcated areas for relaxing, making and taking meals and sleeping, it is an extremely flexible space, which is particularly suited to parties. On a wall at the far end of the loft is a collage of mirrors, all in different styles and shapes, startling in its overall effect and an obvious talking point at social gatherings.

The look and feel of this spacious loft apartment is undeniably one of freedom and movement – an apt reflection of what is going on in South Africa today, both politically and commercially.

LEFT **A pop art pink panther holding a Zulu shield and a tribal warrior stand guard in Craig Port's vast Cape Town loft in Bree Street, one of the country's oldest streets. As the name suggests, it is a sister street to New York's Broadway – both were Dutch streets in Dutch colonial cities. Although popular in New York for many years, it is only recently that city-centre loft-living has caught on in South Africa.** ABOVE **Craig's apartment is in this former warehouse and printer's workshop.**

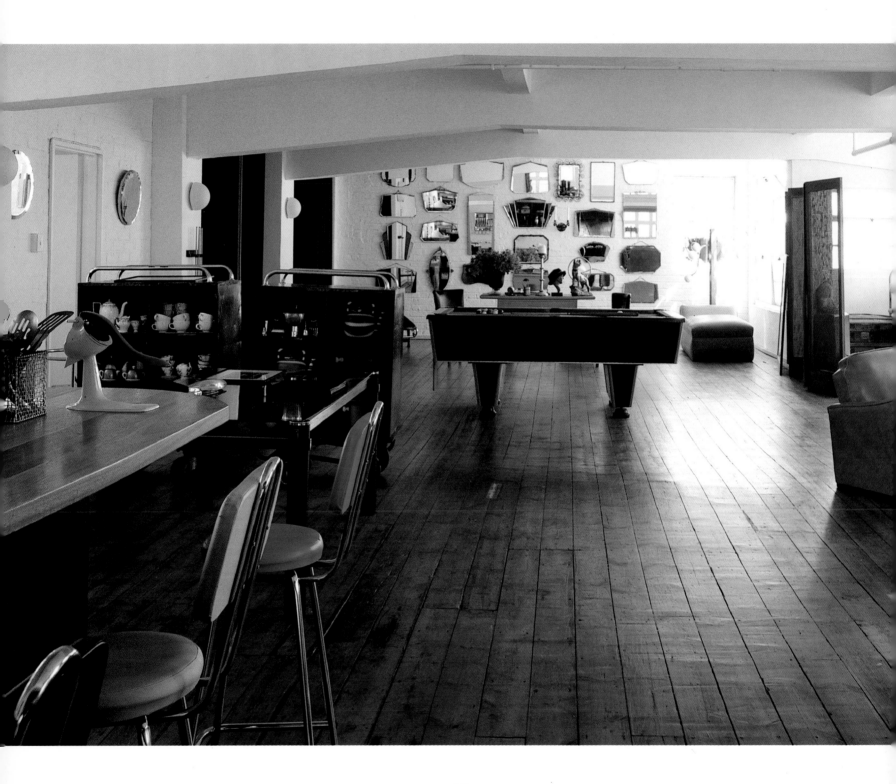

LEFT

This view from the entrance past the living area takes in only about half of the total space of Craig's loft apartment. At the far end, the wall of mirrors, twenty-three of them in various sizes and shapes but mostly Art Deco, is a real show-stopper.

RIGHT ABOVE

A Philippe Starck chair looks perfectly at home alongside salvaged hospital ward trolleys stacked with colourful kitchenware.

RIGHT BELOW

A 1950s look has been created in the kitchen area with long-legged chairs from American-style diners and a milk shake machine.

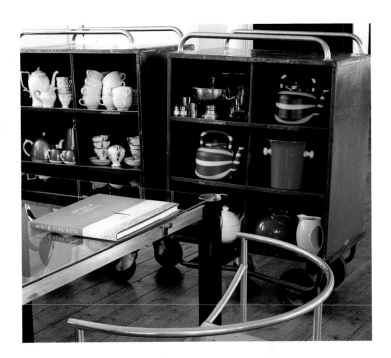

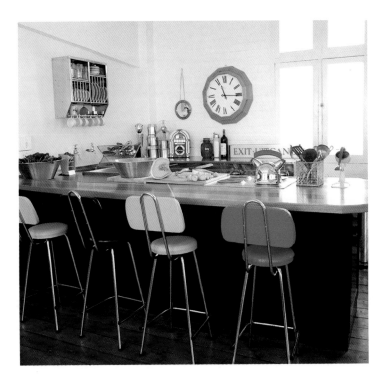

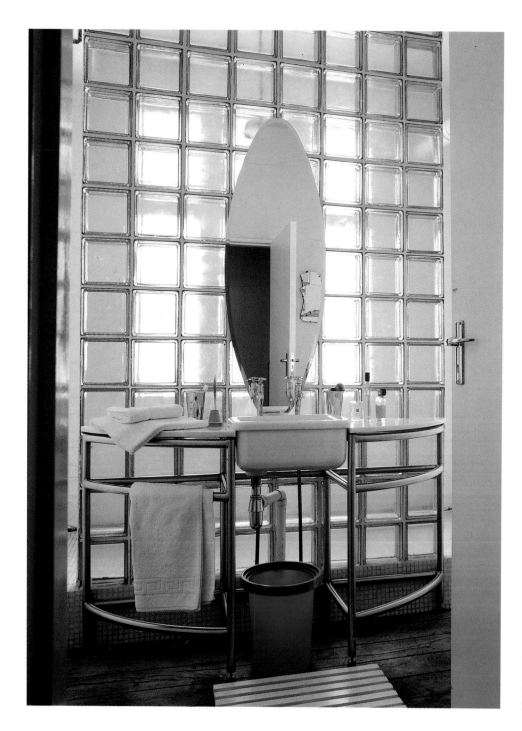

LEFT
By recycling both commercial and institutional furniture and fittings, Craig has created a home that is stylish and modern. In the bathroom, he has used glass bricks and a laboratory sink. Elsewhere, a fitting room from a clothing store has become a wardrobe.

RIGHT
In the guest room, the clothes hanger at the foot of the hospital bed is a converted pasta drier from an Italian restaurant. The bed itself comes from the Groote Schuur Hospital, where Dr Christiaan Barnard performed the first heart transplant.

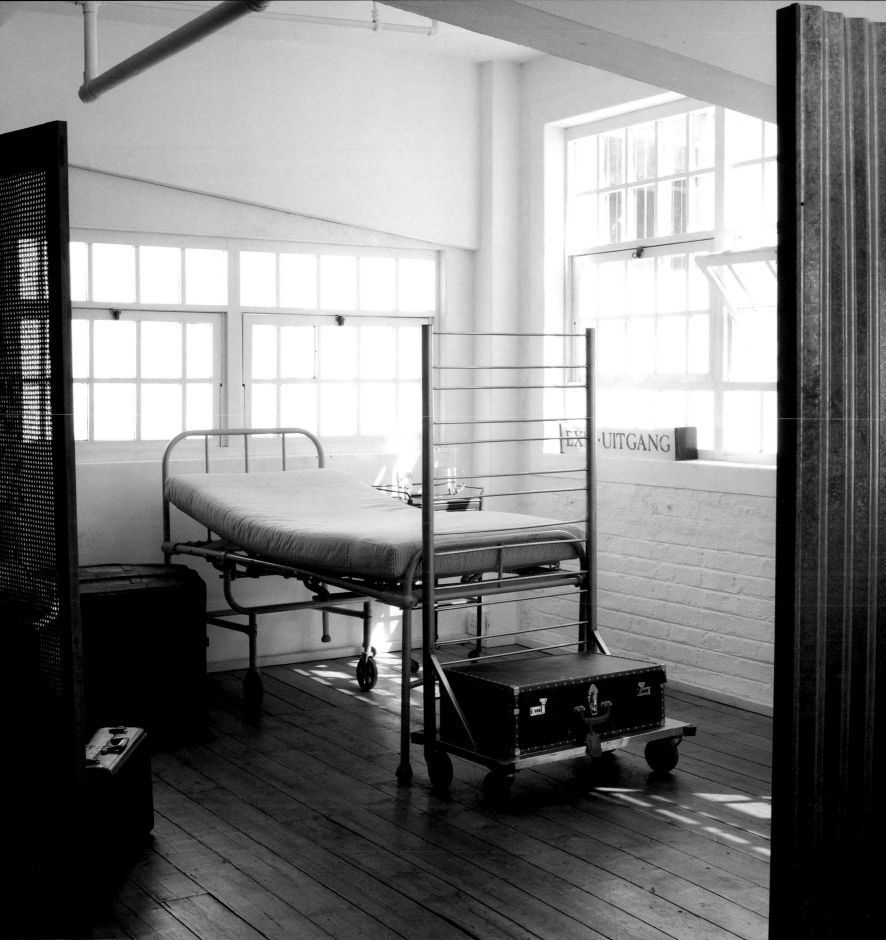

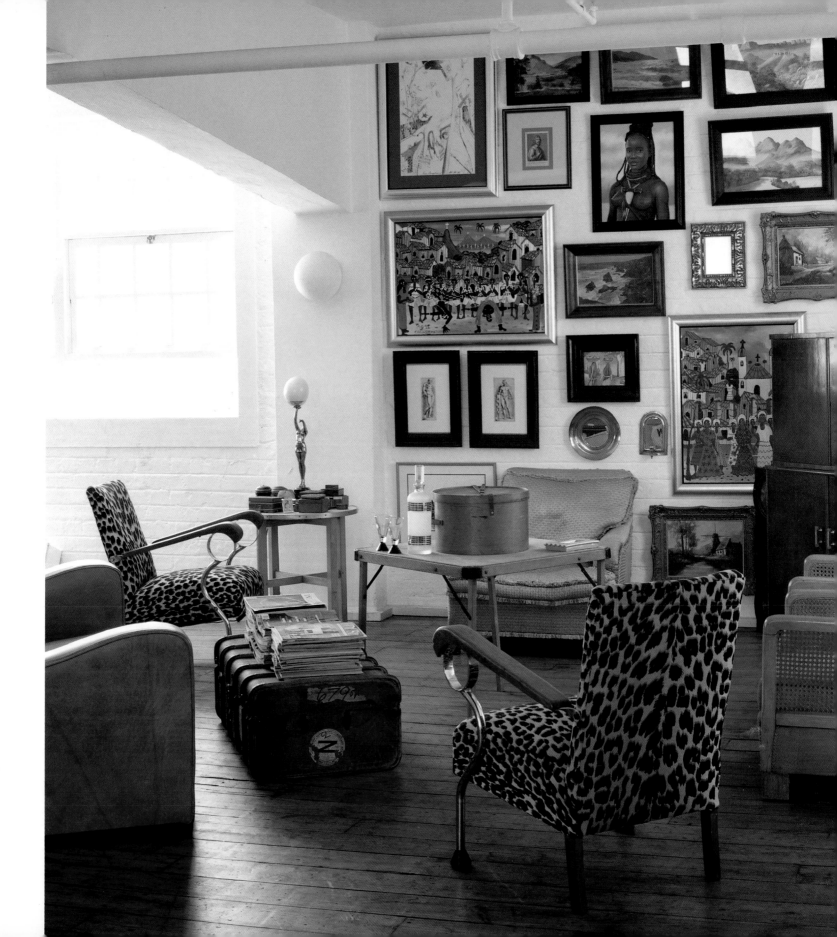

LEFT

In the relaxed seating area, the pictures almost covering the wall include a tribal girl in traditional dress and – happy travel memories for Craig – two cheerful Brazilian 'samba' pictures from Bahia. Verging on the kitsch and sentimental, the South African landscapes, which were unearthed at local flea markets, were chosen with a mixture of affection, irony and economy.

RIGHT

Like many of Craig's pieces, the rounded Art Deco display cabinet at one end of the dining area was found at a local second-hand shop.

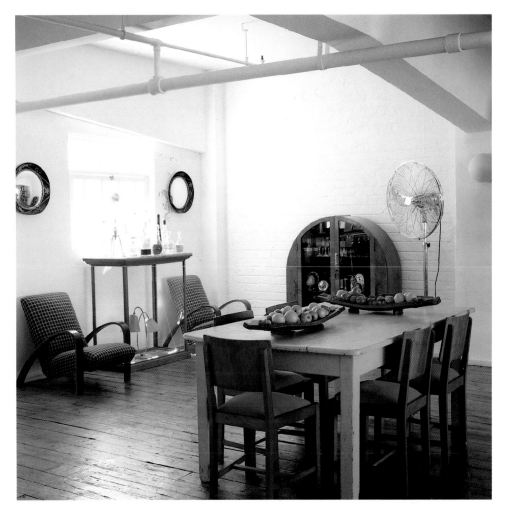

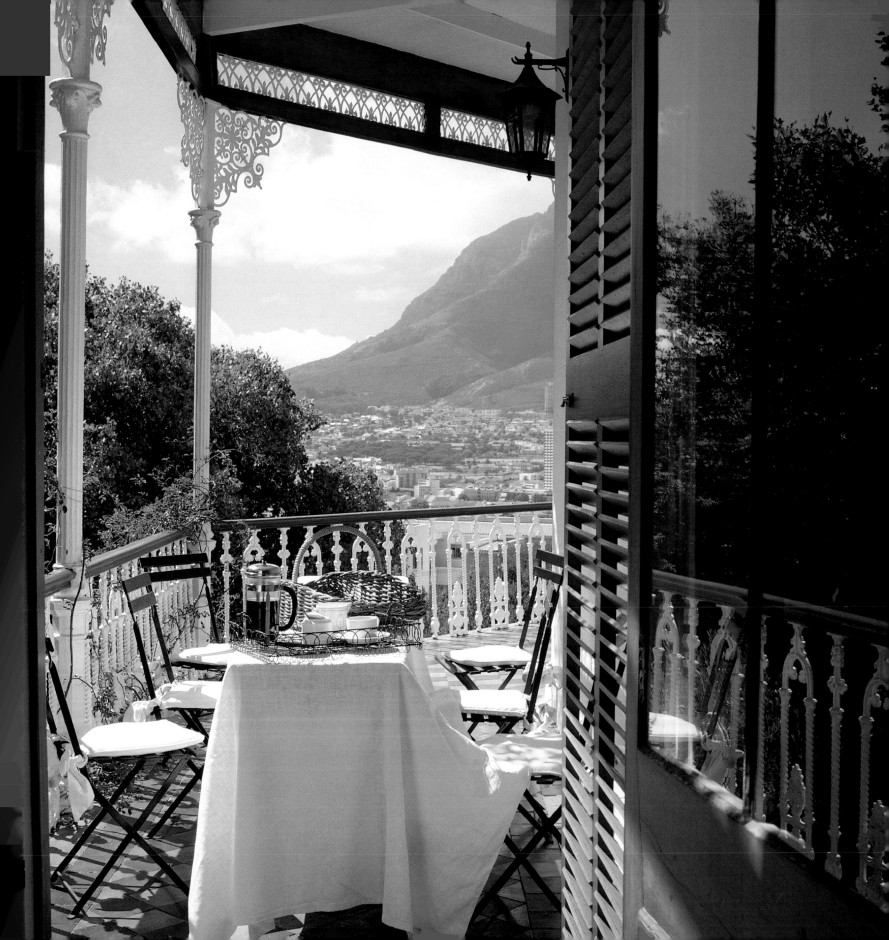

UPDATED EDWARDIAN

Although rather overawed by the grand Edwardian house they bought on first viewing thirteen years ago, Gerhard and Libby de Villiers were not at all prepared for the amount of time and work it would take to turn it into their ideal home. 'After thinking we had perhaps glimpsed paradise, we felt that for five years we had lived in purgatory,' recalls Libby. 'We often asked ourselves whether we had taken on more than we could handle.'

Their ten-roomed, two-storeyed house was built in 1906 by the owners of one of Cape Town's most prosperous department stores. Set in a large, tiered garden with views over the city and Table Mountain, the house is typical of the colonial homes built during the heyday of the British Empire, resplendent in period architectural features, such as the filigree, cast-iron decoration of the balcony and the ceilings of pressed steel. Still, Gerhard and Libby, of French Huguenot and Dutch stock, fell in love with their home not because of its colonial pedigree but because it was a challenge that as a couple – she an actress and theatre producer, he an engineer – they could face together.

The original elephantine bathtub was still in place when they moved in, but the 'running water' on the ground floor ran in one door and out of the other! The house was literally falling apart.

So the de Villiers, with their furniture piled up in one room, lived in overalls, scraping, painting and fixing. The first words their baby son learned were 'Mamma', 'Pappa' and 'angle grinder'.

The interiors – the proportions of the rooms, the staircase, flooring, fireplaces – are still handsomely Edwardian, but the de Villiers, soon suffering from a 'lace-curtain overdose' and no longer in awe of the architecture and history of the house, staged a second takeover bid, resolutely doing it their way. This meant mixing the furniture that came from their respective families with furniture they had made themselves, including the dining room table and their bed. Traditional South African furniture in yellow-wood and stinkwood now coexists with stainless steel fittings and pieces from Malaysia, Indonesia and Africa; a stunning wood sculpture turns out to be a step ladder once used in West African granaries. Paintings by well-known South African artists decorate the walls, together with pieces by their son and daughter, future stars themselves perhaps; under the staircase there is an impressive collage of their paintings. Growing up in an evolving building site certainly unleashed their imaginations, and their bedrooms upstairs are crammed full of their own collections of *objets d'art*.

LEFT A South African dream of happiness: sitting on the *stoep*, or veranda, looking out over Cape Town and Table Mountain. The local term for the frilly Victorian ironwork on the veranda is *broekielace*, meaning pantylace. In Victorian and Edwardian times, when it was imported from Britain, ironwork covered the façades of all those houses whose owners could afford it. ABOVE An unusual seashell curtain hangs at the kitchen window.

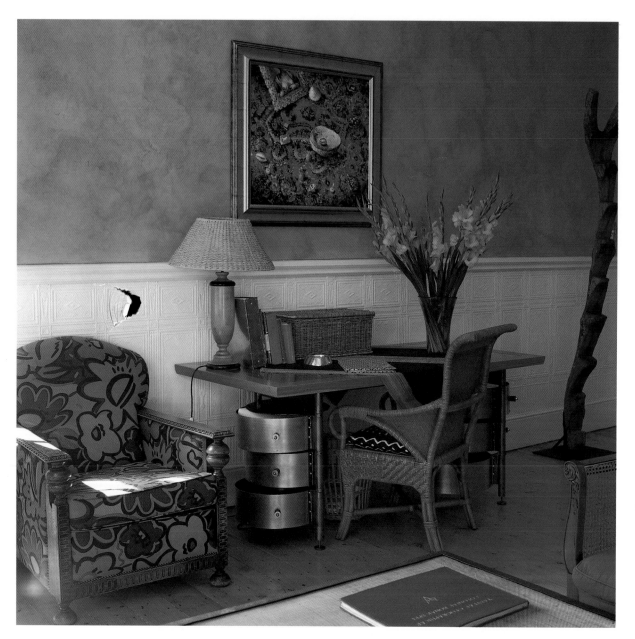

LEFT

The mix of materials and furniture styles includes a metal and wood desk, which Libby designed herself, and a cane chair from Malaysia. The painting by the South African artist Penny Siopis is described by Libby as 'nice and loud'.

RIGHT

The colourwashed orange walls are a vivid backdrop for the surreal painting by the well-known South African artist Judith Mason. The Victorian colonial-style recliner is an appropriate partner for the 'colon' sculpture – a West African artist's depiction of a European colonist.

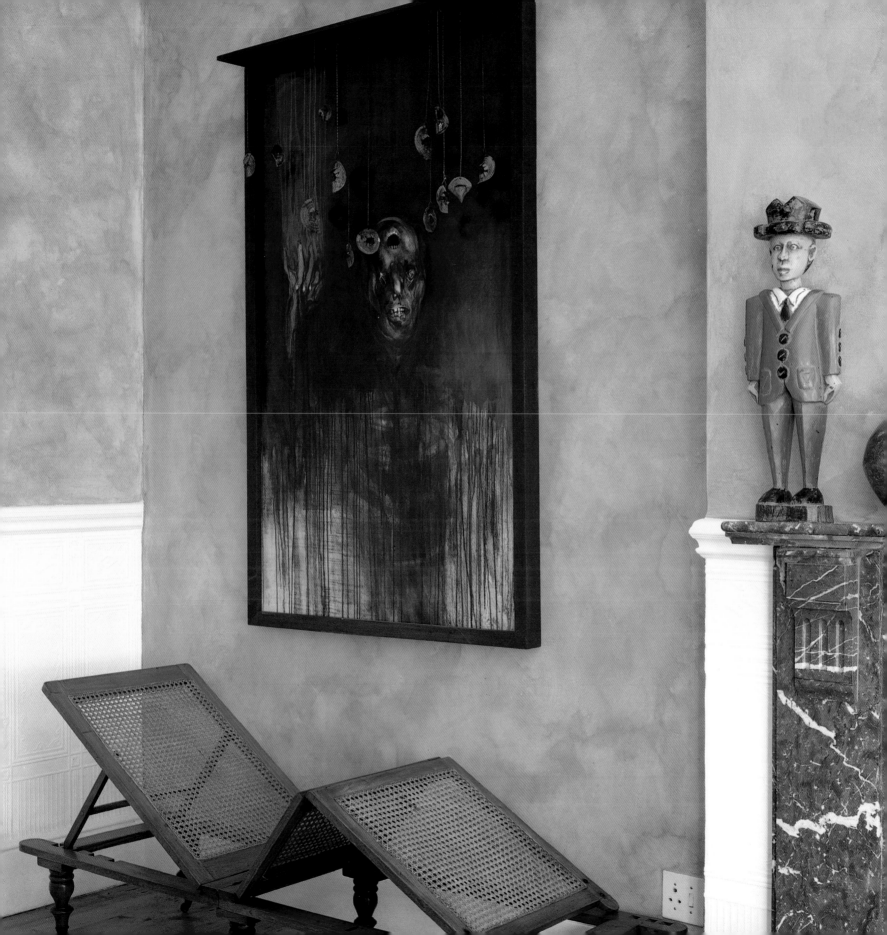

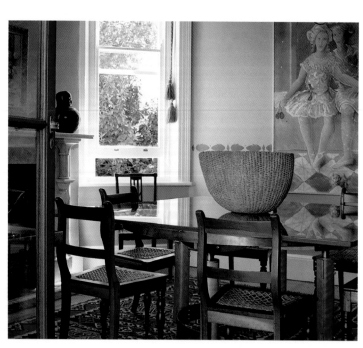

LEFT ABOVE

The rustic Zulu fish sculpture over the ornate marble fireplace makes a striking contrast with the sleekly abstract Italian sculpture to the left.

LEFT BELOW

The dining table is custom-made from stainless steel placed on cherrywood legs. Typical of South Africa are the stinkwood *riempiestoel* chairs, their seats made of woven strips of leather for keeping cool. The painting is by Christo Coetzee.

RIGHT

A skylight allows extra light into the spacious kitchen. The industrial lamp was bought for next to nothing.

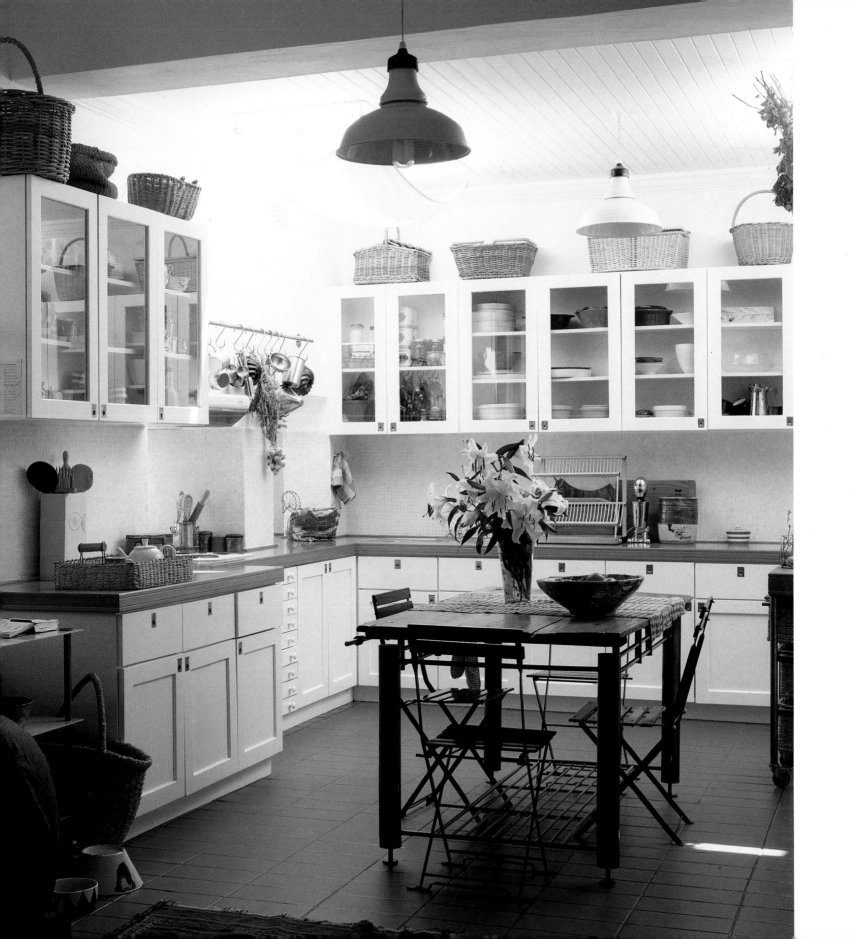

ABOVE

The furniture in the guest bedroom includes an iron and basketware chest of drawers and another *riempiestoel* chair, from the Sandveld hinterland.

RIGHT

Libby designed the modern, stripped-down four-poster bed in the main bedroom, which complements the Victorian feel of the cupboard, rug and bedspread.

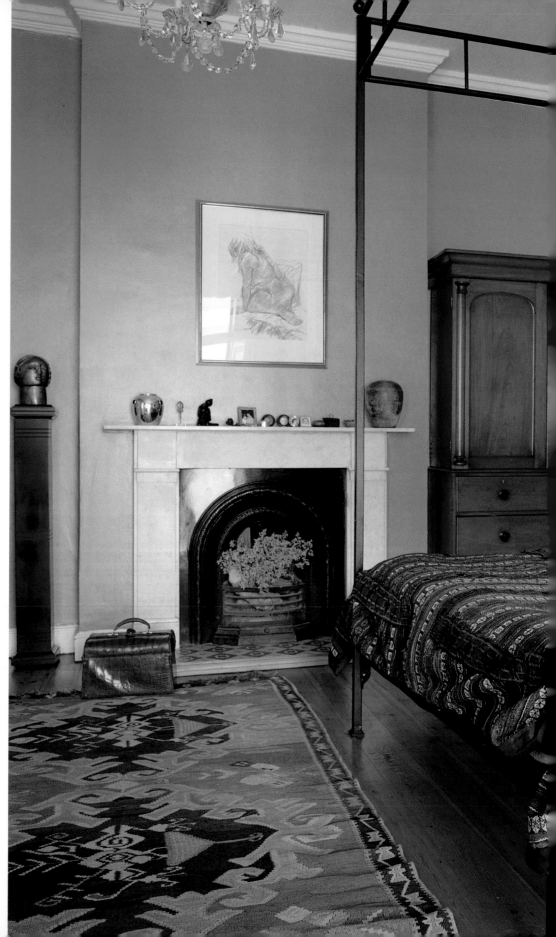

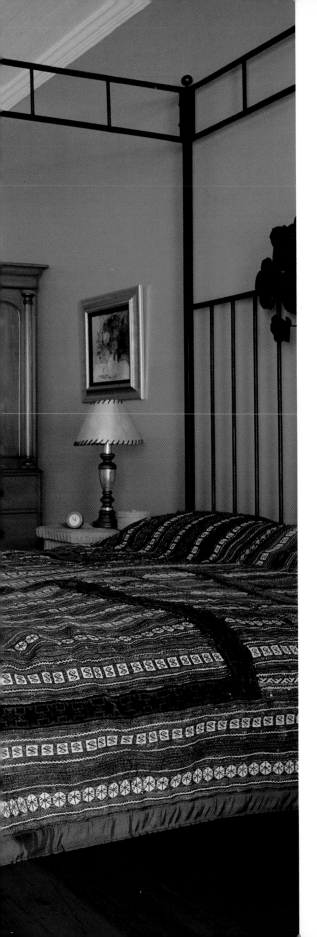

RIGHT

The enormous bathtub, standing on an Oregon pine floor, dates from the original bathroom. This part of the house looks very much like it did when it was built almost one hundred years ago, but the addition of pictures on the wall and modern furnishings has given the room a distinct character.

MIXING STYLES

'There seem to be so many styles in our house that my friends are convinced that I can't make up my mind about what I like,' admits Laureen Roussouw. 'So, let's call it eclectic, or rather neglectic – neglectful of the usual rules of ghastly good taste.'

Laureen's home, which she shares with her husband Koos and their two daughters, is in Durbanville, half-way between Cape Town and Stellenbosch, South Africa's second oldest town. From the outside, it's an average 1950s suburban house, with ample space both inside and out. The expansive grounds, swimming pool and tennis court appeal particularly to the children. For Laureen herself, who grew up on a farm, the house and grounds are big enough to provide her with a feeling of homecoming and as much elbow-room as she needs.

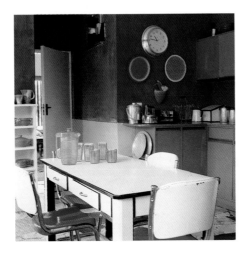

Koos, a lawyer, commutes to Cape Town for work, but Laureen works mainly from home as a journalist and stylist. She specializes in interiors, which means that her familiarity with the subject allows her not to take it too seriously, and she is spared the rather solemn design orthodoxy and hang-ups with 'gracious living' that sterilize so many homes. Instead, she veers towards 'junk shop chic', particularly so in her vividly painted kitchen, which looks rather like a 1950s American milk bar.

The remaining rooms are much more restful, looking out over grass and trees. The large living room on one side of the house and the main bedroom on the other let in light from all sides. To Laureen, 'the sunshine, and the rain, are right there in the rooms' as the outside merges with the inside, via *stoeps*, or verandas.

The main living space is large and open plan. Paintings by Leon Vermeulen, Pieter Vermaak and other friends from their university days in Stellenbosch hang on the walls. There are tables high and low, and chairs from far and wide in various lean-back and laid-back styles, such as English club and American garden chairs, and vernacular paraffin box chairs made out of wooden boxes from the Southern Cape. Around the dining room table is a sterner set of stiff-backed chairs with crosses and hymnal holders, originally from a Scottish church. In contrast, there is a reclining Balinese planter's chair, as well as an Indian table and other Asian pieces and fabrics. 'With the ending of apartheid,' says Laureen, 'our horizons have widened, and this shows in our homes. After the Balinese and other exotic trends, the latest seems to be the Moroccan look. But I have never gone in for a particular look, just filled my house with things from home and away, traditional and modern, and pictures by old friends.'

LEFT This is one of the quieter corners of the Roussouw family kitchen, which looks like an American milk bar from the 1950s. Bold colours are the main feature of the room, in stark contrast to the overall brown effect that existed when the family first moved in. **ABOVE** The second-hand enamel table and brightly coloured chairs, which look as if they have come straight out of a 1950s Hollywood movie, are representative of the Roussouws' taste in junk shop chic.

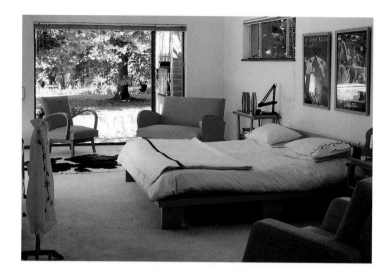

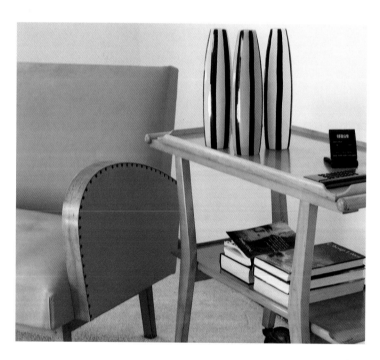

LEFT ABOVE

Light streams into the bedroom from all sides, giving the impression of a sheltered, outdoor sleeping area.

LEFT BELOW

Much of the furniture in the house, some of it originally office furniture, dates from the 1950s. The elegant vases on the bedside table are also from that time.

RIGHT

Various styles feature in the light-filled living room: a minimalist open fireplace, modern, ostrich egg lamps on the mantelpiece, leather club chairs from the 1900s, an Indian table and a colonial recliner from South East Asia.

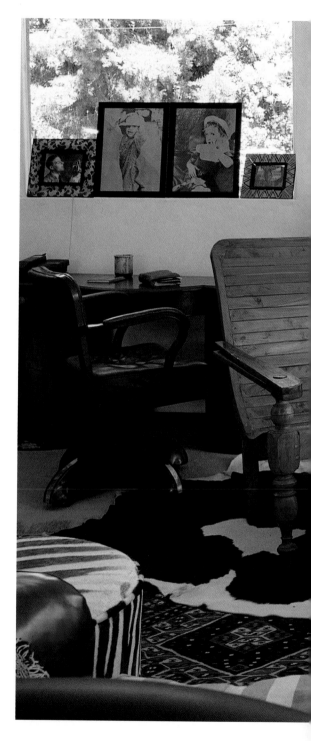

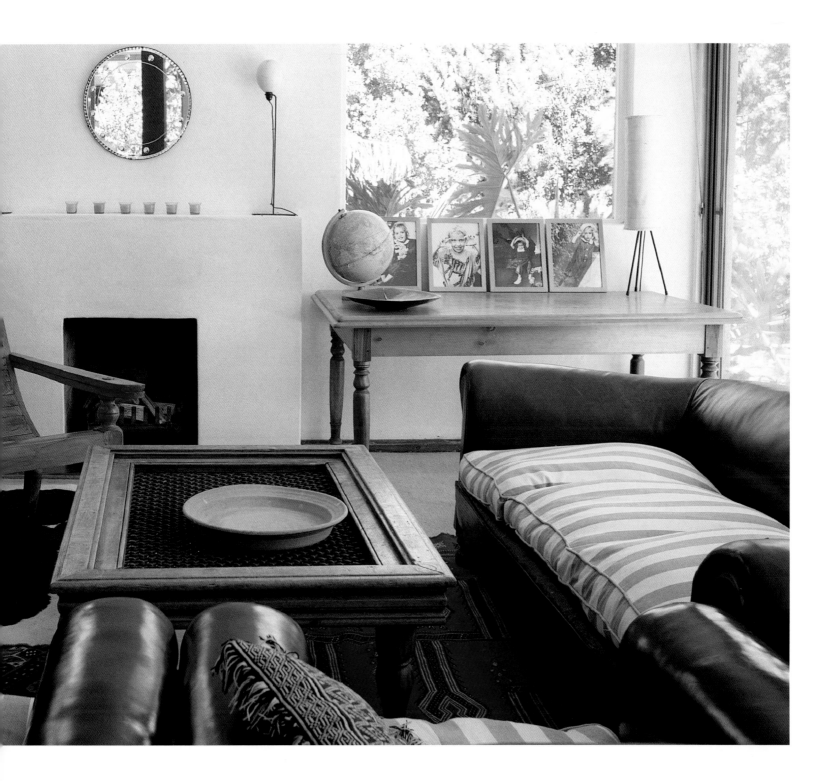

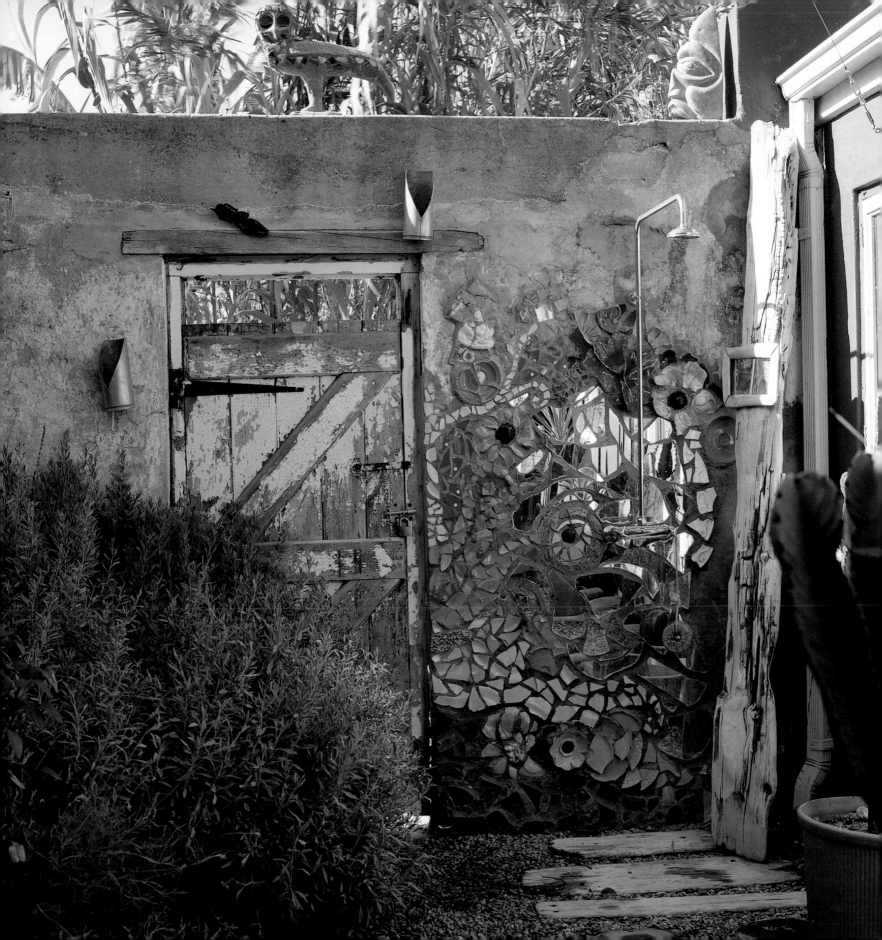

URBAN BEACHCOMBERS

'We are both magpies. On the beach, we pick up pieces of driftwood, and at markets and second-hand shops we find other kinds of flotsam to bring home,' says Shane Petzer, speaking of the home he and Scott Hart have made together. But it's certainly a lot more than the mere magpie's nest he makes it out to be.

Their house in the Observatory area of Cape Town was built in 1902 during the post-Boer War building boom. Neglected and run down for a number of years, Observatory has survived much of the urban disruption of the automobile age, and retains its charming, turn-of-the-century Edwardian ambience. Now more upwardly mobile, it is filling with young, creative people like Scott, a clothes designer, and Shane, a psychologist.

When they moved into the house, Scott and Shane made the decision to preserve its façade; the veranda, with its lacy, period ironwork underpinning a corrugated iron roof, looks past a heavily scented frangipani tree to a quiet street with similar houses, evoking a strong feeling of neighbourhood. Inside, they have also kept some of the Edwardian features, such as the floorplan and open fireplace, and even added to them with mock-pompous light fittings; a chandelier, for instance, came from a bankrupt bordello.

Still, the old house underwent radical, if mainly cosmetic, surgery. The old wooden floors were sanded and bleached, and a variety of patterns, textures and colours introduced. The walls have been imaginatively and vividly decorated, and complement the eclectic choice of furniture and furnishings. In the bedroom, they have juxtaposed a William Morris chair with an Indonesian bed; in the living room, there are several chunky club chairs in vibrant colours. A meat locker has been repainted and placed in the living room; it displays a meditation tray, a Bodhisattva head from Thailand and a toy car from Zimbabwe. Most of the sculptures and paintings are from Southern Africa; some are by roadside artists, picked up while Scott and Shane were travelling. Other items, such as the Kurdistan rugs, came from markets in Asia. A museum-piece fridge – a family heirloom of sorts – stands in the kitchen. Bunting on the shelves introduces a festive touch.

Scott and Shane describe themselves as *strandlopers*, a reference to the earliest recorded people at the Cape who were beachcombers and lived off the sea. With their keen eye for the decorative possibilities offered by flotsam and jetsam, they have, in their way, recycled old Cape traditions.

LEFT The mosaic shower in Scott and Shane's courtyard is work in progress: in energetic moods they consider extending it to near Roman bath proportions; at other times they see it as no more than tongue-in-cheek kitsch. Echoing the shower wall, the earthenware owl perched on the garden wall is encrusted with mosaic tiles. It was made by Koos Malgas. ABOVE A close-up of a mosaic flower and the shaving mirror attached to a piece of driftwood.

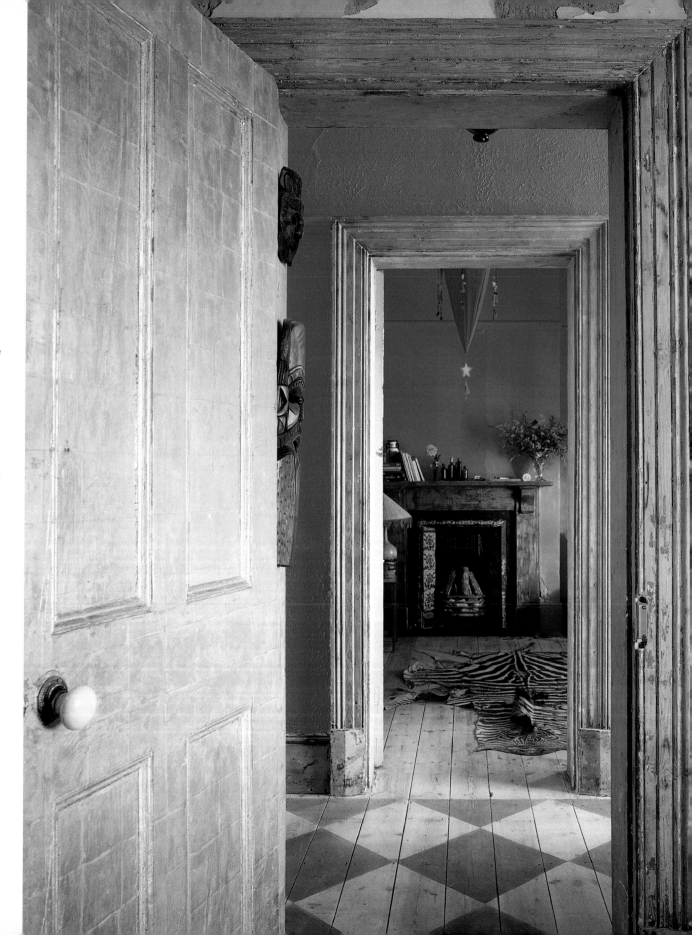

RIGHT

Every room in the house has been painted in vivid colours. In the study, where the plaster was falling off, brown blotches of exposed wall were left in full view, to harmonize with the surrounding deep blue paint, turning a defect into a feature.

RIGHT ABOVE

The bicycle, propped up against the crimson textured walls in the hallway, is representative of Scott and Shane's mobile lifestyle. The floorboards have been stripped back and painted in a blue diamond pattern, introducing yet another shade into an already colourful decorating scheme.

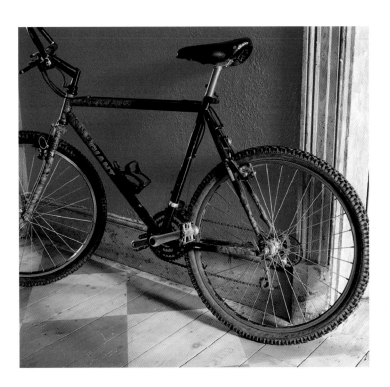

RIGHT BELOW

The juxtaposition of colour in the living room – terracotta armchairs against purple, colourwashed walls – is bold and uncompromising. The squashy armchairs provide an obvious temptation to forget about outdoor pursuits and stay at home.

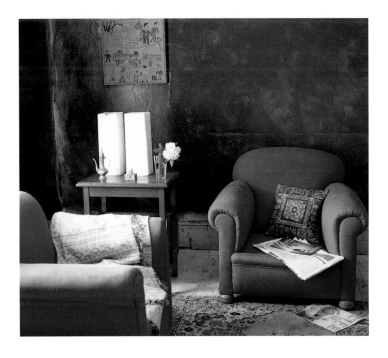

LEFT ABOVE

Cut-out paper bunting on the kitchen shelves adds a festive touch to the stacked kitchenware.

LEFT BELOW

Kitchen accessories hang from a ladder that was salvaged from the beach.

RIGHT

The unusual striped effect on the wall was created by recycling the original wallpaper. Loose bits of paper were first torn off, then the surface was smoothed over by gluing on layers of white tissue paper. Finally, the entire area was painted in grey stripes, leaving the irregularities to show through. Fabric bunting acts as a kind of pelmet.

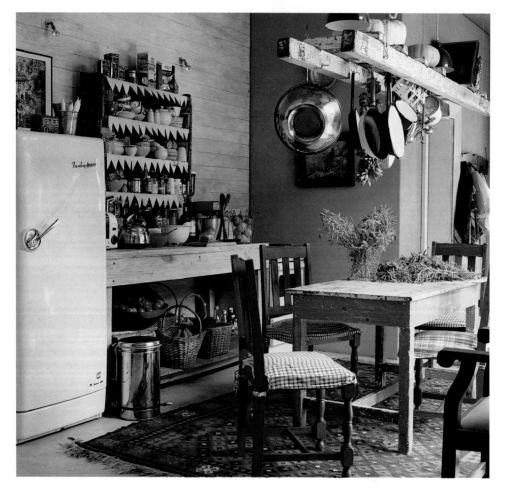

LEFT

A subdued use of colour and minimal decoration give the bathroom a tranquil atmosphere. The wooden screen at the far end of the room is covered with linen embroidery. When the weather is fine, of course, there is a choice between the inside bathroom and the courtyard shower.

RIGHT

The distinguished, sleigh-like bed in unvarnished wood is from Indonesia. With its bright green and acid yellow striped walls and harlequin-style bed linen, this room demonstrates Scott and Shane's mastery of colour.

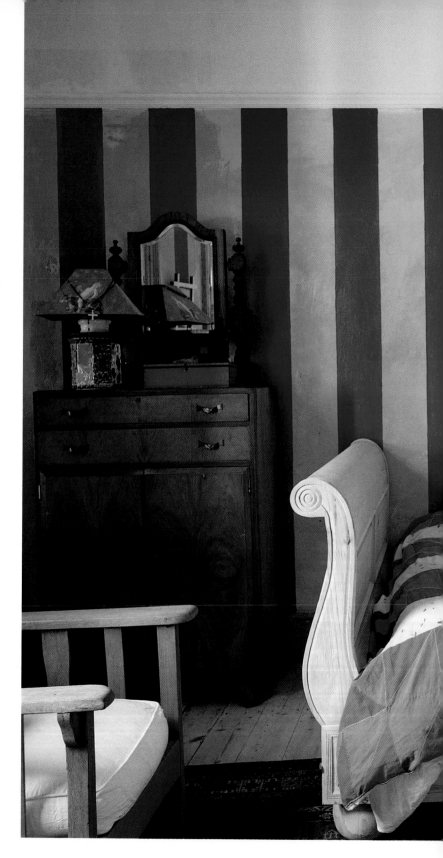

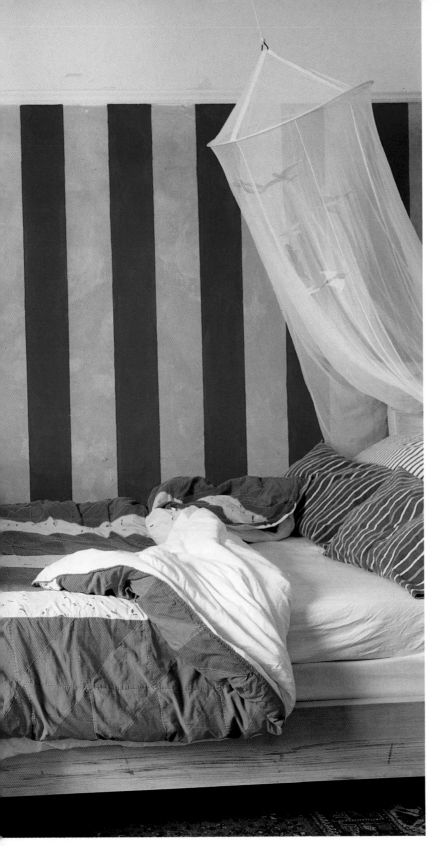

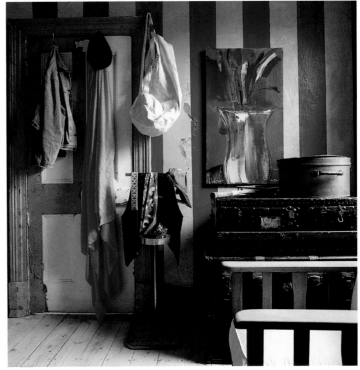

ABOVE

In a corner of the
bedroom, beside
the Morris chair, is
an assortment of
trunks, hat-boxes
and other antique
luggage used for
storage. Some of the
pieces came to Cape
Town in the days of
the ocean liners.

MINIMAL

The cool and
uncluttered
minimalist look has
had a particularly
healthy influence
in South Africa.
It has helped to
dilute a strong
local tendency to
overdecorate in
either a 'Boer
baroque' style or
fussy English country
house style. One can
see from the houses
featured in this
chapter that some
of South Africa's
finest homes are in
the minimalist style.

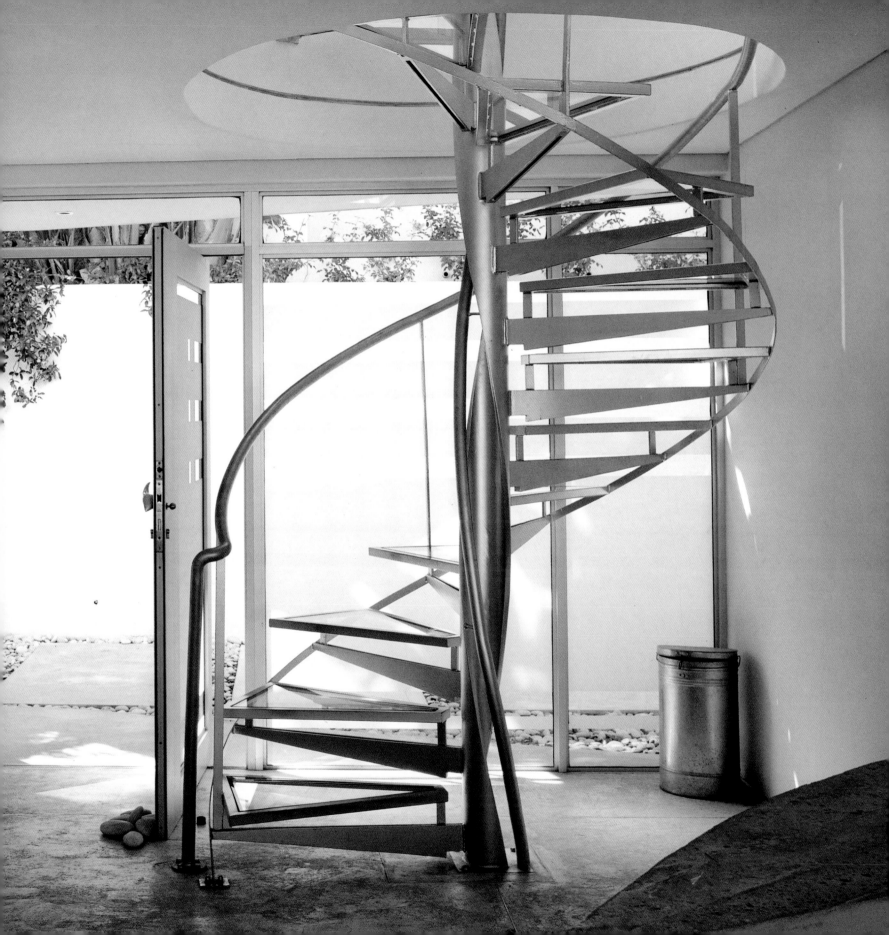

OCEAN VIEW

In her home between mountain and sea, Gail Santer is very happy to be a 'semigrant' – a word applied to the many talented people who have left behind the stress and crime, as well as rewards, of the economic capital, Johannesburg. Stopping short of becoming fully fledged emigrants, they have moved to more reassuring parts of the country. And what could be more reassuring than the Cape?

But, unlike many other 'semigrants' who, if they can afford it, adopt the wine estate lifestyle, Gail decided to have a completely fresh start. In Johannesburg, she had lived in a sizeable traditional house with a thatched roof, large grounds and horses. But her Cape home is in Bantry Bay where the big views and 'Malibu-on-the-beach' atmosphere more than compensate for the relatively small size of the houses.

With the help of architect-designer Stefan Antoni, Gail embarked on a 'less is more' operation on her newly acquired house. She remodelled the whole of the interior so that the two floors now open onto a terraced living space, allowing uninterrupted views of the sea and sky. Lion's Head mountain is behind the house and the sparkling blue waters of Bantry Bay are in front; she is able to see the ocean as she lies in bed, as well as from most of the other rooms.

The floors are pale, covered with tiles outside, and inside with a layer of white cement mixed with sea sand. Everything is simple and understated, with white and sandy colours predominating. But the house also makes great use of metal for some of its chairs and other fixtures. Brushed steel features in the kitchen, the bar area and, especially, the bath and shower room. Here is the perfect mix of opulence and austerity: the room is big enough for a party, there are pictures on display, yet the wall separating the bathroom from the bedroom is made from corrugated iron. Before it became associated with poverty, this was the standard building material during more pioneering times; it is good to see it making a comeback.

The contemporary look of Gail's house bears no resemblance to the rather fussy overdecoration of so many homes and, as a consequence, it is very much in demand for fashion and film shoots. Filming, in fact, keeps Gail in contact with her former life in the fashion business. She is always busy; part of her time is spent putting her fashion know-how at the disposal of the *Ikamva la Bantu* campaign, which manufactures black dolls for black children, helping to create employment opportunities as well as a better self-image among the children.

LEFT To enter Gail Santer's house, one has to step down from street level onto a patio shaded by a banana tree. Underfoot are trim stepping stones made from concrete and surrounded by a river of smooth, round pebbles. The entrance is a quiet prelude to stepping over the threshold and being confronted by an expanse of sea and space. ABOVE A study in texture and shades of cream and grey.

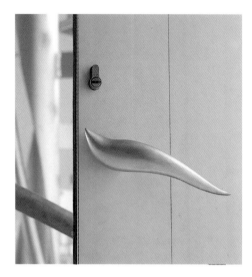

ABOVE

**Many of the fixtures
and fittings in
Gail's house were
either designed or
recommended by
the architect and
designer Stefan
Antoni, whose work
can be seen in many
of Cape Town's
seafront buildings.
This stylish, matt
aluminium door
handle is pleasing
to the eye as well
as to the touch.**

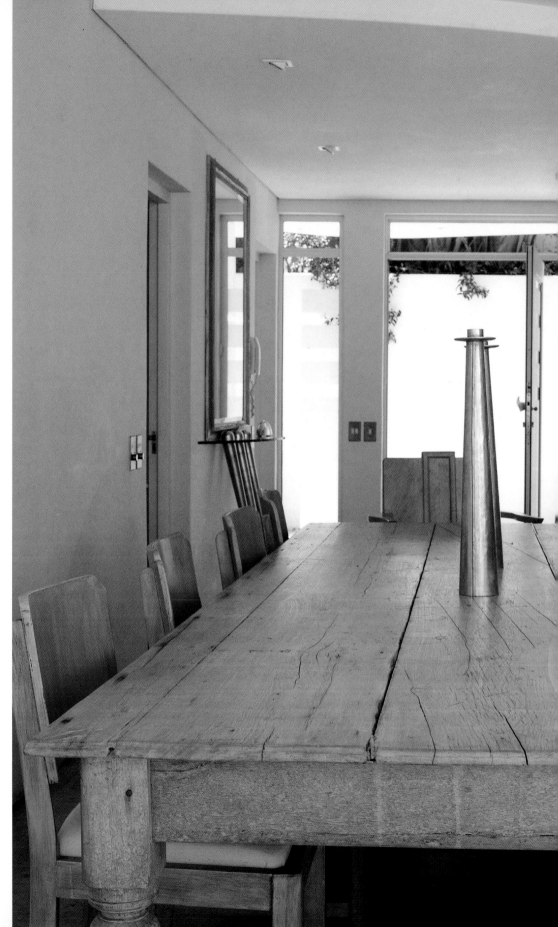

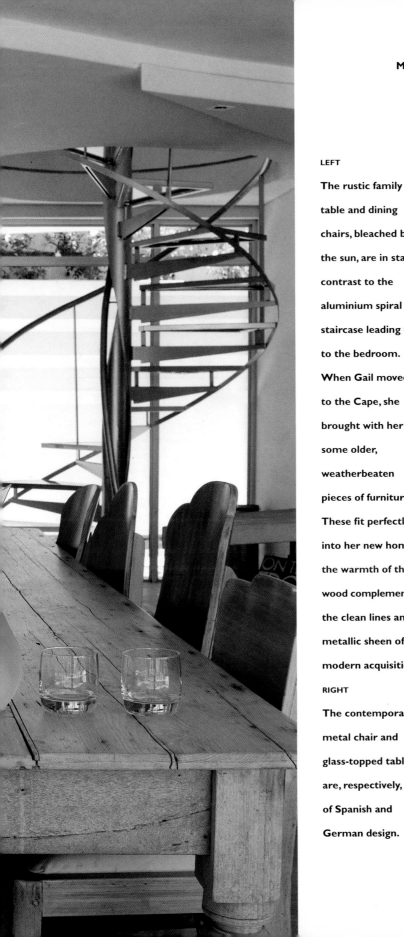

LEFT

The rustic family table and dining chairs, bleached by the sun, are in stark contrast to the aluminium spiral staircase leading up to the bedroom. When Gail moved to the Cape, she brought with her some older, weatherbeaten pieces of furniture. These fit perfectly into her new home, the warmth of the wood complementing the clean lines and metallic sheen of her modern acquisitions.

RIGHT

The contemporary metal chair and glass-topped table are, respectively, of Spanish and German design.

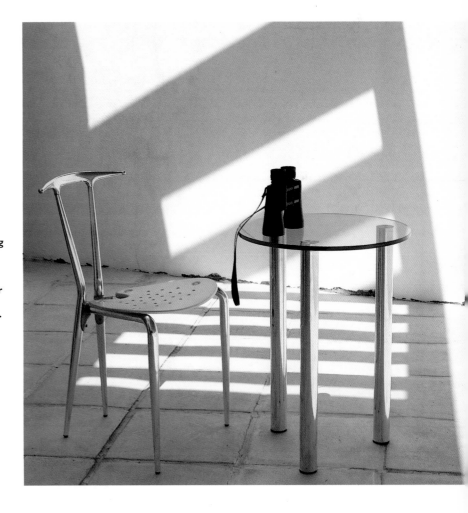

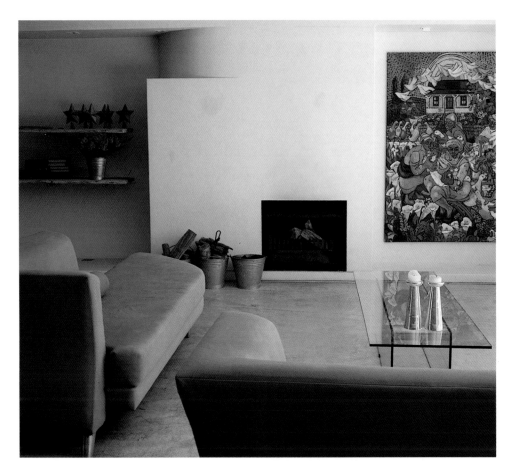

BELOW

Seating in the kitchen area is provided by modern, stainless steel bar stools. Together with aluminium, this material is used widely in the home.

BOTTOM

Galvanized iron Christmas stars, mounted on springs, bring a festive touch to the living room. Although decorative, they suit the overall minimalist scheme.

LEFT

The floor is made of a mixture of white cement and sea sand, demarcated with thin strips of aluminium. The open fire is particularly welcome during the Cape winters.

ABOVE

Even when the fire is not lit, warmth radiates from the sunny painting on the wall. A typical rural Cape scene, it features women wearing scarves and plucking geese.

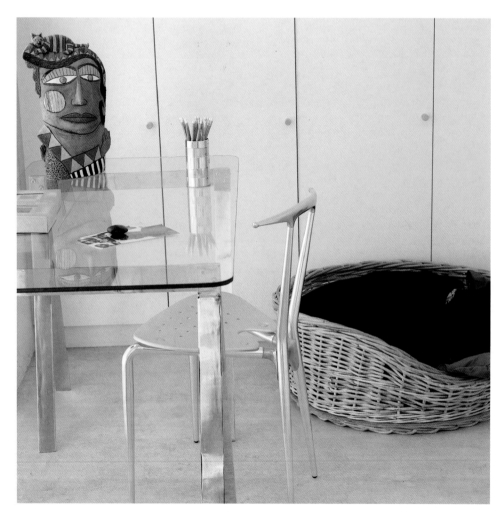

LEFT

The contemporary glass-topped table is the perfect neutral setting for a colourful naive sculpture.

RIGHT

This striking bathroom is large enough to hold a fair-sized party. With the exception of the wooden sculpture, which provides texture, colour and warmth, the materials used are a fashionable mix of marble, glass, stainless steel and corrugated iron. Until quite recently, corrugated iron was decidedly unfashionable and considered the poor man's building material. That is no longer the case.

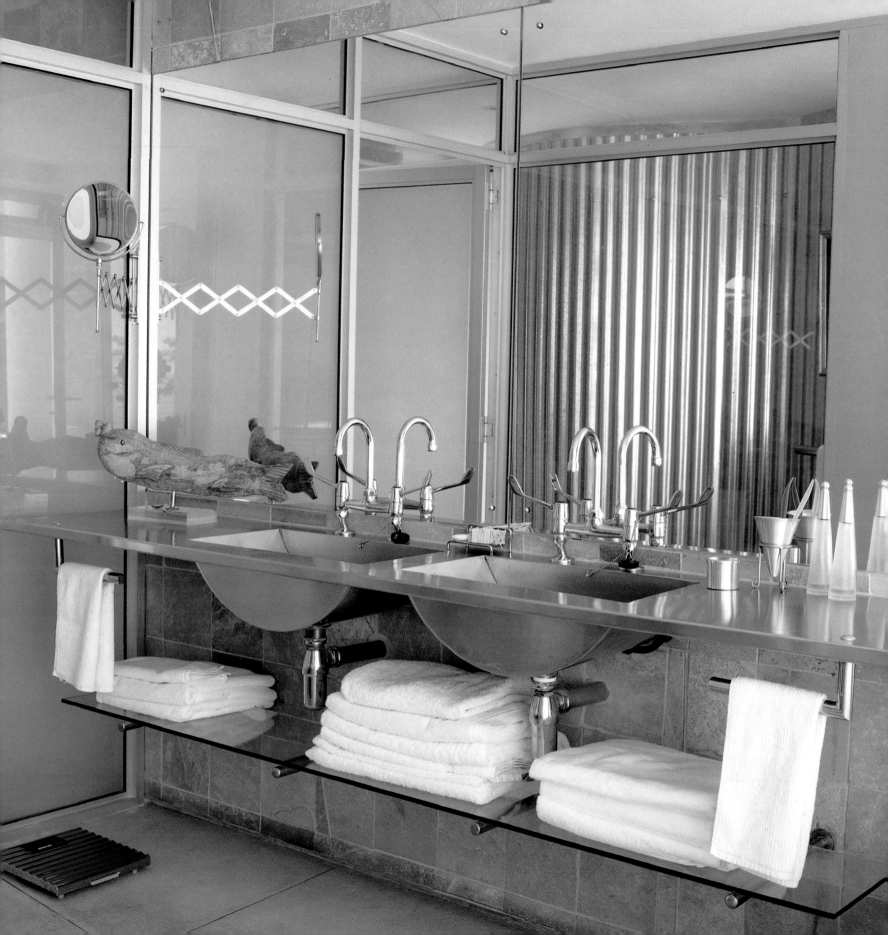

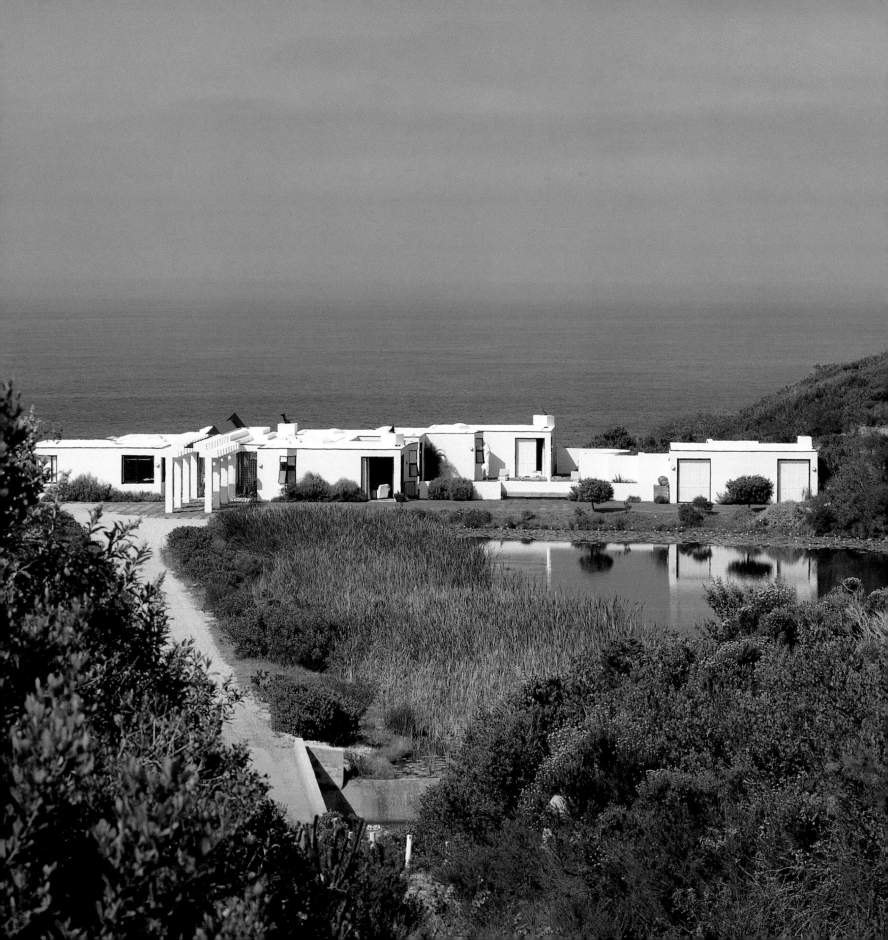

CLIFFTOP PARADISE

Perched high on a cliff edge, with a peaceful nature reserve on one side and plunging views of the Indian Ocean on the other – perfect for whale-watching – Plettenberg Park Hotel has probably the most spectacular setting in the whole of South Africa.

The hotel was built as a 'getting-away-from-it-all' home by Russell Stevens, a hotel executive. But his business instincts apparently got the better of him; after a few years, he converted it into a hotel. Not that it shows. There's not a desk or key-ring in sight and nothing remotely like a lobby or function room. What's more, guests in the four suites set their own timetables, eating when and whatever (within reason) they wish.

The building, designed by architect Tony Doherty, is spare and minimalist, based on cubes, with trellises used as space dividers and lots of skylights. Designer Stephen Falcke who, incidentally, has worked for Nelson Mandela, picked up the minimalist theme in his interiors. In a near-magical setting like this, he says, the priority was to let the outside in, and to keep everything 'low-key, with absolute simplicity, natural light, and mainly whites and brown'.

African cereal stampers lined up at the hotel entrance double as umbrella stands. Inside, there's a fireplace, a Portuguese wooden table, iron and glass tables designed by Falcke and variously styled chairs, some of them siesta-inducing. Restrained decorative touches include soothing black-and-white Picasso prints, ostrich eggshells in wire baskets and intricately patterned seashells in a wooden bowl. Although there are fabrics and pottery from South East Asia, most of the objects are African, chunky in shape in warm colours and with rough, weathered textures. Kenyan and Nigerian pots, wooden water-buckets and basketwork are all inviting to the touch. The walls are decorated with animal skulls and horn hunting trophies as well as a splendid series of masks in a restrained Modigliani-like style.

Although the suites, with their sleigh beds and crisp white linen, promote total relaxation, they do open out onto the great outdoors, encouraging more active pursuits. Just a short drive away is the upmarket resort of Plettenberg Bay. But much closer and more appealing is the hotel's own nature reserve, covered with *fynbos*, the family of flowers and plants unique to the Cape and celebrated by botanists since the time of Linnaeus. There's a tidal pool and a private beach where you might glimpse fish eagles and the odd baboon or rock rabbit. And, to contrast with the dramatic sea views, there is the Zen-like tranquillity of the hotel's lake filled with water lilies.

LEFT Between a small, calm lake on one side and the restless waves of the Indian Ocean on the other lie the buildings of the Plettenberg Park Hotel, whose architecture couldn't be simpler: a series of low, white cubes. In contrast to this peaceful view, that from the other side is much more dramatic: the buildings are perched on the edge of a cliff that falls abruptly down to the sea. **ABOVE** The pleasing geometric patterns of the hotel's exterior.

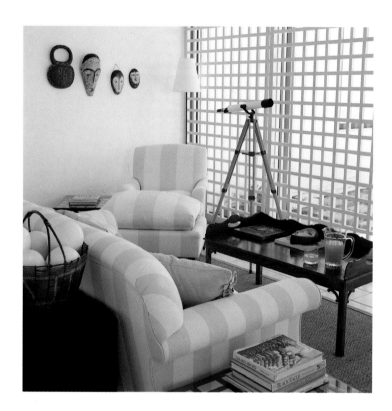

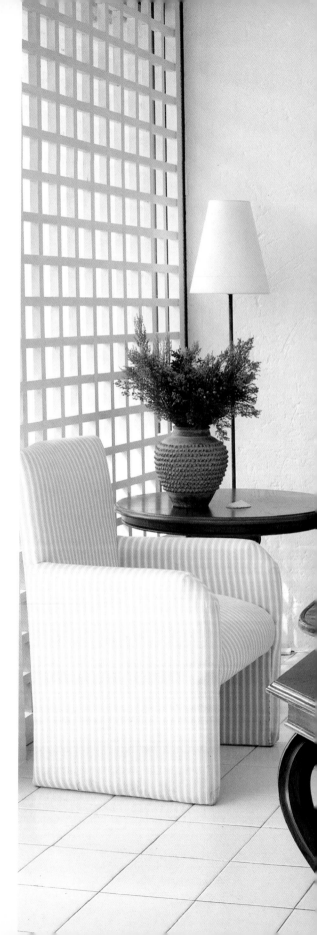

LEFT

Trellis dividers help to make the most of the natural light and feeling of space.

RIGHT

Not wanting to compete with the breathtaking views, interior designer Stephen Falcke has kept to very simple effects, such as the contrast between light and dark. The freestanding closet and octagonal Portuguese table stand out against the light-coloured walls, floors and soft furnishings. The decorations – African sculptures and utensils in dark wood and earthenware, shells and dried Cape plants – are kept deliberately simple.

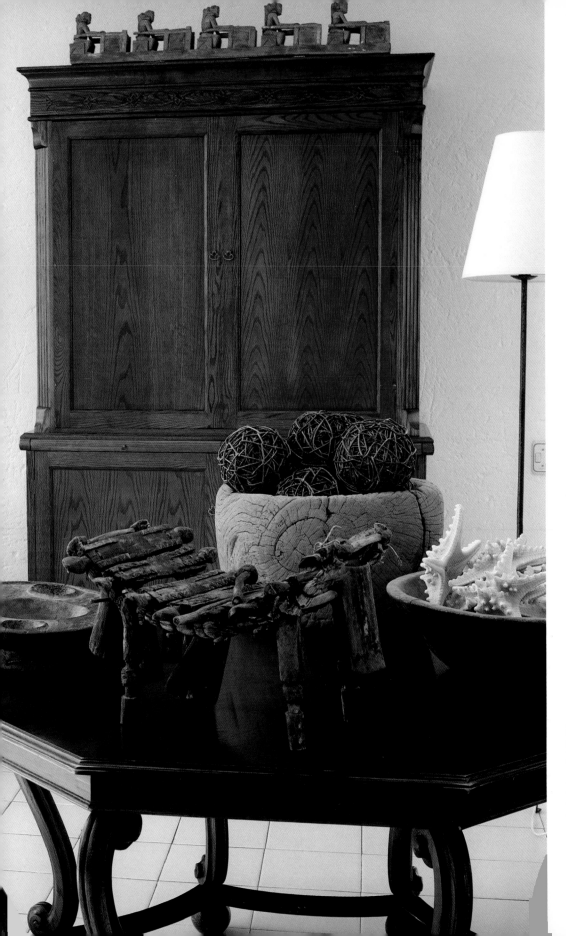

The simplest of decorative displays combines a mix of cultural influences. On an old chest, five African water buckets made of wood lead the eye to the Picasso print on the wall above. This juxtaposition could be viewed as a reminder of Picasso's affinity with African art.

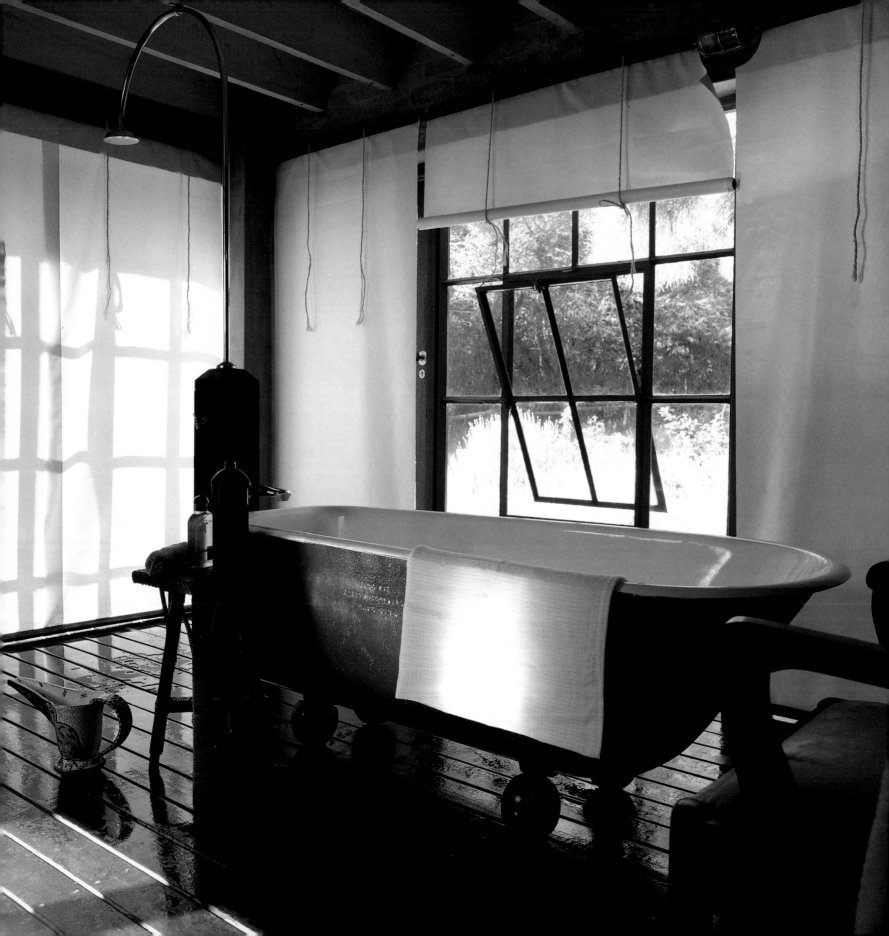

REFUGE IN THE WOODS

Horse stables that have been converted into homes are really nothing unusual – think of the many mews houses in London – but the stables in a countrified part of Cape Town that Cherylle Cowley transformed into her home originally resembled a concrete bunker, congenial for neither horses nor people.

By using wood, glass and imagination in all the right places and combinations, Cherylle has turned this thirty- to forty-year-old brutal building made of breeze blocks into a rugged and robust enclosure full of light, space and peace. Floor-to-ceiling glass walls and oversize windows let in views of trees, fields, sunshine and rain showers. An enormous spreading cactus, one of the many trees surrounding the house, has given the house its name: *Truksvei* – Afrikaans for prickly pear.

Inside the house, there is an eclectic mix of furniture, pictures and possessions: Caucasian hangings, which serve as carpets; a rollfront filing cabinet; a hardwood table with cement legs; a Voortrekker (Boer) day bed; a sleigh bed; Congolese, Indian and other carvings, paintings and personal memorabilia. But in spite of all the various objects, there is still room to breathe. What would be attention-seeking elsewhere is soothing here, such is the overall calm atmosphere that Cherylle has created.

This is, perhaps, seen most clearly in the Zen-like bathroom with its minimal decoration and fixtures that are bathed in light and reflected off a shining, slatted wood floor.

The house seems to take on all the weather patterns: the enormous curtainless windows let the outside in, and the club chairs, chesterfields and recliners help one soak up the atmosphere. Couch potatoes beware, though. Cherylle has no television; her view is that 'having a television here would be like taking a ghetto-blaster on a walk in the forest'.

In such a house, it might be tempting to adopt a lazy, hedonistic lifestyle, but Cherylle is a busy woman and has tried to strike a balance between the active and the contemplative. Her days are full, with much of the time spent at her desk. Set in a large, semi-circular niche of corrugated iron, this working area is energizing just to look at. The purposeful kitchen, with its cement surfaces, fridge housed in a steel case and storage space looking like sports lockers, is very much a workshop. Here, Cherylle manufactures her multi-flavoured ice-creams, which she sells to a few upmarket outlets in Cape Town. Formerly a high-powered advertising executive, Cherylle now works from home. With such a home, who wouldn't?

LEFT Before Cherylle Cowley converted her stables into a home, the bathtub was used as a horse trough. In the bathroom, as in the other rooms, extra-large windows let in the maximum amount of light. But the roller blinds here are unusual – the windows of most of the rooms in the house are kept bare. ABOVE The ceramic bird jug on the bathroom's wet, glistening floor. The wooden slats let the water from the open shower drain away quickly.

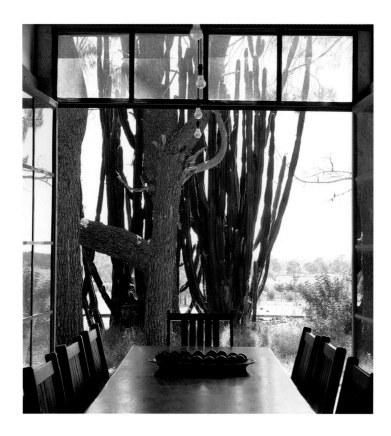

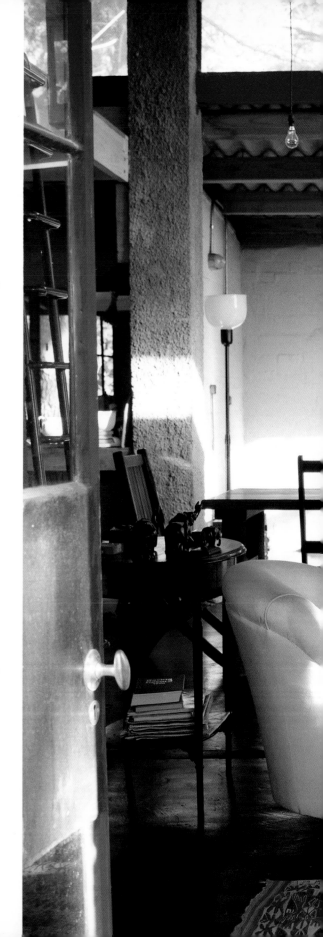

LEFT AND RIGHT

Surrounded as it is
by trees and cacti,
Cherylle's home
in the woods is a
peaceful retreat with
an ambience that
soothes rather than
prickles. The large
curtainless windows
allow the inside of
the house to merge
with the outside;
with the addition of
the many skylights,
one is always aware
of the changing light
and seasons. The
restful atmosphere
is emphasized by
the simple, clean
lines of the furniture.

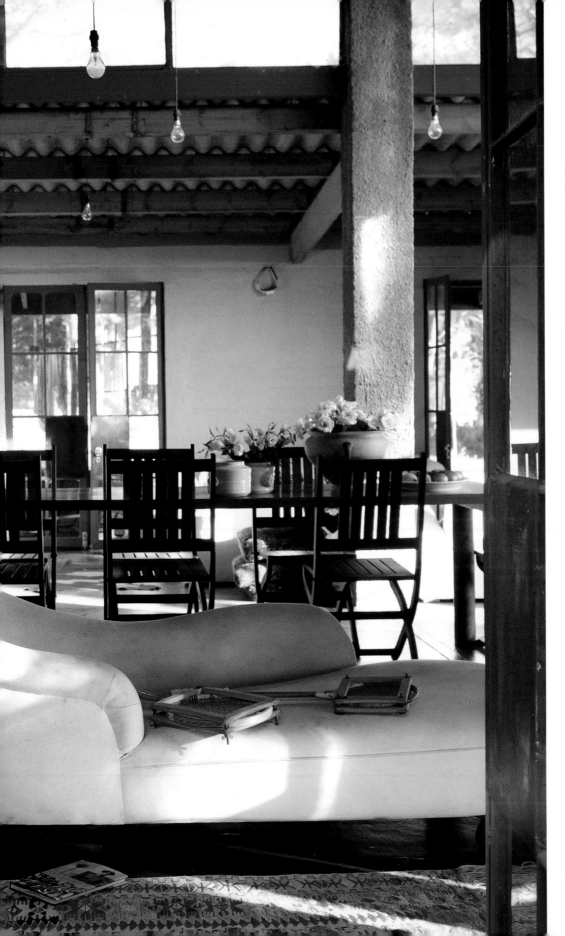

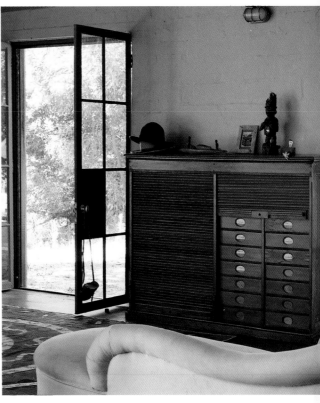

Cherylle's display of
objects from all over
the world includes a
Turkish wall-hanging
on the floor and a
powerful fetish figure,
with a mirror set in
its middle, that
stands on the roll-
front filing cabinet.

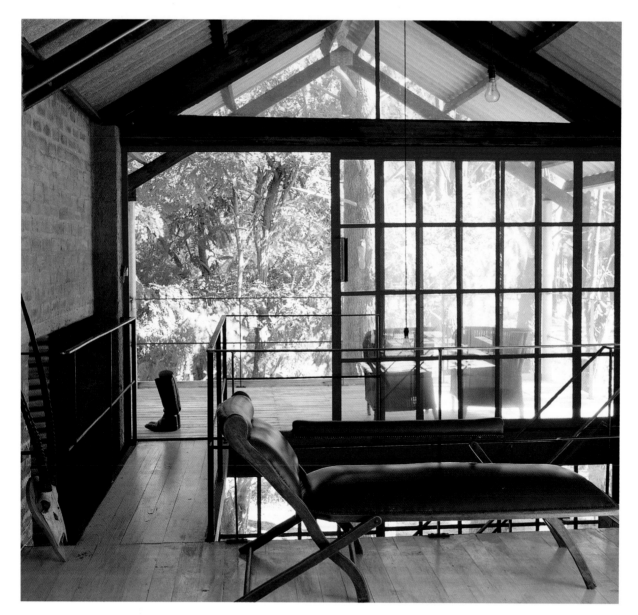

LEFT AND RIGHT

Seen here are two views of the bedroom on the upper floor. At one end there is an adjoining veranda that looks out over the trees. The room is simply furnished with a sleigh bed and an almost life-sized figure sculpted by Eugene Jardin. In this spacious modern setting there are a few reminders of South Africa's colonial past. The day bed is Voortrekker – the name given to the Boer pioneers who set off from the Cape in their covered wagons and settled in the interior. Animal horns were standard decoration in their homesteads.

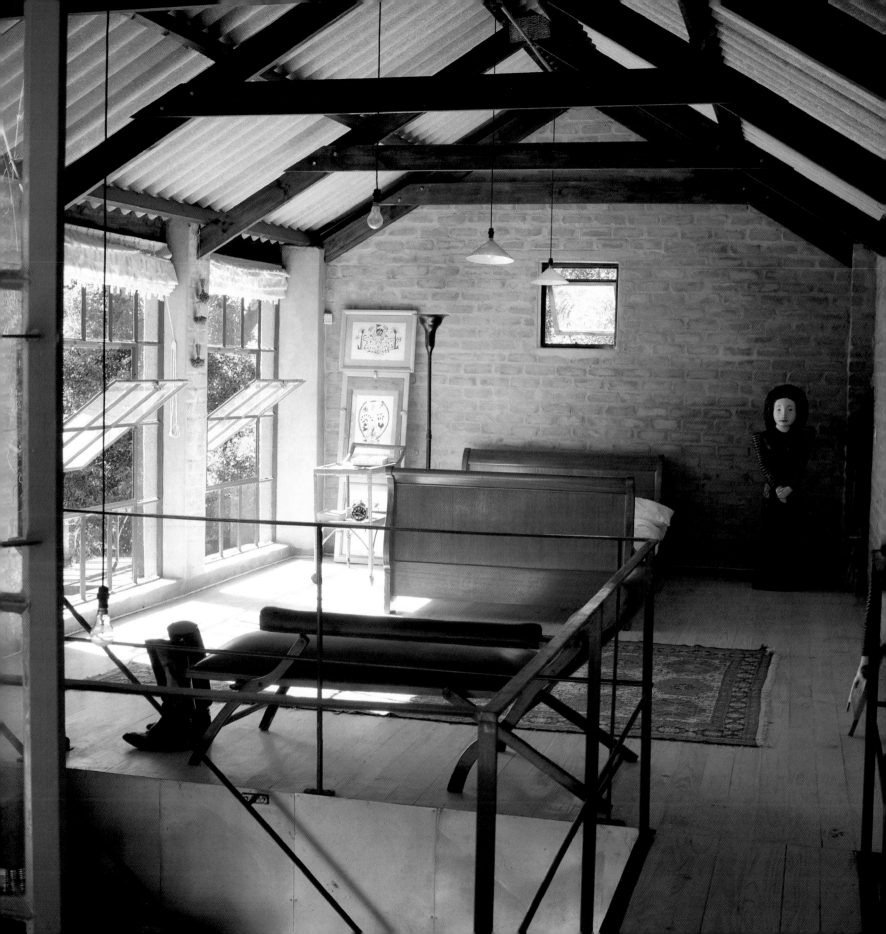

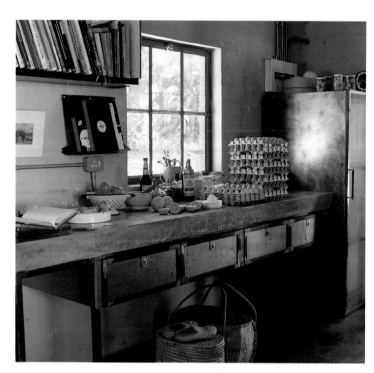

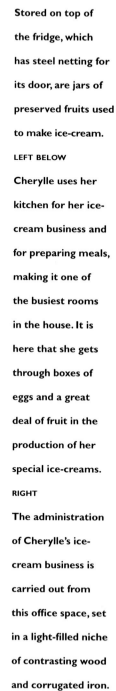

LEFT ABOVE

Stored on top of
the fridge, which
has steel netting for
its door, are jars of
preserved fruits used
to make ice-cream.

LEFT BELOW

Cherylle uses her
kitchen for her ice-
cream business and
for preparing meals,
making it one of
the busiest rooms
in the house. It is
here that she gets
through boxes of
eggs and a great
deal of fruit in the
production of her
special ice-creams.

RIGHT

The administration
of Cherylle's ice-
cream business is
carried out from
this office space, set
in a light-filled niche
of contrasting wood
and corrugated iron.

SETTING THE SCENE

Scene-setting is second nature to Leon and Stephani Morland; in their professional lives they create scenes and moods in television advertising and fashion, and in designing and decorating their home they have done the same. When they built their house in the shadow of Table Mountain, they felt there was no need to bring in an architect; instead, they chose to design it themselves with the help of builders, craftsmen and artisans.

Stephani points out that 'the minute Leon sees something, he starts redesigning it', and that is exactly what happened with their home. What was originally just a very ordinary garage, and an unlikely starting point, Leon extended and transformed into the most open of open-plan houses. Living, working, cooking, eating, entertaining and so forth all take place in one large area. The bedrooms, kitchen and walkways are grouped around a nave-sized central space, under a trussed roof three floors high, with oversize windows at the front and back. There are no curtains, which is virtually unheard of in South Africa – being curtainless is considered almost more suspect than being shirtless, so strong is the cult of the curtain, draped in various twisty-twirly ways.

Whereas most homes in the neighbourhood are set back from the street, the Morlands' pushes forward and is painted a most unsuburban Chinese red, a colour they eventually settled on after no fewer than six colour changes. Water plays a vital role outside. There is a long narrow pool behind the house, and to go through the front door, one has to step over a tiny pond filled with goldfish. Apparently, this is good feng shui, the Chinese lore of orientation that has been rediscovered and is now so popular; however, two centuries ago, early Chinese immigrants buried their dead near Table Mountain according to feng shui principles. The Morlands don't take feng shui that seriously, though, 'only when it suits us'.

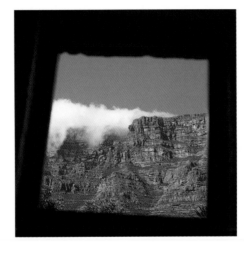

Inside the house, some of the pictures on the walls were painted by Leon, who also designed quite a few of the furnishings, such as the tables and lamps. Other decorative details include props that Leon used in advertising campaigns for foreign companies, with whom South Africa has become a popular location. However, his most satisfying assignment was making a home-grown television commercial entitled 'Building a new country'. This was aimed at persuading South Africans to vote in the 1994 elections and laid the foundations for the Rainbow Nation. To the Morlands, and to many others, there is a clear connection between building a new country and building a new house.

LEFT **From the outside, it is difficult to imagine that the Morlands' vividly coloured house, which was built to their own design, started as a garage. Painted a Chinese red, the house continues the oriental theme with lattice-work double doors.** ABOVE **From their windows, the Morlands have close-up views of Table Mountain, shown here with its famous 'tablecloth', as the locals call the clouds that sometimes drift over the summit.**

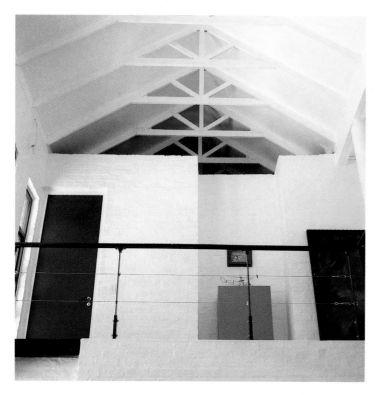

BELOW

This life-sized wire sculpture was made by a local artist. Wire sculptures, which originally depicted model windmills, motor cars and aeroplanes, have now become much more sophisticated and are a popular art form in South Africa. They can often be bought from roadside vendors.

ABOVE

Looking up at the roof trusses, one can see how the house makes full use of a space of barn-like dimensions, the equivalent of three floors in height. Open stairs and walkways provide access to the upper rooms.

ABOVE

Originally garden decoration and once used as a film prop, this 'classical' head is made from concrete.

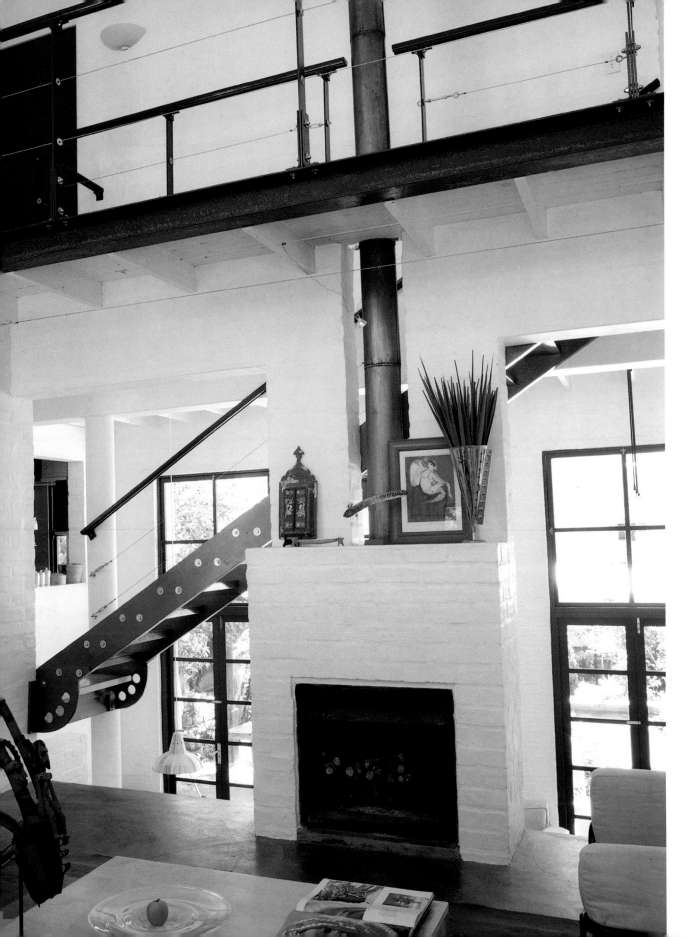

The Morlands have managed to create a tremendous feeling of space in their home, as shown here in the seating area, complete with an open fireplace. The balustrades and staircases provide plenty of walkabout space. This upper balustrade is made from metal ship cabling, but the 'Meccano', metal-looking steps in the background are, in fact, made from wood. *Trompe l'oeil* and other visual tricks are part of Leon's skills as a set designer. The paintings are by Cape Town artists; the wooden mask is from Mali.

E T H N I C

Ethnic, and in
particular African
art, has never
been more popular
throughout the
world as it is now.
In South Africa, this
interest in art has
much to do with
the country's
reaffirmation of its
African identity.
Ethnic art collected
in South Africa
ranges from Ashanti
in the north-west of
the continent to
Zulu in the south-
east, each with its
own characteristics.

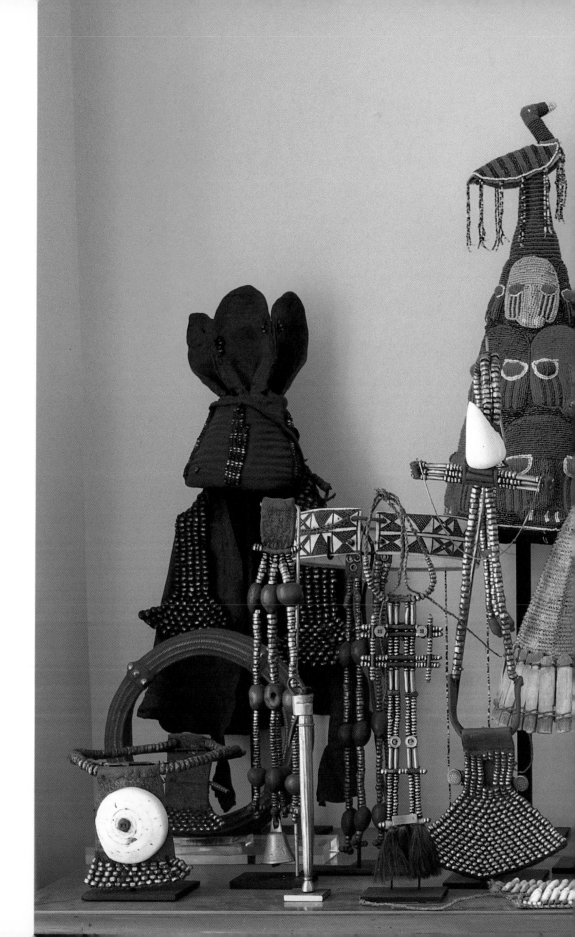

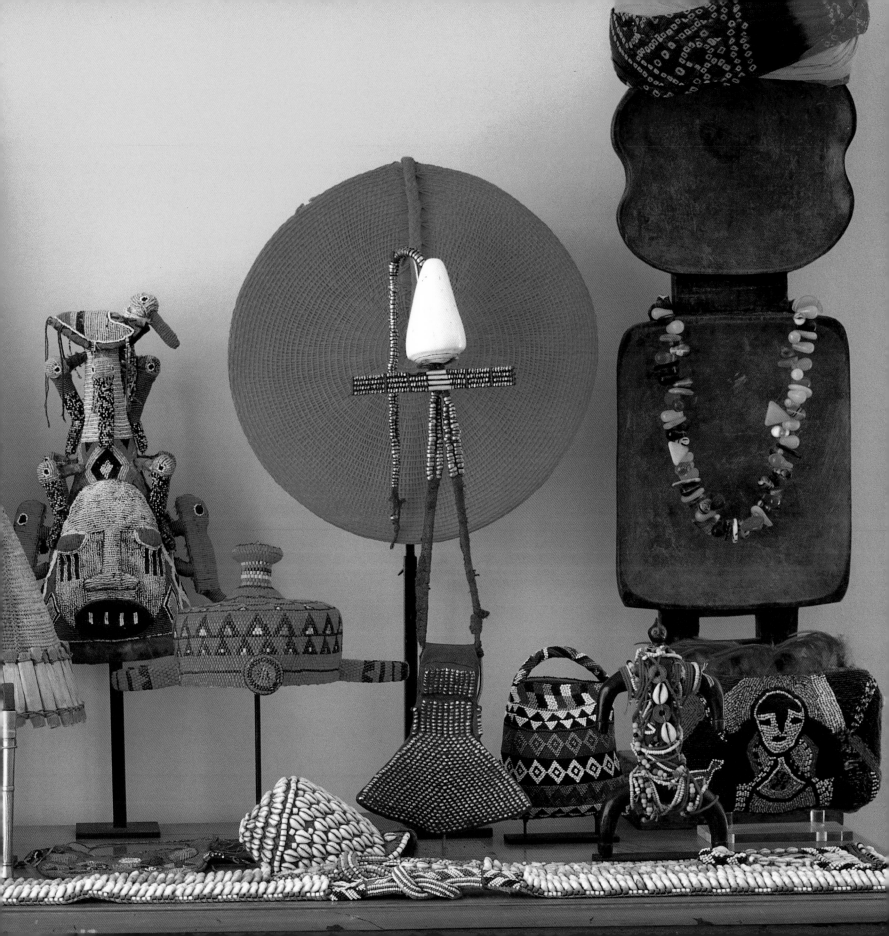

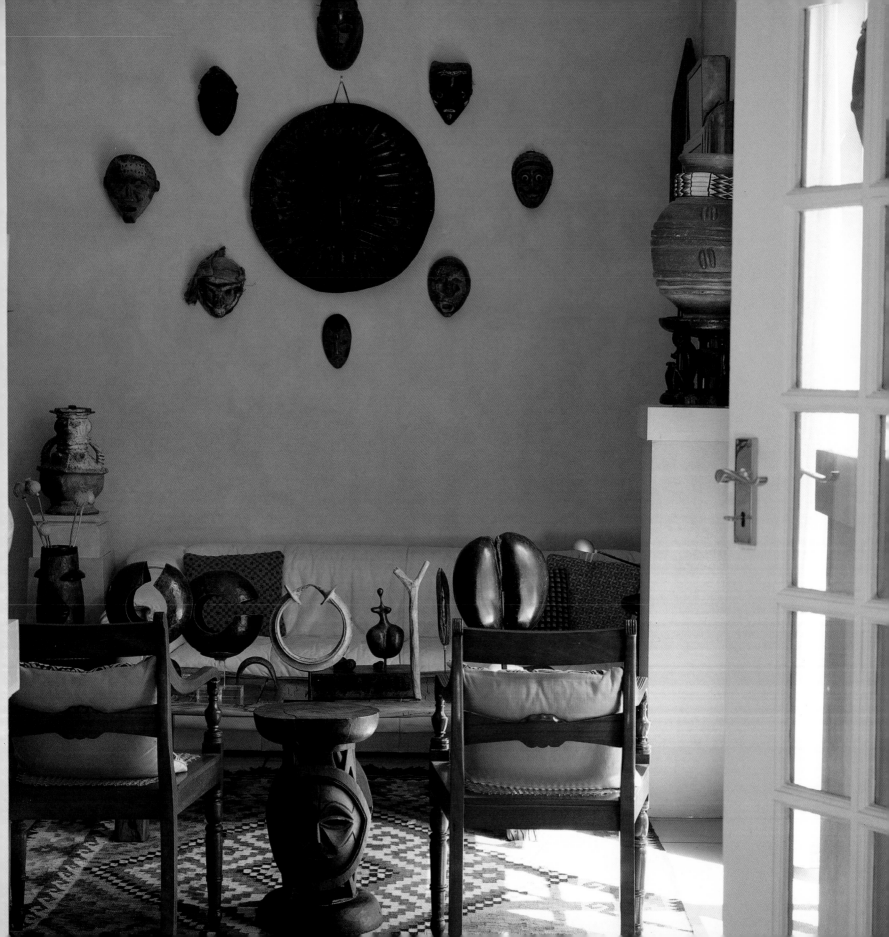

TRADING PLACES

From Eurocentric to Afrocentric, the balance is shifting in South Africa's art and design as well as in its political and social development. This can be seen in many ways, and particularly clearly in the home of Colin and Sue Sayers. They live in Kenilworth, a suburb of Cape Town that, at the outset, tried to live up to its 'old country' name. Their home once formed part of the rather elaborate servants' quarters on the Kenilworth estate which belonged to the local gentry. But the colonial feel of the original house has been completely overwhelmed by its contents, which are Asian, Oceanic and, above all, African. There are artefacts from all parts of the continent, but Colin is most passionate about his wooden sculptures from Angola and the Democratic Republic of Congo.

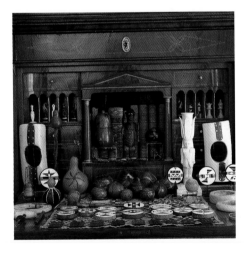

Sue claims that Colin 'can't say no to objects he loves', and to solve the problem of where to display their ever-growing collection, they have devoted more and more space to it – upstairs, downstairs and in the courtyard, making changes to the house that are more cosmetic than structural. Most of their furniture, including a French provincial sideboard, an old grocery cupboard, refreshed and re-lacquered, and an Indian colonial day bed, provides perches for an extensive range of African imagery.

Colin has a very good excuse for his collector's mania: African art is his business, and it has been for a long time. It was thirty years ago, well ahead of the current trend, that he experienced a kind of conversion and a major shift in his perception of African art. What he previously saw as tasteless curios, he re-experienced as powerful imagery. 'African art is hardly pretty, but it is never boring, and it does have incredible presence.'

He then turned his hobby into his career, becoming an art dealer specializing in all things African. It was a very limited market for much of the time, but since the end of apartheid, the open frontiers of the new South Africa have brought a flood of new suppliers and buyers to the country, which is now a major clearing-house for art from all over the continent.

The customers who buy from Colin's Cape Town shop, situated in the antique trade area near Greenmarket Square, are often foreigners, visitors passing through, or those who have recently settled in the country. But the home market is also growing. Knowledge is increasing and tastes are changing; Colin feels that all those years ago, when he first recognized the importance of African art and the vital role it plays in the culture and identity of his country, he did, indeed, make the right choices.

LEFT **All available space in the Sayers' home has been colonized by their collection of African art. On the wall, encircling an Ethiopian shield, are seven African masks, all of which originally had various ritualistic purposes, together with a single mask from Java, designed to ward off disease. The carved wooden stool on the floor is Tongan.** ABOVE **The varied objects displayed here include gourds, sculptures carved out of wood and ivory, and Zulu snuff containers and ear-plugs.**

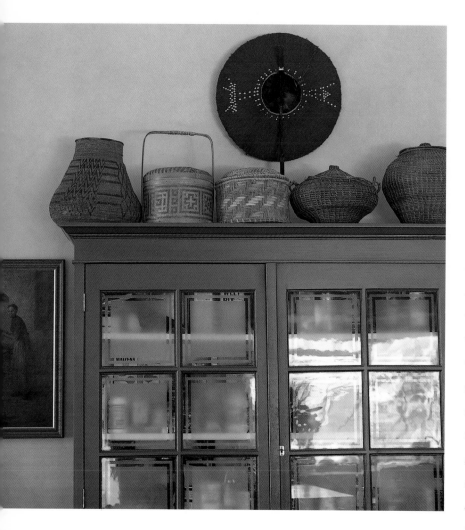

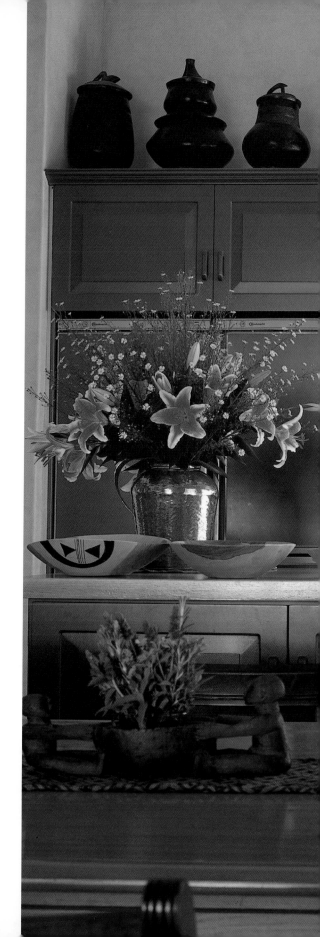

LEFT

An old grocery cupboard has been lacquered green and its glass sandblasted. It has now become a perch for an assortment of African baskets. Flattened out against the wall is a red headdress which, according to tribal tradition, Zulu women have the right to wear once they are married.

RIGHT

A procession of sculptures and ceramics from the Lozi, Chokwe, Ndau and Mboko tribes decorate the tops of the green kitchen cupboards. These tribes all live in countries bordering South Africa.

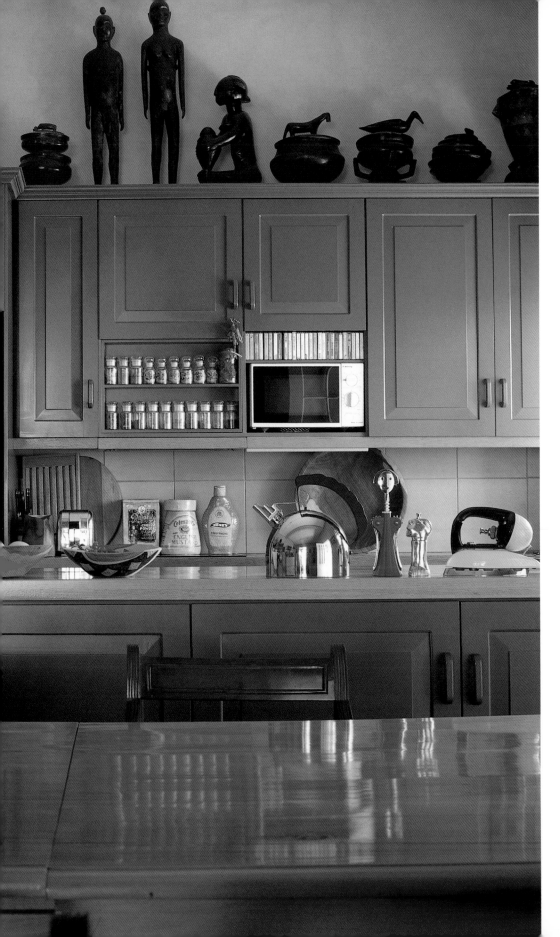

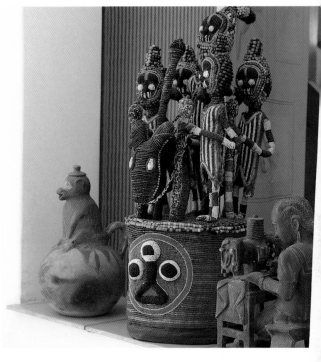

ABOVE

This niche in the
entrance hall
accommodates a
Lozi monkey, a West
African sculpture of
a woman at her
sewing machine
and, one of Colin's
showpieces, a group
of beaded Yoruba
figures standing
on a plinth.

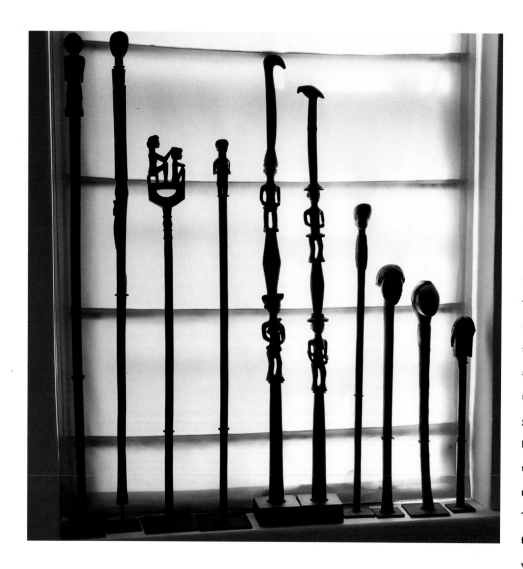

LEFT

This striking, backlit display on a landing window sill is of Chokwe, Luena and Ovimbundu staffs that once belonged to chiefs and other tribal dignitaries. In African tribal culture, as elsewhere – think of batons, maces, wands and sceptres – status, and sometimes one's relationship with the gods, were indicated by the carvings on the staffs.

RIGHT

This collection of figures, all carved with a particular purpose in mind – African art is both utilitarian and spiritual – represents a whole archive of traditional culture.

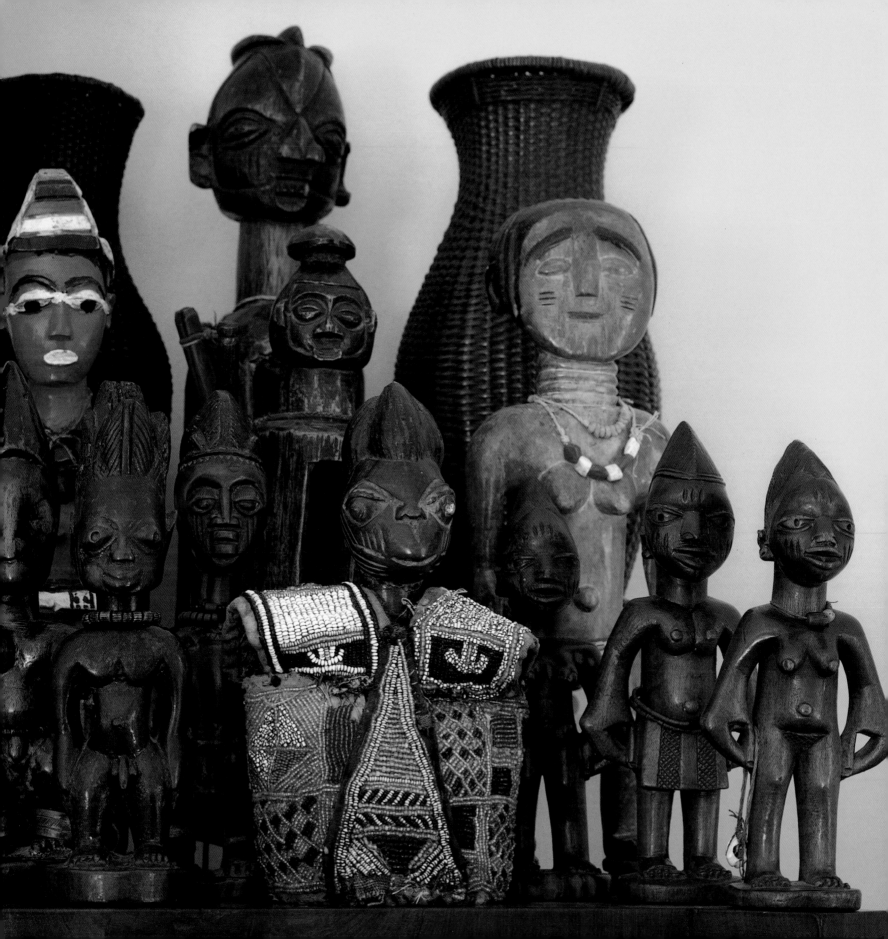

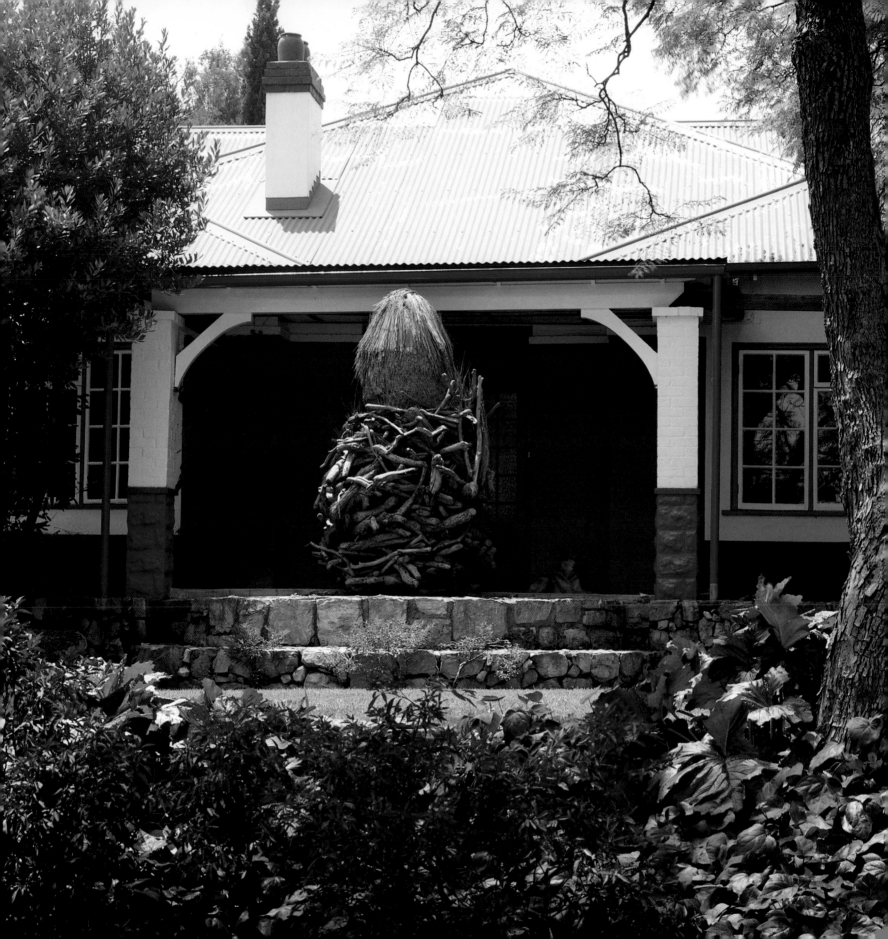

AN AUTOBIOGRAPHY

The current vogue for home decoration, reflected in the large number of decorating and interiors magazines serving a relatively small market, is viewed with just a little cynicism by Peter Rich, an architect, builder and university teacher. 'My home,' he says, 'is not the result of a decorating project. It's more an autobiography.' The same can be said of his collections of *objets d'art*, which are mainly Southern African and started as 'an autobiography, or record, of relationships with friends'.

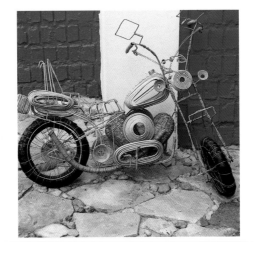

Many of those friends were African, mostly from the Ndebele area. Peter got to know them when he was younger while travelling from Johannesburg to Lourenco Marques, the Portuguese colonial town now called Maputo, in Mozambique. At that time, Ndebele art, characterized by bold Cubist-style murals on the walls of traditional homes, as well as colourful beadwork, was under threat as a result of apartheid resettlement policies.

Peter decided to document what was happening, to record and defend Ndebele culture. 'This was the way in which, in the early seventies, the intelligentsia woke up to African art; we became pseudo-anthropologists, but also custodians and patrons. Art is an assertion of identity. But because you're outside the culture, you become a kind of reinterpreter.' Today, he is still trying to preserve and further the lessons of traditional tribal art and architecture, 'playing with African space', as he puts it, by teaching and helping to stage international exhibitions of Ndebele art.

All this autobiography played a major role when, twelve years ago, Peter bought and remodelled a sixty-year-old Johannesburg house. According to colonial bylaws, houses had to face the street, in this case, southwards, away from the sun. But Peter grafted on a north-facing extension, so the house now looks two ways. 'South Africans pay lip-service to outdoor living but they don't think it through and don't use the sun enough.' By applying certain Ndebele building traditions, thinking in terms of a series of diagonals and designing his house as a sequence of courts, the revised layout brings in as much of the sunny outdoors as possible, catching the light at different times of the day and seasons.

Inside the house, wherever you look, there is African art, not only Ndebele but also Zulu, Venda, Angolan, Gabonese and West African, as well as contemporary paintings and sculptures. Clearly, the contents of the house, like its exterior, also face different directions, trying to reconcile opposites. 'More than anything else, this house is about being hybrid,' says Peter.

LEFT The Africanization of Peter Rich's colonial home is immediately obvious – a cairn-like structure dominates the entrance to the house, with its corrugated iron roof and *stoep*, or veranda. Made by Andries Botha, who is inspired by Zulu and Ndebele art, this work evokes fertility symbols and tribal rites. ABOVE A synthesis of African and Western cultures in the shape of a Harley-Davidson model motorbike, reinterpreted as wire sculpture.

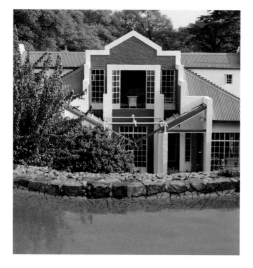

LEFT ABOVE

A new façade facing north has been grafted onto the back of the original colonial structure, not only to Africanize it but also to take full advantage of the daylight hours.

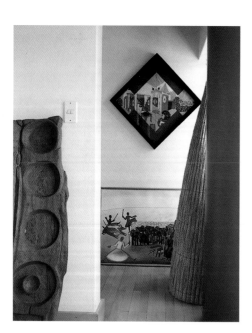

LEFT BELOW

The framed picture on the wall, which depicts the interior of the house, was painted in Ndebele style by Peter.

RIGHT

In the newer, Africanized wing of the house, the stonework, beadwork and sculptures, in wood and earthenware, are either African or inspired by African art.

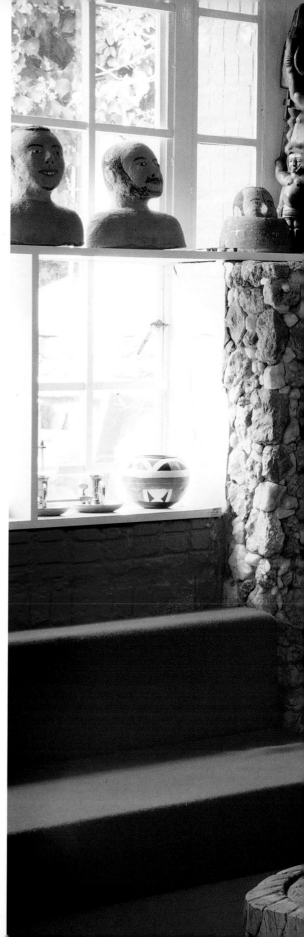

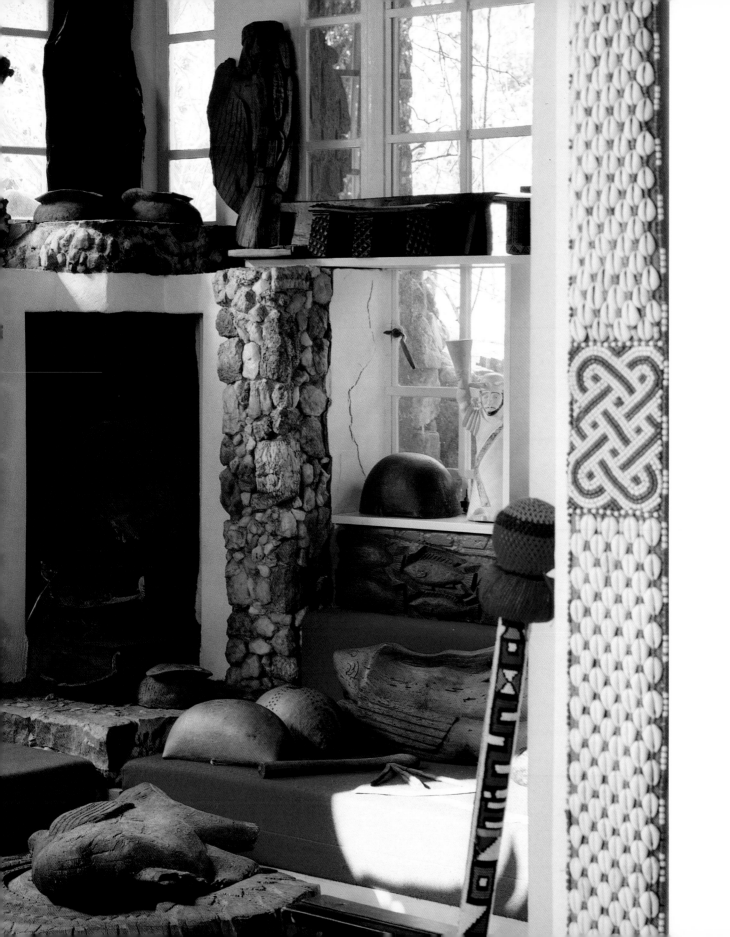

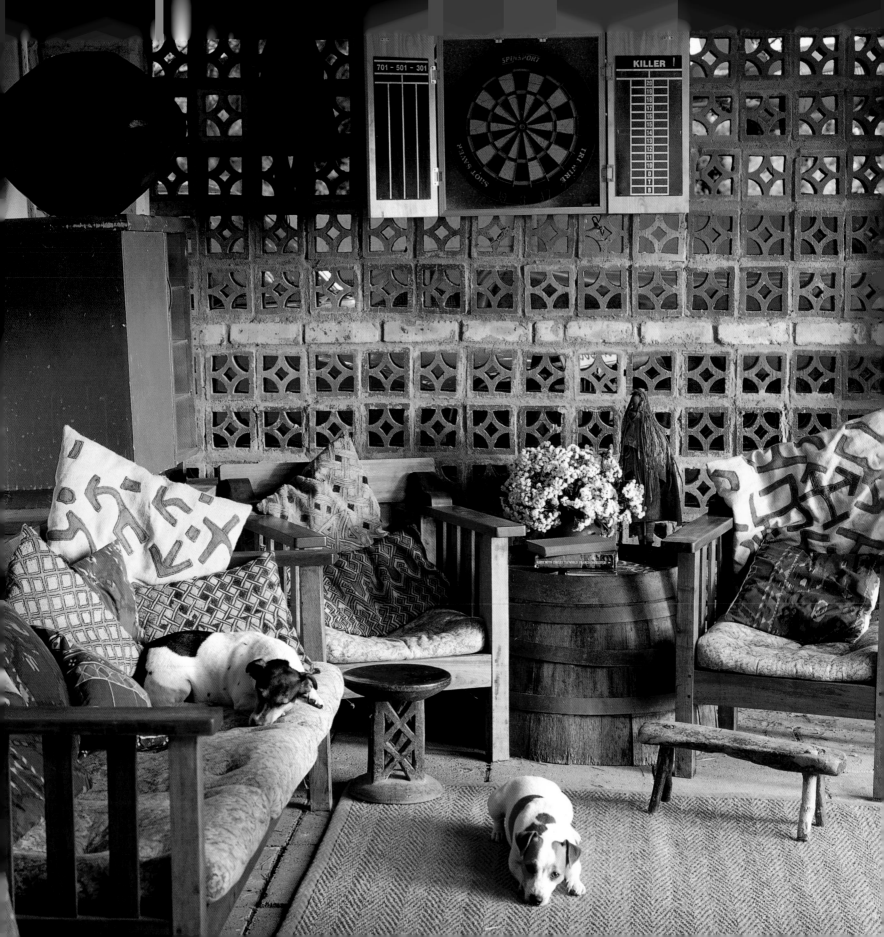

TREASURES OF AFRICA

Steven and Juliette de Combes live on the very edge of the continent in the village closest to the Cape of Good Hope. The terrace of their modest bungalow commands exceptional views of the sea below; dolphins and whales can often be seen, even the occasional albatross. Inside, their home is a mirror of Africa, the walls and display spaces spilling over with tribal art from near and far: Zulu beer vessels, Masai beaded bags, Tonga and Lozi stools, Senufo chairs, Himba dolls, Bambara door locks, Kuba cloth, Shona headrests, a Chokwe thumb piano.

By trekking deep into the continent, sometimes on foot beyond the reach of roads, and living rough, they have slowly but surely put together their collection of African art. In building up a network of suppliers, they have become expert in such matters as the elaborate and lengthy greeting rituals – queries about the well-being of family, friends and cattle – that are the essential prelude to all exchanges, social and commercial.

Although African art is Steven and Juliette's business, it is also their passion; for them, the greatest temptation is to fall in love with their own stock and so slow down their turnover. Not surprisingly, nearly everything in their home is African, apart from the odd piece of European and Mexican furniture.

Their collection of art and artefacts reflects the vastness of the continent and the variety of its peoples. Some pieces celebrate the power, prestige and status of African chiefs, while others are a celebration of beer-drinking, snuff-taking, song and dance. From them, one can learn about African religious beliefs, about witch-doctors, diviners and the language of beads – beadwork woven into intricate patterns of different colours can express a wide range of emotions, often centring on the language of love.

Steven and Juliette's collection is not only an exciting treasure trove of African heritage but also an illustration of how African artistic expression is evolving. One of their most striking possessions is a large, multi-coloured model aeroplane, nestled in a tree outside the house. It is one of a series made in a remote part of the Drakensberg by a young Zulu who is obsessed with aircraft. More than art or merchandise, these *objets d'art* are also utilitarian and put to work in practical ways: for example, in the kitchen, plastic bags are kept in a tribal beer strainer and the dogs eat out of African bowls.

Viewed from the outside, Steven and Juliette's house is nothing to speak of, but this matters very little when the inside is overflowing with the artistic wealth of the continent.

LEFT **The *stoep*, or veranda, of the de Combes house has stunning views of the sea. Small Shona and Tonga stools are unlikely but compatible partners for the Morris chairs, whose cushions are covered in Kuba cloth. Standing on the half-barrel is a Himba doll. Most of the contents of the house are African, even the dog bowls!** ABOVE **The de Combes are particularly proud of these Zulu spoons and studded beer vessels used for ceremonial beer-drinking.**

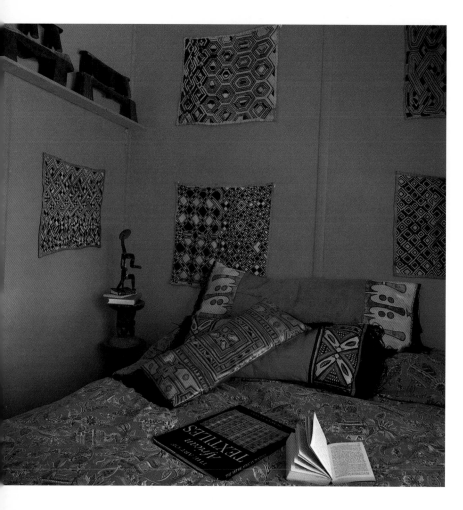

LEFT

The deep fiery red walls of the bedroom are an effective backdrop for Steven and Juliette's collection of tribal art. Squares of Kuba cloth have been fixed to the walls, a shelf holds Zulu headrests and a Zulu beer strainer in figurative form – a prized possession – stands in the corner.

RIGHT

Apart from the Mexican cane chairs, everything in the living room is African, including carved elephants from Zambia, Zulu beer baskets and, on top of the bookshelf, Zulu milk pails. The 'totem pole' is made of stacked stools.

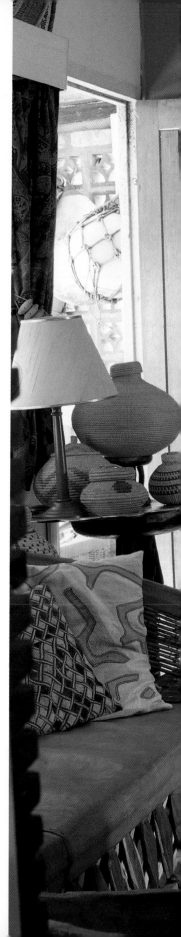

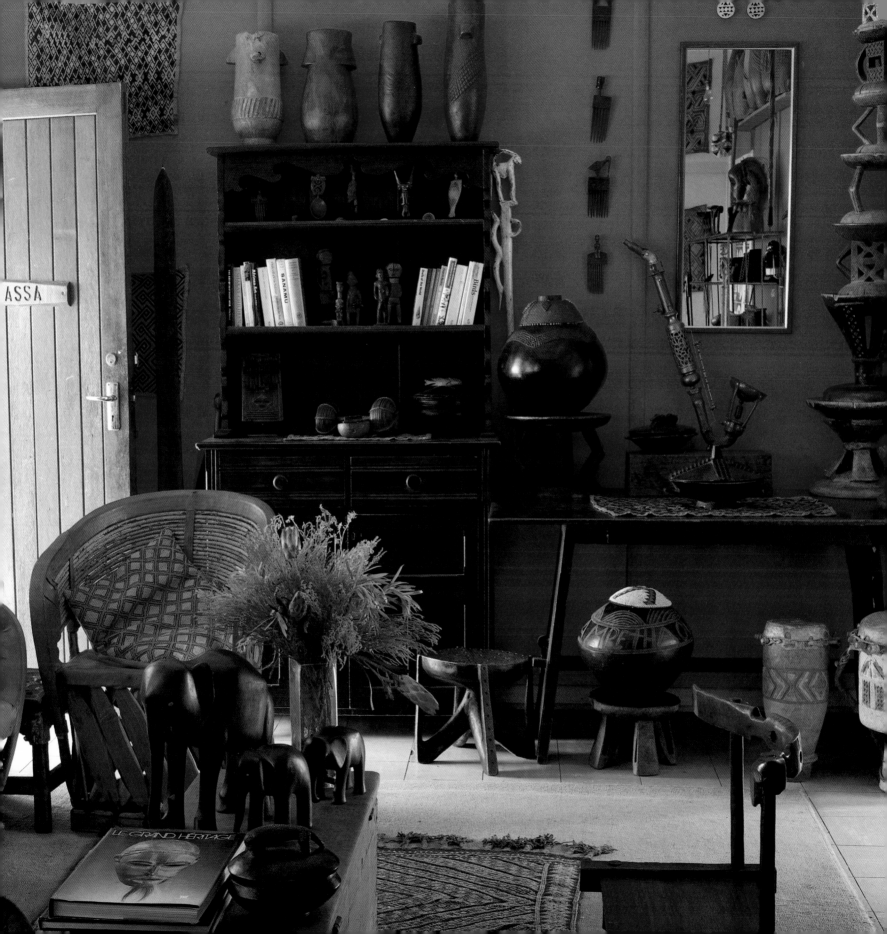

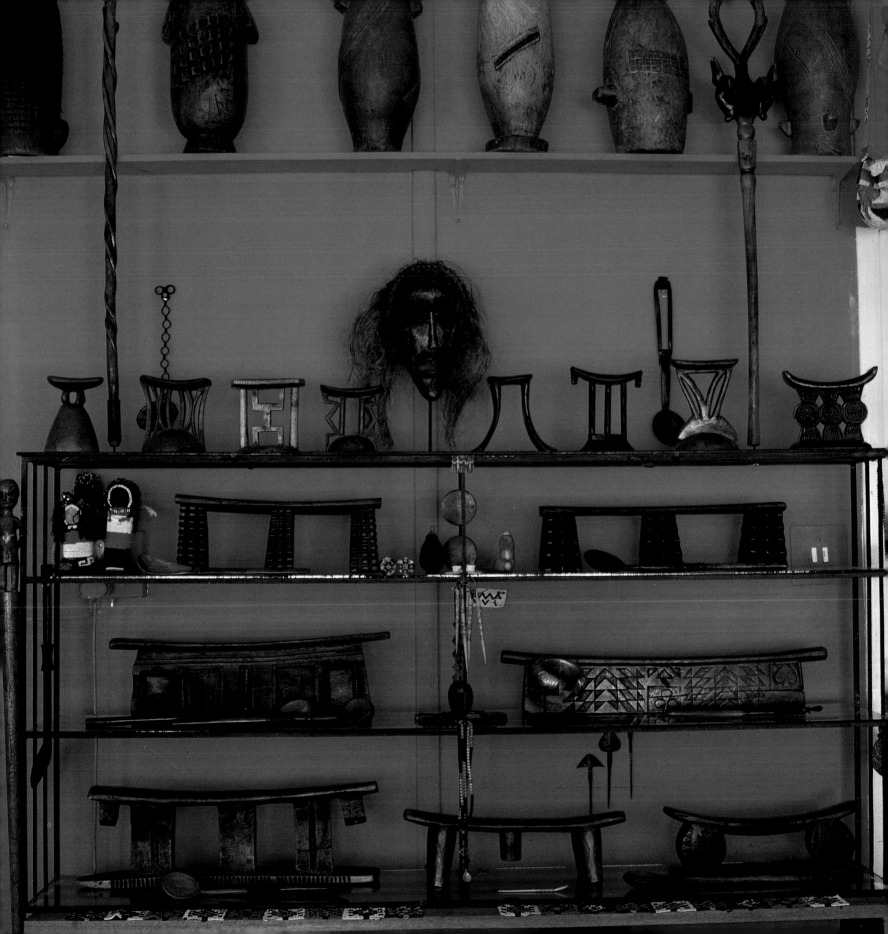

LEFT

These shelves represent a cross-section of the arts and crafts of the entire African continent. The mask in the centre is from Zambia; headrests, in a variety of shapes, come from different countries including Namibia, Zimbabwe and South Africa. The tiny beaded dolls on the left and the row of milk pails on the top shelf are Zulu, which is South Africa's largest tribe. It is also the most famous – for the mystique of its culture and also for the defeats that the Zulus inflicted on the Boers and British during the nineteenth-century scramble for Africa.

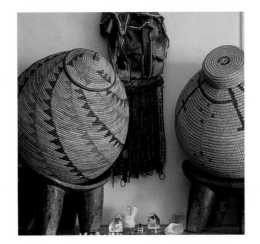

LEFT ABOVE

These spiral bases of conch shells nestle in a shallow Lozi bowl. In their native Zambia, conch shells are considered prized status symbols.

LEFT CENTRE

A mixture of traditonal African art styles, this textural display features decorative Zulu baskets placed on low Senufo stools, and a beaded Xhosa hunting bag hanging on the wall.

LEFT BELOW

Carved from a single piece of wood, this Tongan stool with the inset of a truck symbolizes, in a humorous way, the meeting point of traditional and modern Africa.

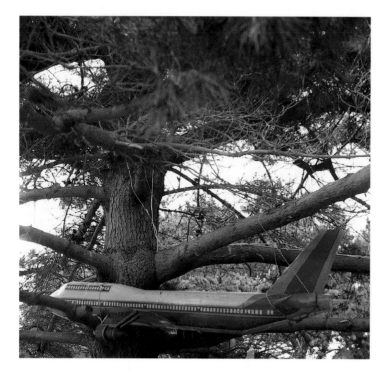

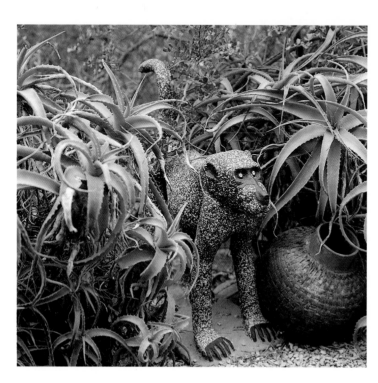

LEFT ABOVE
This model aeroplane parked in a tree was made by the Zulu artist Sibusiswe Mbhele. He has produced a series of them in the distant Drakensberg mountain area of Kwazulu-Natal.

LEFT BELOW
The concrete baboon was made in the Cape Flats and bought from a roadside 'gallery'. Real baboons are common in this area, often found raiding kitchens and harassing tourists at the nearby Cape of Good Hope.

RIGHT
The lush and tangled indigenous-looking garden is the perfect playground for the de Combes' dogs. Anyone for chess?

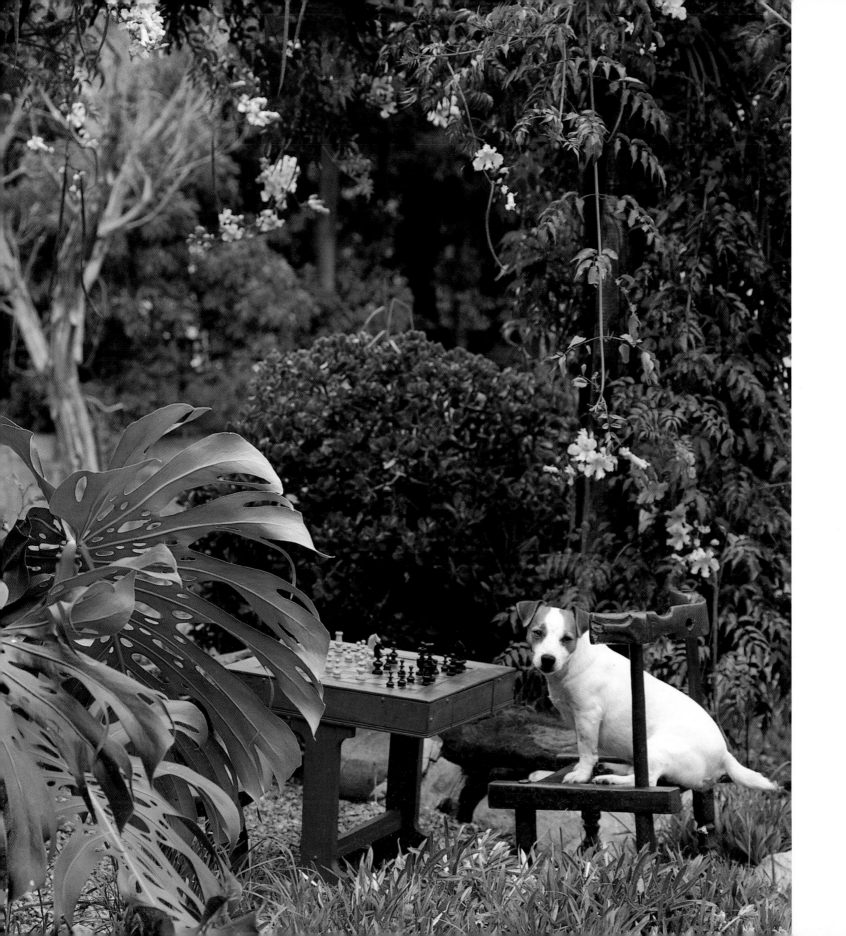

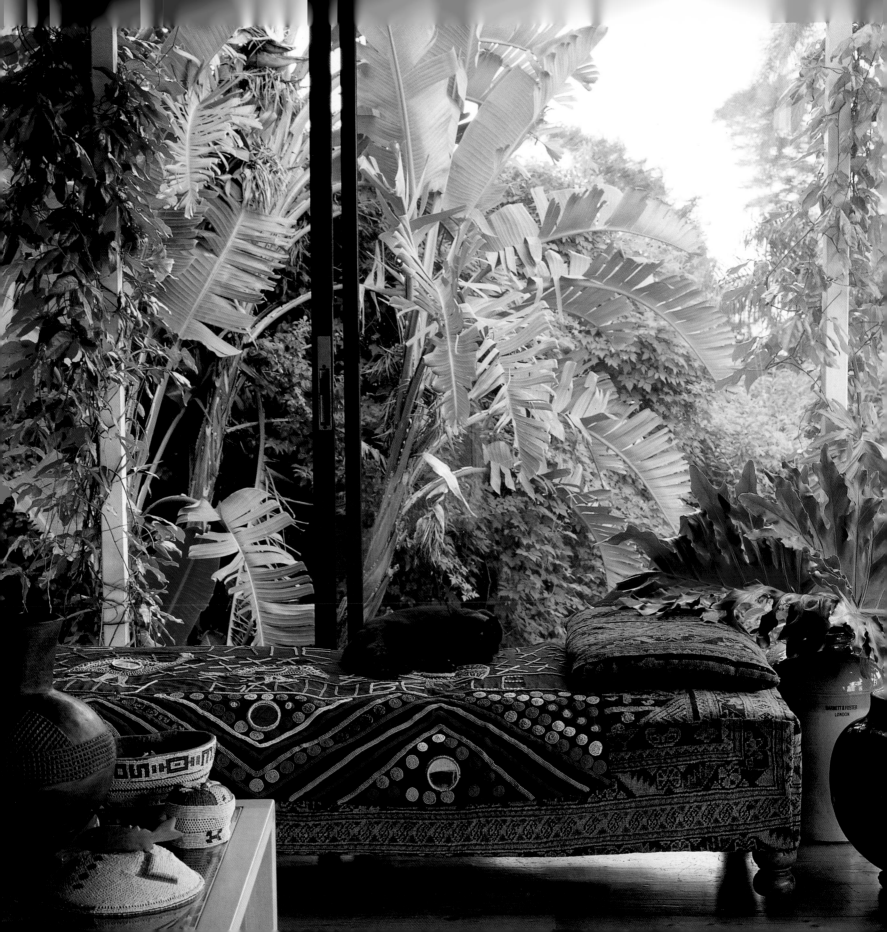

AFRICAN SYNTHESIS

Durban is still viewed by some as a rather stuffy place – it used to be known as the last outpost of the British Empire. But one of those people who has done much to dispel the stereotype is the architect and arts promoter Paul Mikula. At the launch of a multi-media arts complex and hypermarket called the BAT Centre, which he helped to establish, Paul arrived dressed in a Batman outfit.

Equally unconventional are Paul's building techniques and materials: recycled telephone poles and corrugated iron, a material usually associated with down-market, do-it-yourself structures and shanty towns. He has also drawn inspiration for a local community project from tribal rondavels. 'Over the years, I have tried to develop a style that strengthens the indigenous architecture of the area,' he explains. He has a real aversion to what he calls 'the throwaway society' and often uses salvaged scrap in his new buildings.

His own home, which he bought about twenty years ago, is also recycled. Built in the 1940s, it originally resembled a square box with a pyramid roof of red tiles. Paul transformed it. 'I knocked the daylights out of the house – or rather let the daylight in by making it open and flowing and projecting it outwards by means of verandas and decks in the back and front.'

The house is on the Berea, a long ridge once covered by a sub-tropical forest where ivory traders hunted elephants and other wild animals. Paul let the previous suburban garden 'go native', and now indigenous plants, monkeys and louries have returned. From his home, he looks out over the tree tops to the harbour and the horizon beyond. 'We have a magic world outside. The view enables me to remain in constant visual contact with God's architecture.'

That he is a 'wide horizons' man is as evident inside the house as outside: on the bookshelf, for example, you might come across a book he co-wrote on South African Hindu temples. The major decorative influence is African. Paul began collecting African art, especially beadwork, around the time he bought the house and his passion for it has taken over almost every available surface. One feels that even the dining room table – according to family legend, Edward, Prince of Wales, once danced on it in the days of the British Empire – is under threat of invasion.

The rhythms, colours and forms in Paul's life, work and home are undeniably local – Zulu, Xhosa and others are blended together in a creative new synthesis – and reflect his firm belief that 'South Africa's future will be different from that of the West'.

LEFT **Paul Mikula has opened up his house to the tropical lushness of Durban. With the wild bananas, bamboo and lala palms outside, it is difficult to believe that you are in one of the city's oldest suburbs. The pot to the left of the picture is for transporting, storing and drinking beer. The beaded ceramic containers alongside are Zulu and from Mali.** ABOVE **The fabric for the couch cover is Shangaan, decorated with mirrors and hundreds of safety pins.**

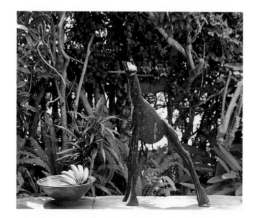

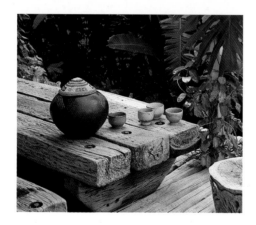

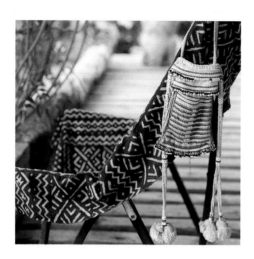

LEFT ABOVE

Carved by the South African artist Sizwe Thambani, this miniature giraffe is a quirky companion to Andrew Walford's ceramic bowl.

LEFT CENTRE

One example of Paul's fondness for recycling is the table made from railway sleepers. Telephone wire has been used for the lid of the Zulu beer pot.

LEFT BELOW

Mud cloth from Mali has been draped over the seat; the party bag is Xhosa.

RIGHT

The decking on the veranda has been made from old mine props; local artist Lucky Shabalala made the stool.

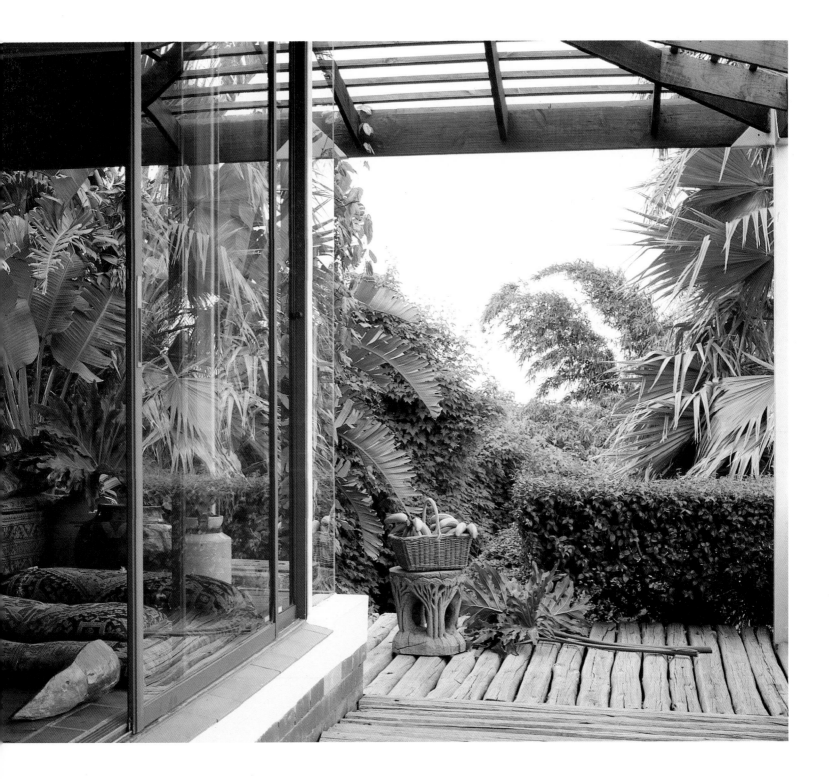

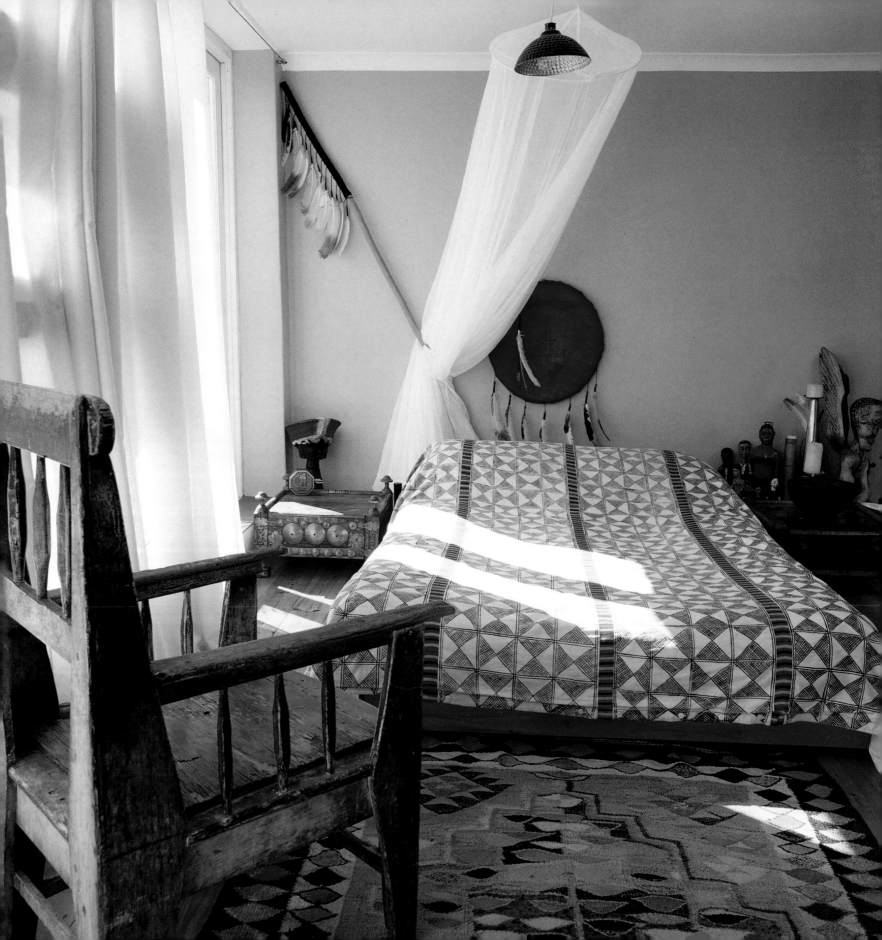

URBAN COLOUR

The first-floor terrace of Tracy and Peter Maltbie's home looks out over four mosques and the compact, harmonious rows of houses in South Africa's most colourful urban area: Cape Town's Malay Quarter. Today, the traditional and community-minded inhabitants prefer to be called Cape Muslims, pointing out that their ancestors came not only from Malaysia, but also from India, Indonesia and even further afield. In addition, the quarter, which looks out across downtown Cape Town, towards Table Mountain, has been renamed BoKaap, meaning upper Cape.

Tracy, a South African, and Peter, an American with Native American ancestry, met in Boston but decided to live in South Africa. Once in Cape Town, it was BoKaap's mix of urbane charm, scenic beauty and accessibility that so appealed to them. Peter now works as a photographer and Tracy sells old and new pieces of African art from a specialist shop close to home.

Peter's photographic studio is on the ground floor of the apartment, while the relatively small living area is upstairs, with the kitchen and bathroom on one side, a living and sleeping space, with the bed set on a raised platform, on the other. Beyond there is the terrace where many hours could be whiled away taking in the colourful life of the quarter below.

Tracy confesses to 'always lurking around strange places finding odd things for our home'. The furniture includes two well-worn, Art Deco easy chairs and a distinctive, and no doubt valuable, *boerstoel*, an old Boer-style Cape chair. There's a Kurdish rug on the floor, a Hausa robe from Nigeria on the wall and a Ewe cloth bedspread from Ghana. A cheerful painted barber's shop board, also from Ghana, hangs in the bathroom; an ivory carving of a lion is from Mozambique. Two imposing red headdresses, worn by Zulu women as a symbol of their married status, decorate another wall.

African art is everywhere – even the CD rack is a Zulu mat-storer. There are also many oriental touches, such as a betel-box and an Indian toran hanging. But there are other foreign influences, too, such as a basket from the Amazon region of Brazil and, above the bed, a Native American medicine shield made by Peter.

It was her experience of working with American folk art that led Tracy to rediscover her own country and its folk art traditions. As a spin-off she has, unsurprisingly, made an exciting and distinctive living space that incorporates artistic influences from all over Africa and the rest of the world, and which is perfectly in tune with the exotic neighbourhood of BoKaap.

LEFT **In the Maltbies' bedroom, the choice of artefacts represents both Peter and Tracy's respective countries. Peter, of Native American ancestry, made the medicine shield decorated with feathers that is hanging on the wall. The weathered chair is a *boerstoel*, typical of the chairs used by the Boers in the nineteenth century. The bedspread is made of Ewe cloth from Ghana.**
ABOVE **A carved Ewe figure and Zulu ear-plugs for communicating with one's ancestors.**

LEFT, ABOVE AND BELOW

In her search for the unusual, Tracy has unearthed a wide range of interesting artefacts and *objets d'art*, all of which she has managed to cram into the small apartment. Included in her cabinet of curiosities are a collection of wooden chests, a cow-bell, betel-boxes, fabrics, shells and stones from Africa and South East Asia.

RIGHT

The view from the bed on its raised platform must be one of the most exotic in South Africa, overlooking the mosques of BoKaap. The fabric on the wall is a Hausa robe from Nigeria.

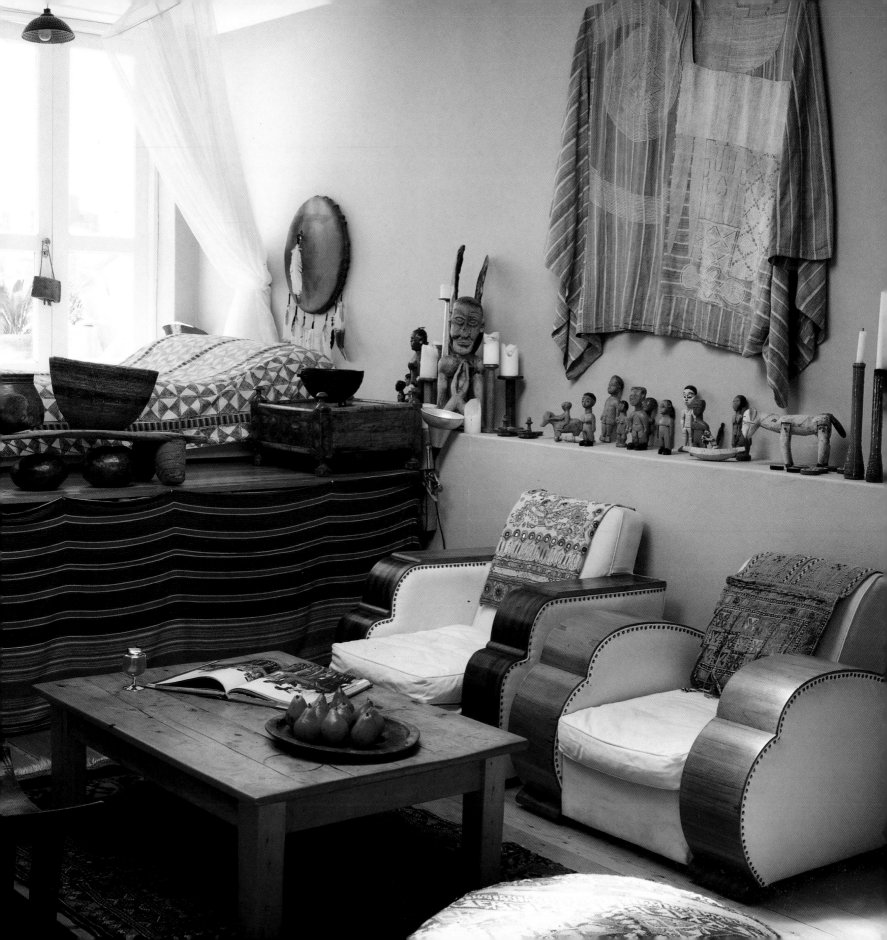

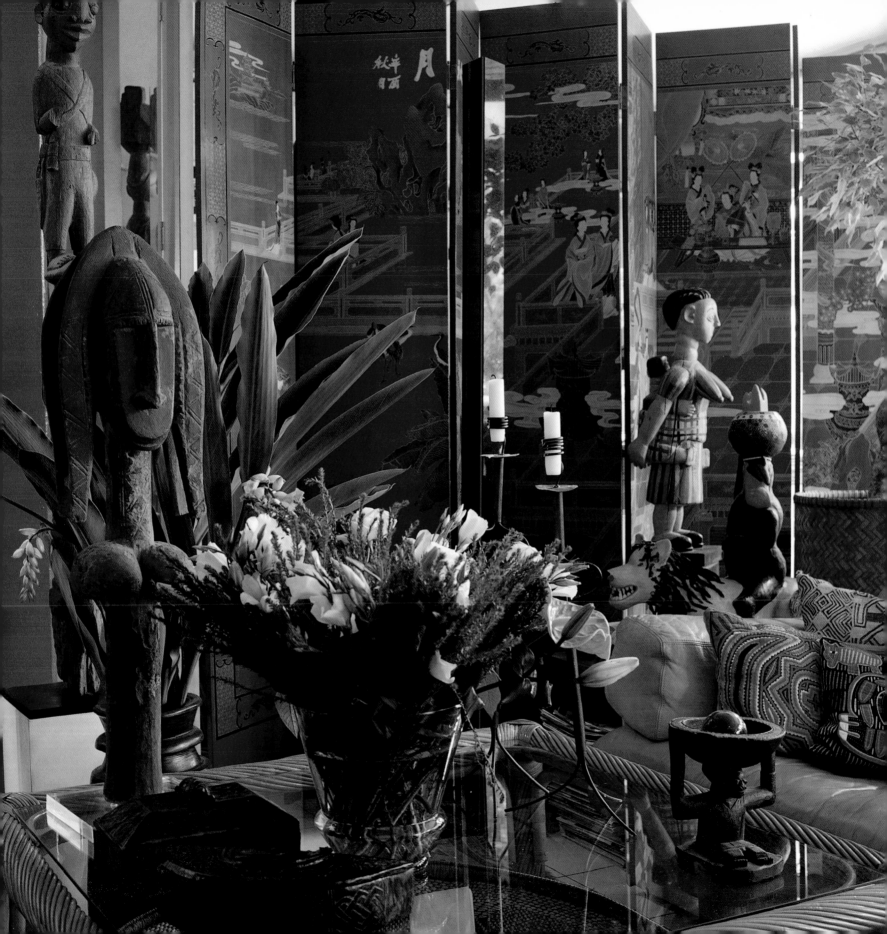

A PASSION FOR COLOUR

'Passionately vivid' is how Anna Starcke has been described, a term that could be applied to her home as well as to her personality. She lives and works as one of the country's leading political and economic consultants and forecasters in suburban Killarney, Johannesburg, in a run-of-the-mill, 1950s apartment block. But, when she opens her door, the blandness outside is instantly dispelled by the kaleidoscopic colourfulness within.

The apartment spreads outwards onto a terrace overlooking trees and upwards by means of a central duplex area and skylights. Plant baskets hang from the ceiling. All the space is for working as well as living, with the exception of the upstairs bedroom with its imposing carved Zanzibari bed, adorned with handpainted tiles. The dining area downstairs doubles as a boardroom. An oak refectory table is piled high with political and economic reports, but office machinery is hidden discreetly behind a huge Chinese screen. The atmosphere of an Aladdin's cave is created by the baroque assembly of sculptures, pictures, furniture and *objets d'art*, reflected and re-reflected in mirrors.

Mixed in with an Eames chair and a Max Ernst lithograph, there are pieces from Zanzibar, Burma and Thailand. A mother earth figure from India sits alongside a fierce, almost life-sized Rajput

warrior complete with red tunic, bandolier, beard and turban. But what is most striking is the panorama of pan-African art that Anna has put together. Township paintings jostle with humorous wooden sculptures of colonial figures painted in vivid colours from West Africa, a Bamileke stool from Cameroun, and Yoruba and Ashante masks. Some of her pieces have become so familiar to her that she has given them nicknames: a Bambara mask is called Tallulah Bankhead after the American actress; another figure she has named after Harry Oppenheimer, the country's most powerful businessman.

Anna's collection of African art started when she bought what was described to her as a 'witch-doctor' piece on her first day in South Africa. She had just arrived from post-war Germany and her outsider's detachment later stood her in very good stead in her career. One could, perhaps, make a connection between the strongly African-flavoured environment that she has created in her home and her predictions, on the professional front, that South Africa would become less Eurocentric and more African. Meanwhile, in her high-pressure life in stressful Johannesburg, Anna's home is both a soothing, shock-absorbing haven and a magic carpet ride to far-away places.

LEFT **The large red and gold folding screen, representing court rituals in ancient China, serves to conceal computers and other office equipment. But it also forms an appropriate backdrop to a theatrical range of objects, which include a Yoruba thundergod, a Nigerian water goddess, a Bambara female torso and a Bamileke stool. Skylights and mirrors add to the overall theatrical effect.** ABOVE **All this theatre is certainly no hindrance to the odd catnap!**

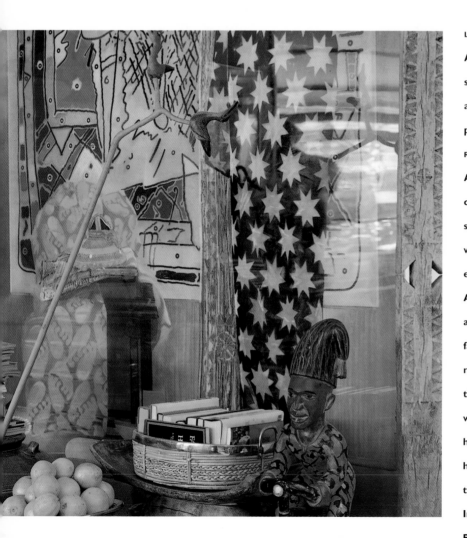

LEFT
A traditional African sculpture stands alongside a large picture by Karel Nel.

RIGHT
A classic Eames chair makes a striking contrast with yet another exotic display. Among the pieces are a bizarre white-faced Gelede Yoruba mask representing the folktale of a woman who wears her house on her head; a mother earth temple figure from India and a bearded Rajput warrior.

FAR RIGHT, ABOVE
AND BELOW
'Bold' and 'dramatic' are probably the best words to sum up the objects in Anna's collection.

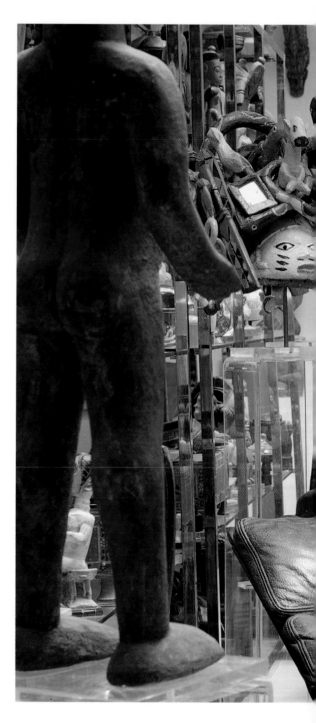

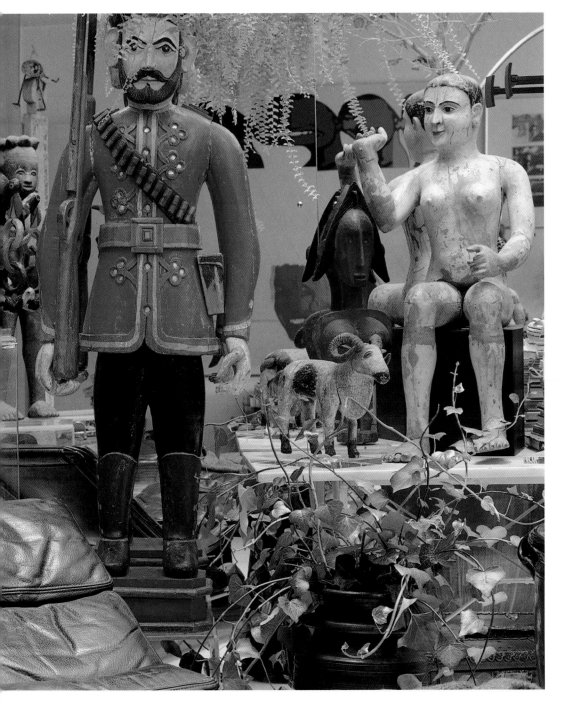

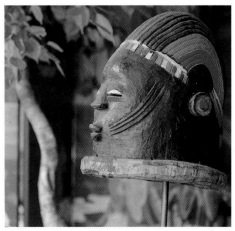

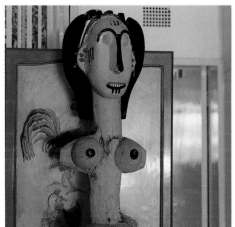

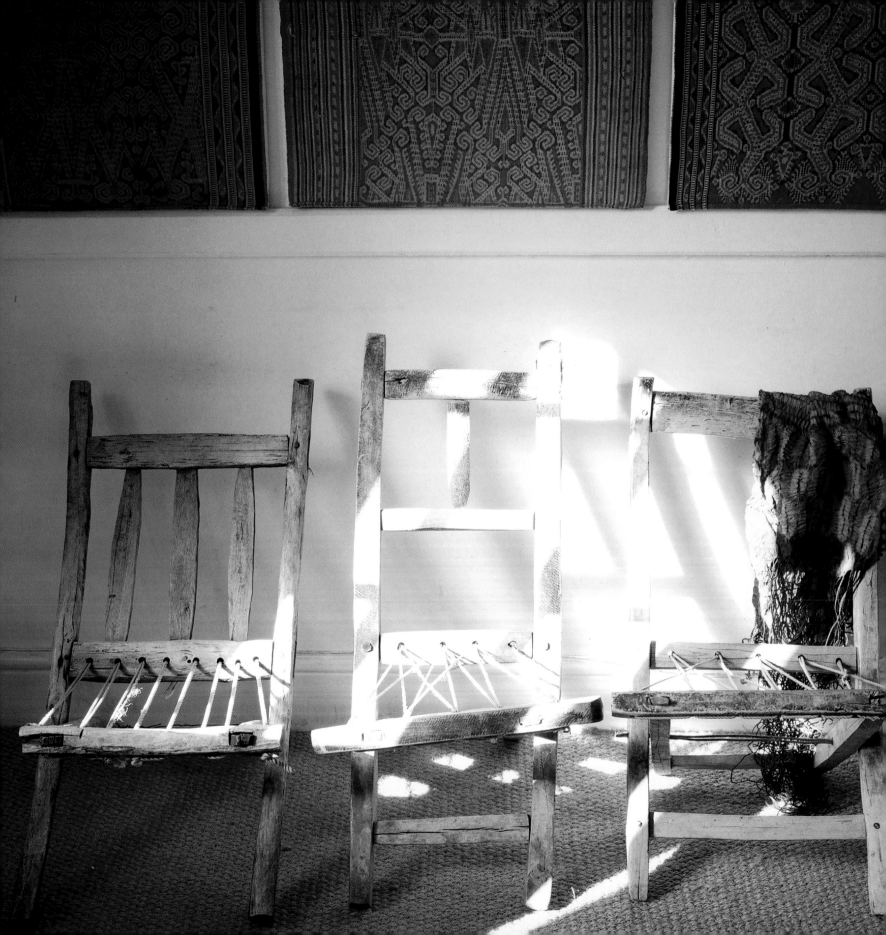

TRIBAL CO-EXISTENCE

From their home in Kalk Bay on the Cape, Michael and Katherine Heuermann and their two children are able to watch the fishing boats come into harbour and go down to buy fresh fish from the seaside market. The country's fishing industry began at Kalk Bay more than three hundred years ago, and the simple Cape sandstone fisherman's cottage where they live has stood on the site for almost half that time. They love their village, with its laid-back and rather raffish atmosphere, its second-hand book and furniture shops and its eclectic social mix of fishermen in seaboots, affluent commuters and permanently pickled 'bergies', a Cape word used to describe hillbillies, vagrants and street people. While some residents want to tidy up and gentrify the village, Michael believes that would be a mistake. He relishes Kalk Bay's diversity where 'there are real people all around you'.

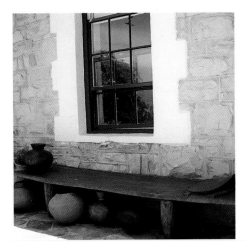

Michael and Katherine have transformed their cottage from a cramped fisherman's 'retreat from the sun' to a more airy and light-filled series of spaces. Katherine, a ceramist, works from home and has her studio on one side of the patio. Her delicate ceramics are in striking contrast to many of the chunkier pieces in Michael's collection of tribal art that fills the house, and which he sells in his African Image shops in Cape Town.

Collecting runs in Michael's family: his great-great-grandfather collected tribal art in what was previously German East Africa. Michael first collected textiles, inspired, perhaps, by his father who was involved in the business. But, after qualifying as a mechanical engineer, Michael decided to change the direction of his career completely and began working in the field of African art and artefacts. He viewed the move as 'more a lifestyle choice, to be involved with material I could get really excited about'.

His search for art takes him to Ghana and the Ivory Coast to buy stock from other dealers. However, he points out that South Africa, previously eclipsed as a source of African art by Central and West Africa, has recently come into its own, and so successfully that reproductions and 'airport art' are now, unfortunately, beginning to proliferate. Although buyers of African art are for the most part foreign, South Africans are becoming increasingly interested in what their own country and continent have to offer. Michael's personal tastes, he says, have been influenced by his travels at home and abroad; from their honeymoon in South East Asia, he and Katherine brought back ethnic art which now lives in happy co-existence with their collection of African tribal art.

LEFT These bleached chairs are beautifully battered examples of traditional, leather-thonged *riempiestoel* chairs. The Bidang textiles on the wall were bought by the Heuermanns during a trip to Borneo. ABOVE In front of the sandstone façade of the fisherman's cottage is a wooden bench from the Ivory Coast. Originally intended as a bed, it was made by Senufo craftsmen. The pots underneath the bench are South African.

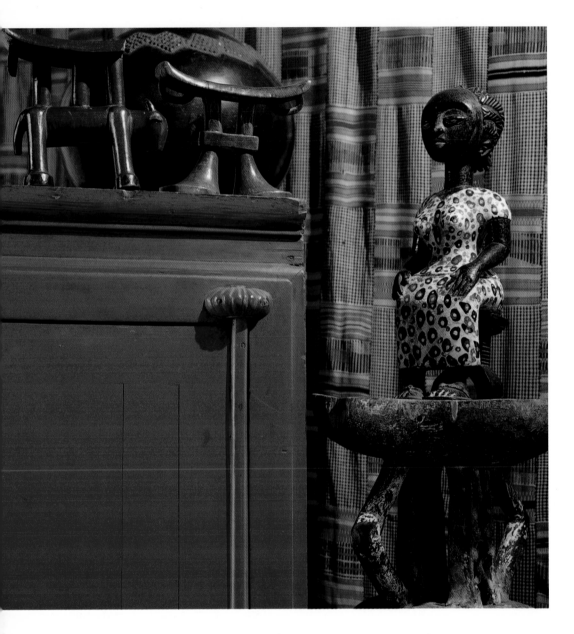

LEFT

A seated Bauole figure from the Ivory Coast is set against a backdrop of Ashante cloth. The headrests on top of the cupboard are Shona and Tsonga. As well as being practical and decorative, headrests have a religious significance in traditional African culture. It is believed that they ease communication with the ancestors while one is asleep.

RIGHT

The basketware mat standing upright on the left of the picture is from Borneo. The yellow plates on the wall are by the well-known ceramic artist Hylton Nel.

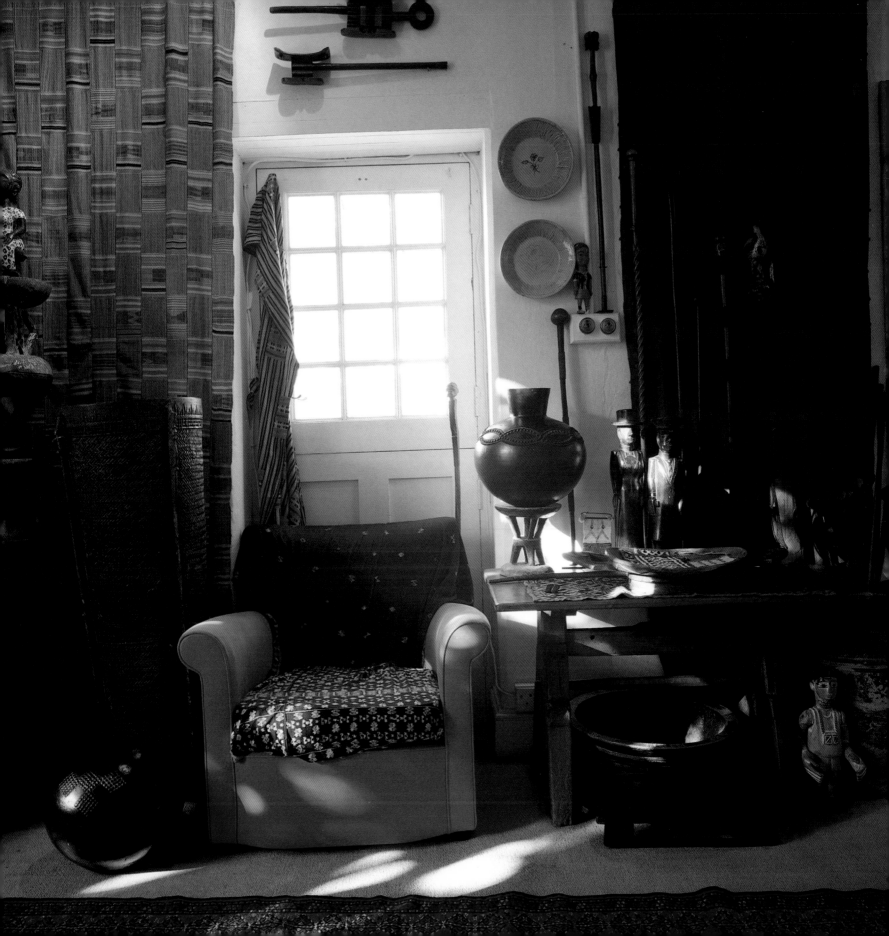

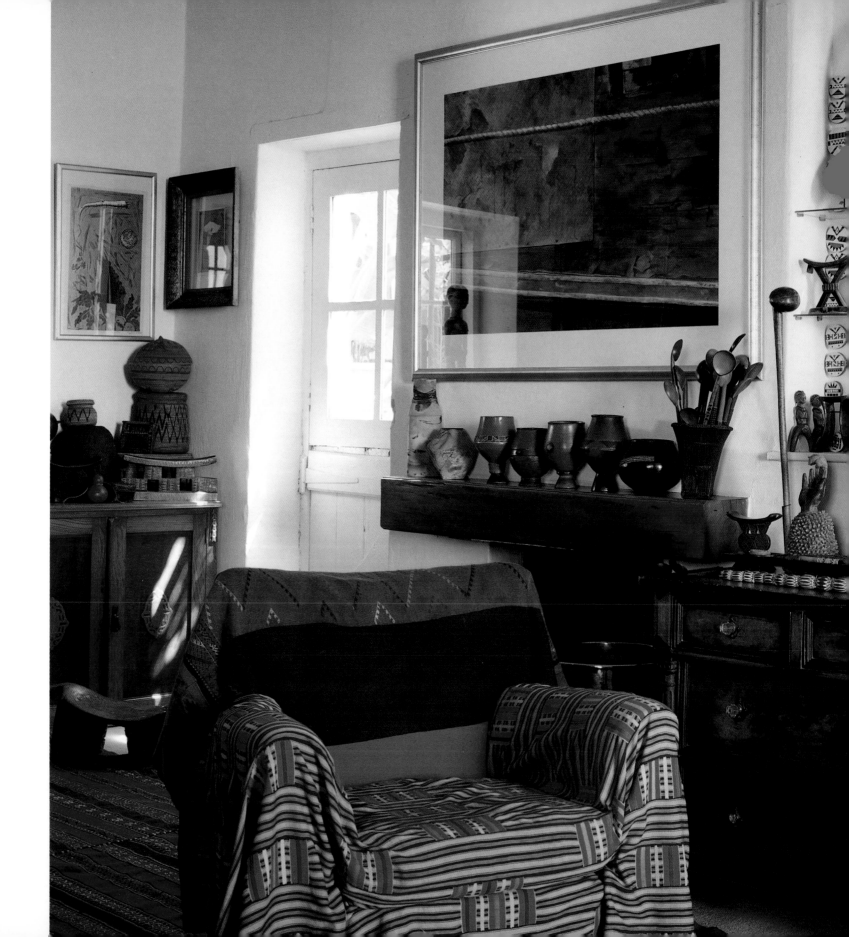

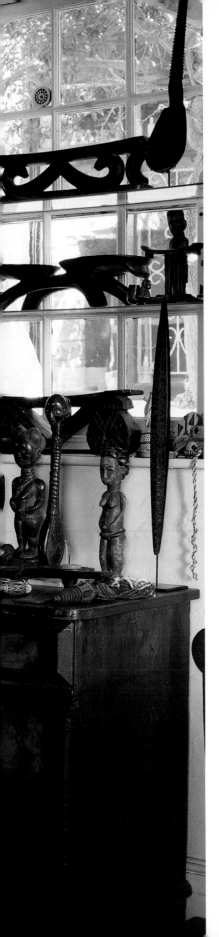

LEFT

Even utilitarian
pieces like these
African headrests,
pots, staffs and
spoons are likely to
have some ritual
significance attached
to them. The round,
beaded ear-plugs to
the left of the living
room window are
said to keep one's
ears open to the
voices of ancestors.

ABOVE, LEFT AND RIGHT

Michael's travels all
over Africa mean
that his collection
of artefacts comes
from every corner
of the continent.
The basketware and
gourds are from
South Africa. The
textiles draped over
the wooden Nupe
chair are from
Ghana and Nigeria
in West Africa.

ARTISTS

In the aftermath
of apartheid, where
great emphasis
is placed on
truth-telling and
reconciliation, the
healing function
of art has become
more important
than ever. Like many
South African artists,
Beezy Bailey uses
his art to forge a new
cultural synthesis
and to express his
country's diverse
artistic traditions.
These impressive
'tribal' heads were
carved by Beezy.

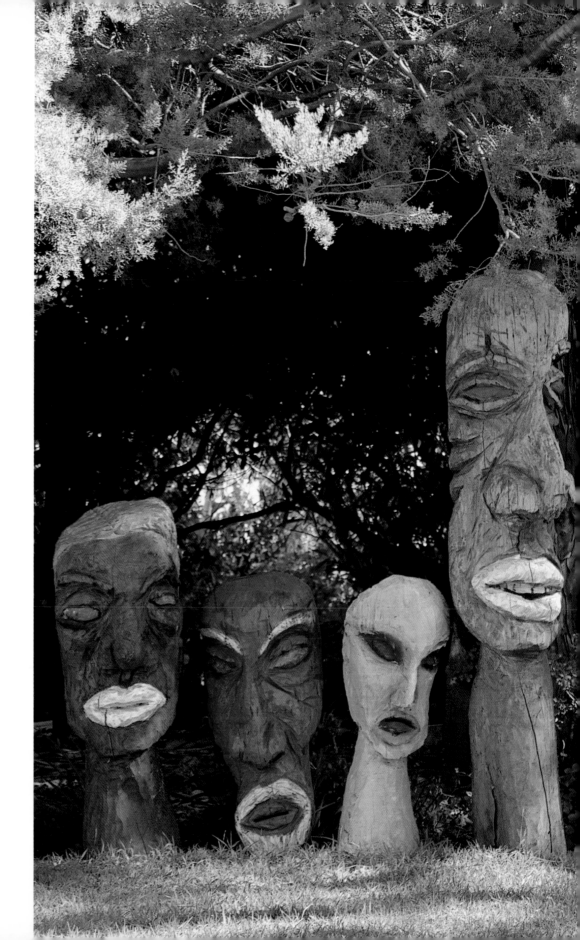

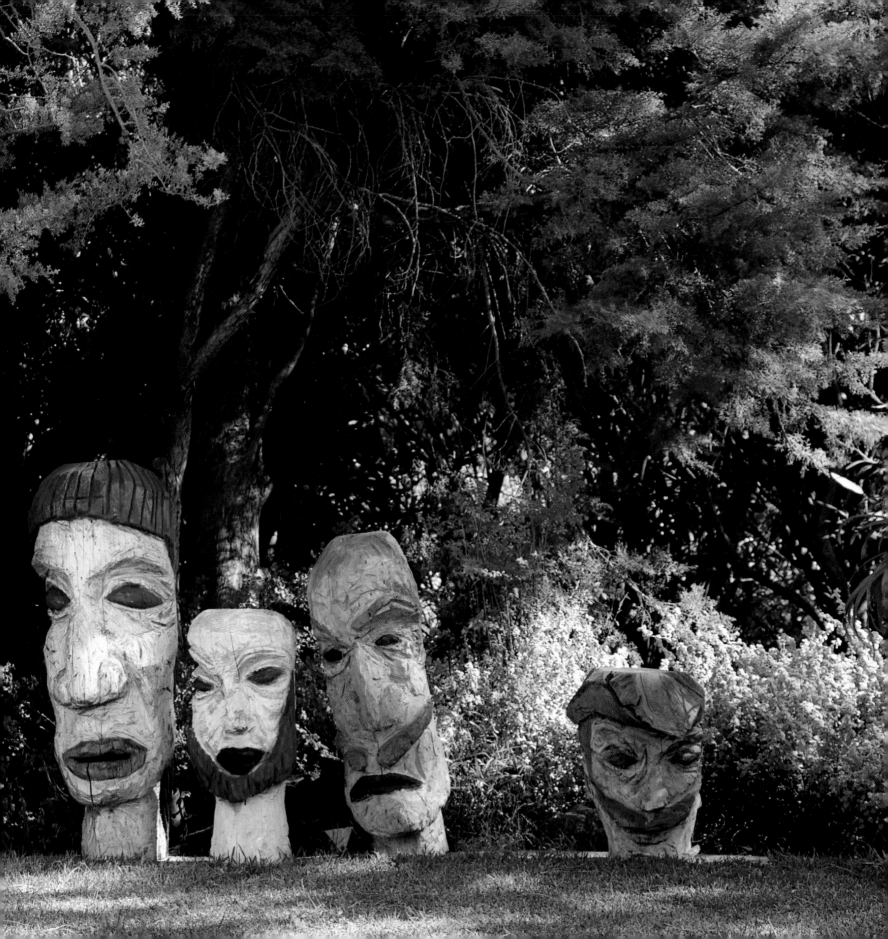

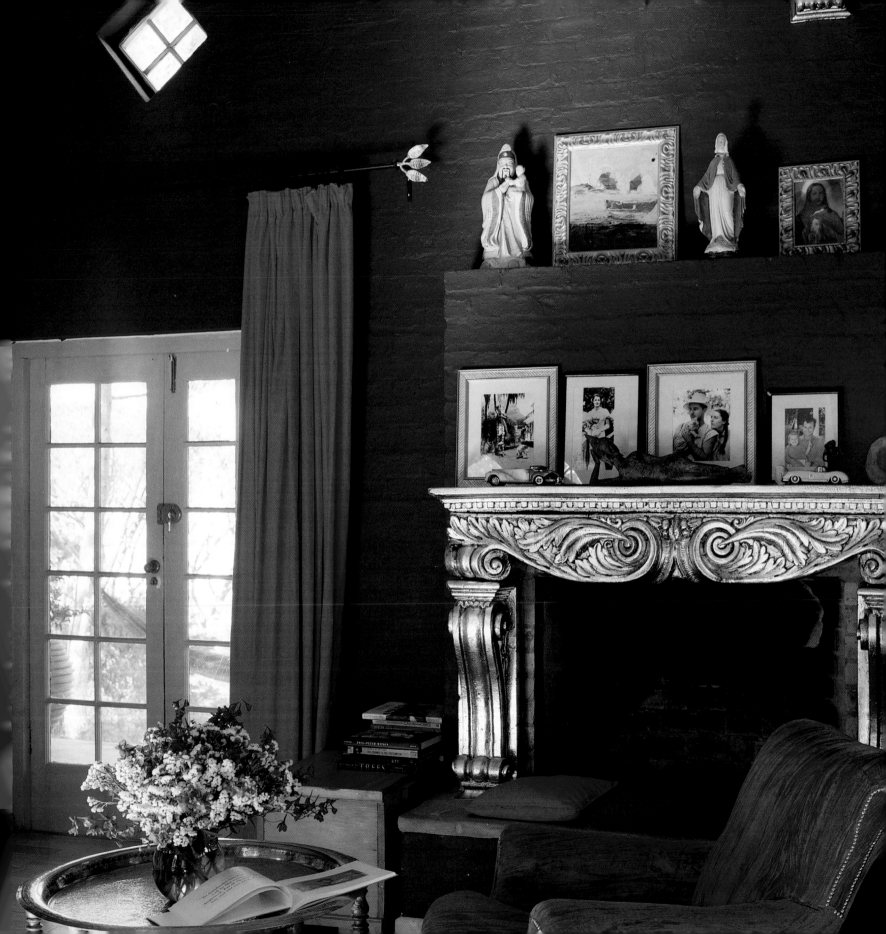

LARGER THAN LIFE

Beezy Bailey was given his nickname by a nanny who found his hyperactive ways 'just too beezy' (busy). He is what you might call a global villager: during his earlier, nomadic years, he spent time in New York, where a lunch with Andy Warhol inspired him to become an artist, and in London where he studied art. But, above all, Beezy is of Africa. Nelson Makuba, an African artist and witch-doctor, is his other artistic mentor. He told Beezy that he was a kind of witch-doctor, too, and that art was *muti* (traditional medicine) for curing a sick society.

After years of travelling Beezy, with his wife Nicky and their young son, is now settling in Cape Town. Their home, on the family estate, is situated half-way up a hill, surrounded by tall trees and with views of Table Mountain, Table Bay and the wine country. Beezy wanted a new house but one that didn't look, smell or feel new and decided that, as a frustrated architect who tended to clash with the professionals, he would design his own.

The feeling of space in the house is created by large rooms, with four-metre-high ceilings, energized with flaming colours chosen specifically 'to put you in a good mood'. The furniture, in various styles – traditional, modern, European, Asian, colonial – has also been treated with strong, intense colours to make the rooms come vividly to life. Most of the paintings, textiles and ceramics are Beezy's work, such as the sculpture of Hockney, but there is also much African art, traditional as well as contemporary.

Beezy designed his house at the same time as setting up a design and lifestyle business – 'Conran meets Warhol' is how he describes it. A multi-media man, Beezy has always been open to a wide range of influences. He is addicted to multiple personality games, assuming different roles, such as the fictitious Chinese sage Lee Ping Zing and local artist Joyce Ntobe. He has submitted paintings signed by Ntobe, described as a domestic worker, to the National Gallery. Only after they were accepted did he reveal that she was one of his artistic alter egos.

To those who reproach him for such stunts, Beezy's defence is that 'to be a true artist, one has to take off the clothes of one's soul and make a fool of oneself'. His willingness to do so may stem from a confidence based on his background: his father was the publisher of *Drum*, a magazine that helped give African writers and journalists a voice. In a similar vein, Beezy says: 'We have found a new way to say we are South Africans; there's nowhere else in the world where cultural barriers are being crossed as here.' His home and his art make this point clearly.

LEFT In the living room, Beezy has combined the effect of an old, traditional space with modern, pulsating colours. The fireplace is a concrete cast from a French château, decorated with silver-leaf to make it glisten with life. The recycled armchair is Victorian and the table from India. **ABOVE** A self-portrait of sorts depicting Lee Ping Zing, one of Beezy's artistic alter egos. The design is based on burial money that is burnt at Chinese funerals.

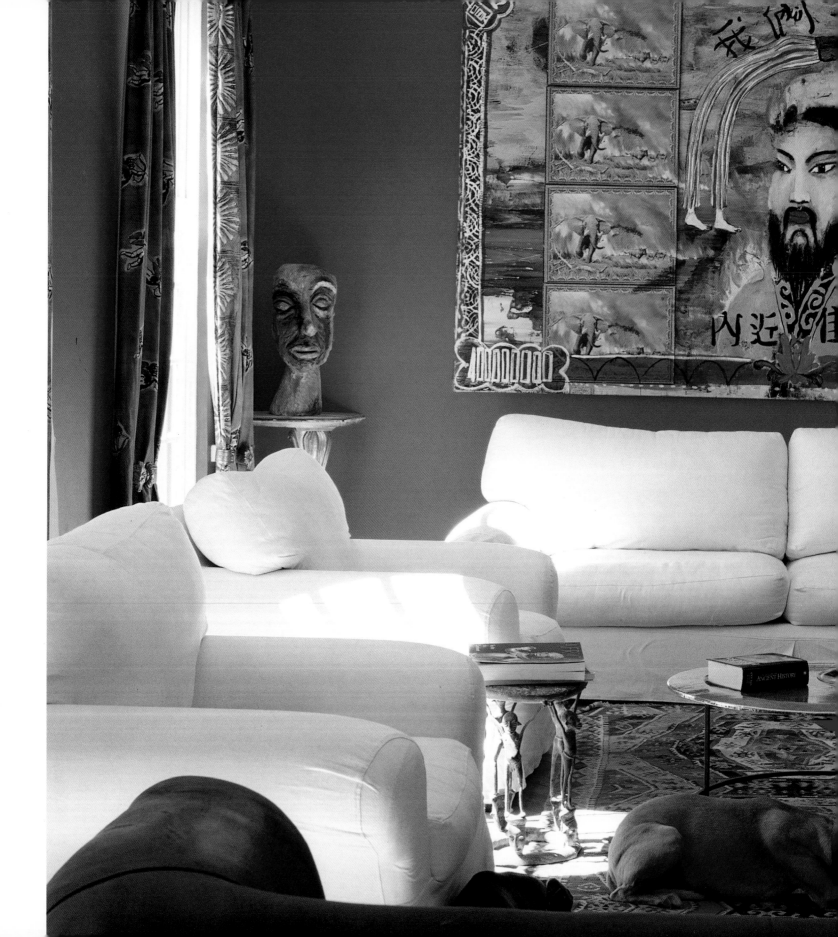

LEFT

With all the colour in this living room, the sofa and armchairs just had to be white! The purple head in the corner, a smaller version of those in the garden, is another of Beezy's head sculptures. Lee Ping Zing, who, according to Beezy's personal mythology, is a soul brother 'encountered' in a New York Chinese supermarket, features once more in the large picture on the wall. The motifs and scenery surrounding his mandarin head are all African. The copper table was made by an Austrian craftsman based in Johannesburg.

RIGHT

The rugged-looking benches and chairs grouped around the kitchen table are in complete contrast to the ornate barber's chair shown on the left. Beezy brought the dresser with him from a previous home in Riebeek West, a Cape farming village. Hanging from the beamed ceiling is a copper ship's light.

ABOVE

This Edwardian barber's chair, upholstered in red leather, makes a baroque feature in the spacious kitchen. It was found at a second-hand shop in Cape Town's Long Street, a mecca for interesting bygones.

FAR RIGHT, ABOVE

AND BELOW

Beezy is truly an artistic all-rounder and multi-media man. He designed and made these plates and has also written and produced many books. The one shown here is about Lee Ping Zing.

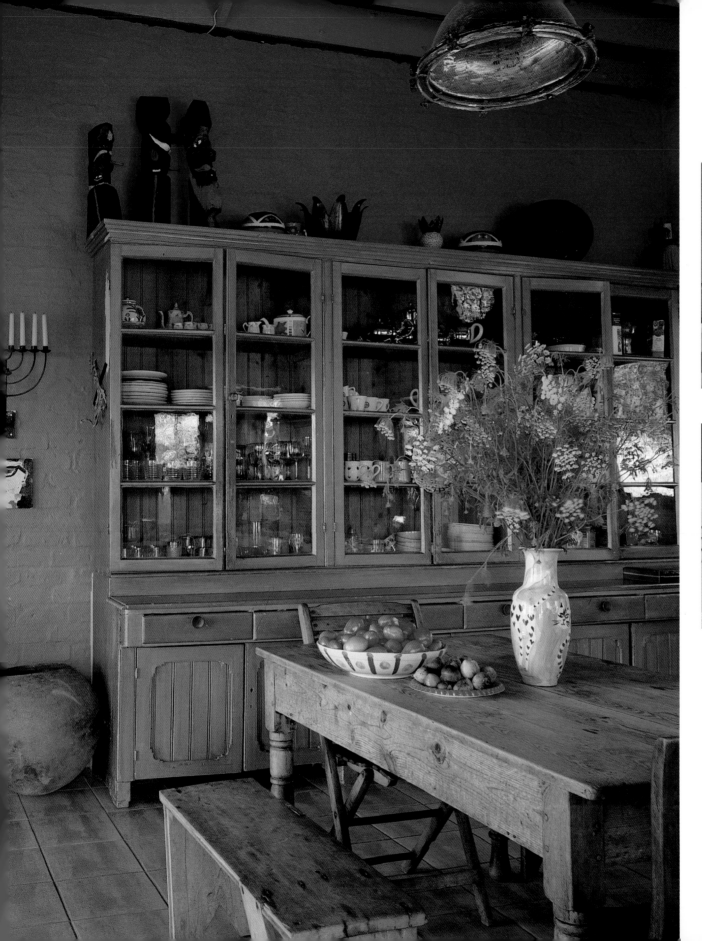

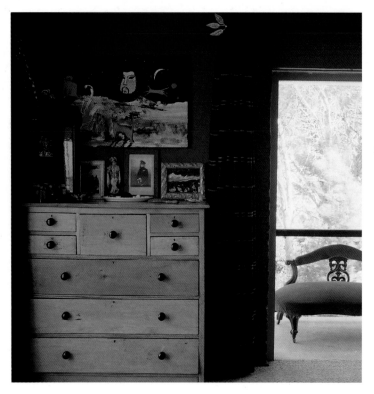

ABOVE LEFT

The traditional chest is made from yellow-wood, much prized in South Africa. The curtains, designed by Beezy, were made in Swaziland; the Victorian seat was bought at an auction and then recovered in sumptuous velvet.

ABOVE RIGHT

This cupboard, bought in the Cape rural hinterland, near Riebeek West, was painted by Beezy with angel and devil motifs in a style loosely derived from Bavarian baroque. Beezy calls it 'my German cupboard'.

RIGHT

Another example of Beezy's colourful world is in the main bedroom, where the vibrant blue walls and pink door are a daring but successful partnership. The ubiquitous Lee Ping Zing presides over the kilim-covered bed.

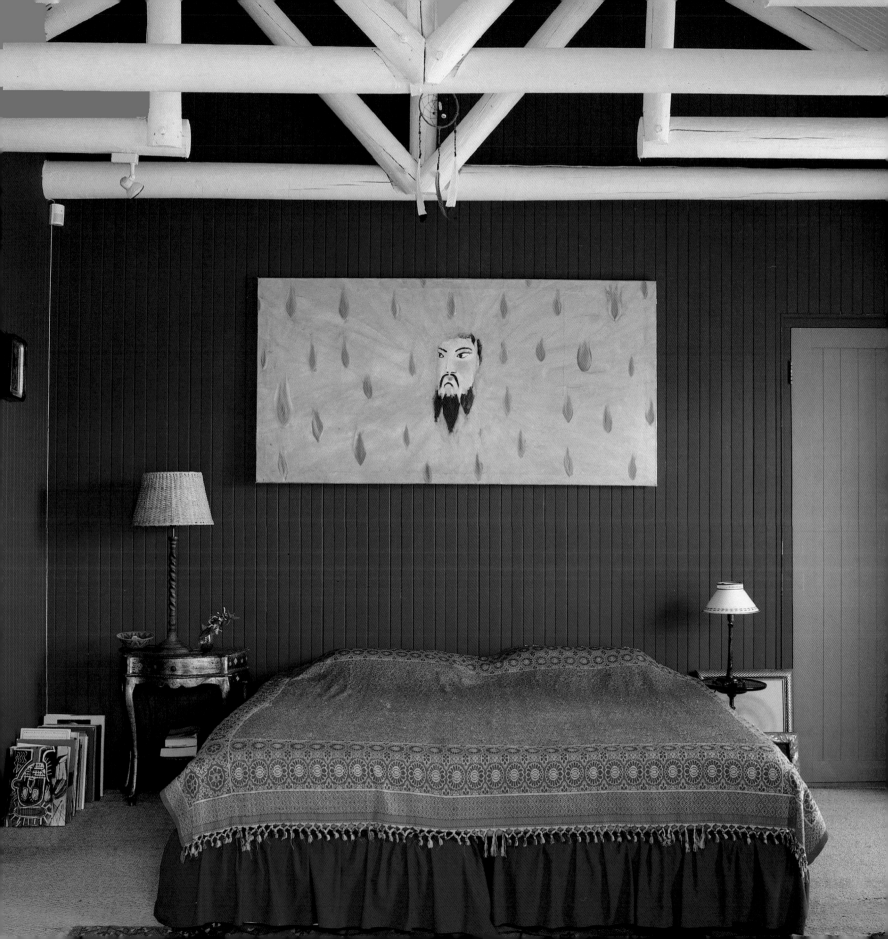

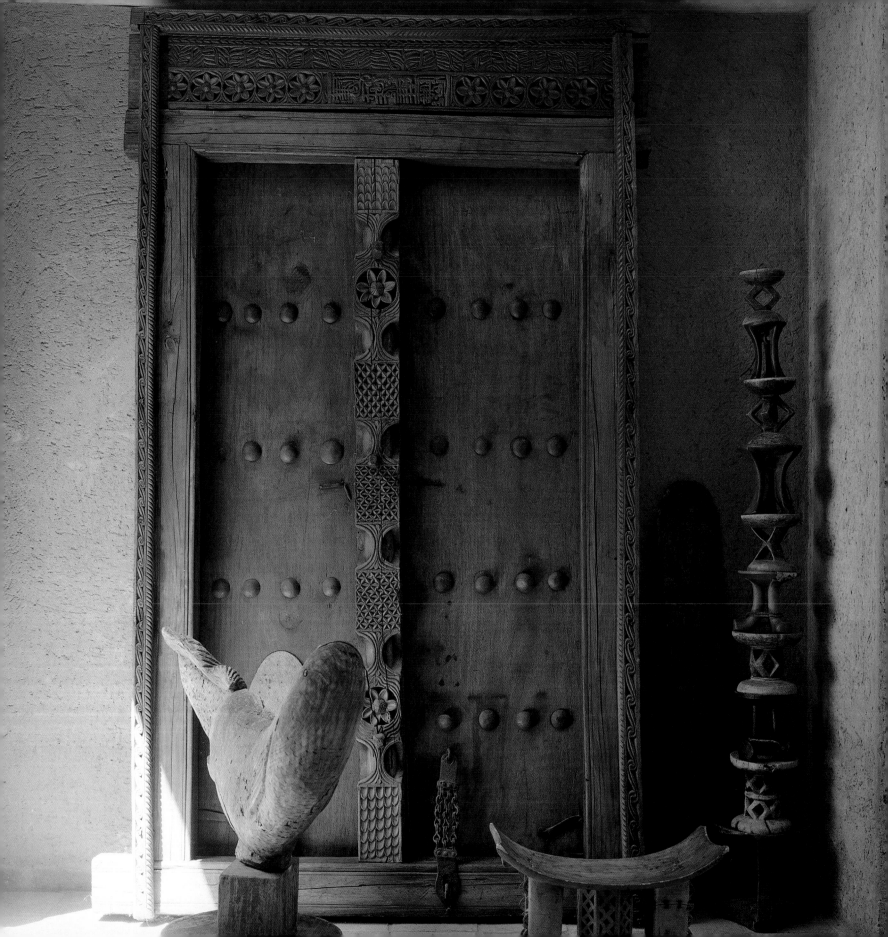

COLLECTED ART

Something of a Zen-like tranquillity seems to pervade Karel Nel's house. Set back from a quiet road, behind a garden and a pool, the shape of the façade is so simple and spare that it verges on the austere. But the effect is enlivened by warm sand-coloured walls and an elaborate Zanzibari door, one of several that Karel has made into centrepieces in his house after hunting them down with the persistence of a passionate collector.

Karel's home is also his painting studio and a showcase for an exquisite art collection from all over the world. It is a celebration of multi-culturalism, a modern version of the cabinet of curiosities, except that Karel not only contemplates his treasures but is inspired by them when creating his own works. These, in turn, are collected 'multi-nationally', not only by the locals but also by Americans and Europeans – one of his latest commissions is for the French island of Réunion in the Indian Ocean. 'What I'm paid for my art, I put back into my collection,' he explains, 'and that gives me the feeling that I can afford it.'

Except for the fact that Karel is very warm and welcoming, visiting his home is like gaining privileged after-hours access to a connoisseur's collection. It is particularly surprising to come across it in the cosseted Johannesburg suburb of Rivonia. Being shown

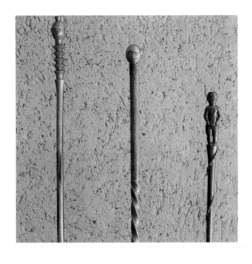

through the house, glass of wine in hand, is a great pleasure but also a learning experience; he has researched and documented all his possessions, and discusses them most eloquently. One is reminded that he teaches art at the University of the Witwatersrand; prior to that he studied at Saint Martin's School of Art in London and at Berkeley, California. It was there he deepened his interest in mysticism and meditation, and also in the links between art and science.

Although Karel's own paintings are influenced by both Kandinsky and Klee, he is most passionate about Gauguin, whose preoccupations and profile feature in his own canvases. Following in Gauguin's footsteps, Karel has visited Tahiti and the Marquesas Islands several times, and he owns some Gauguin woodblocks.

Clearly, Gauguin's yearning for far horizons and his interest in the 'primitive' and with 'going native' are shared by Karel. His fascination with cultural cross-pollination is very much in evidence in his home: the Zanzibari doors, his collection of Swahili *objets d'art* and the paintings inspired by the Comoro Islands in the Indian Ocean. In his life, his art and home, Karel is creating his own blend of the local and the global, the African, European and Asian, and sharing it as generously as he can.

LEFT Decorative rather than functional, this exterior Zanzibari-style door from Lamu in Kenya stands against an interior wall. This corner of African artefacts includes a leaping fish by the Northern Transvaal shaman artist Jackson Hlungwane, an Ashante stool, a Somalian writing tablet in Arabic script and stacked stools – Shona, Tonga and Potok. ABOVE A set of ceremonial staffs – Zulu and Xhosa from South Africa, and Hehe from Tanzania.

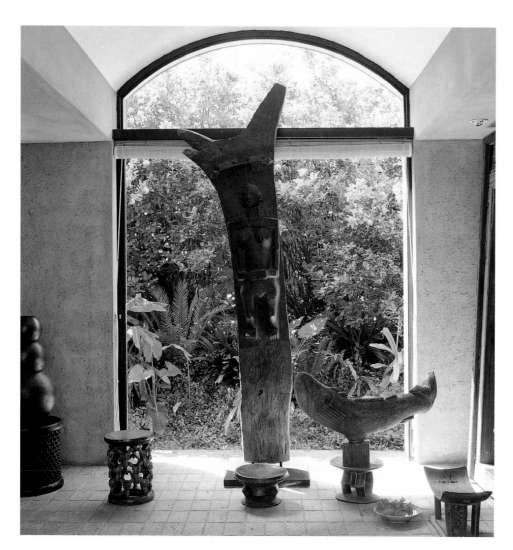

LEFT

The same corner
of the house as
shown on the
previous page but
from a different
angle features, from
left to right, rounded
Swazi pots, a stool
with a bat-eared
fox design from
Cameroun, a Dogon
figure on a house-
post from Mali and
Jackson Hlungwane's
leaping fish.

RIGHT

For Karel, Zanzibari
doors have a
special significance.
Overlooking the
swimming pool,
this particular door
is made from
beautiful old wood
embellished with
bronze, both inviting
to the touch and
visually compelling.

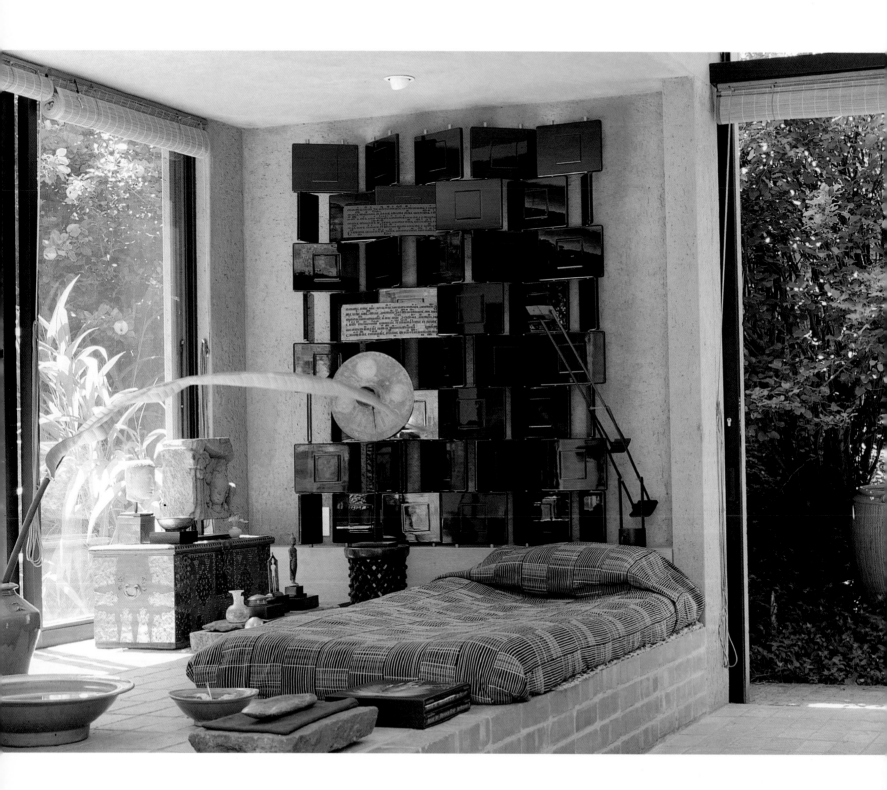

LEFT

Light streaming in from two sides, a Japanese-style futon bed and sacred Thai texts give this bedroom a mildly monastic feel, but with the ascetic infused with the aesthetic. The lacquer and wood screen against the wall was designed by Eileen Gray and the Tizio lamp by Richard Sapper.

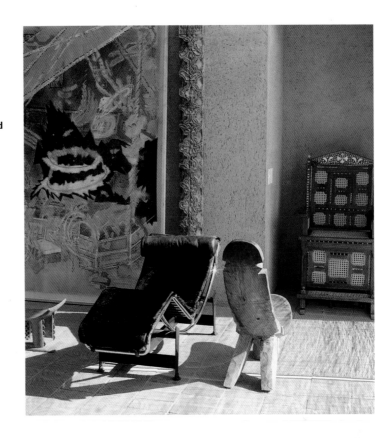

ABOVE

Xhosa ivory arm bands are displayed on some Kente cloth from Ghana in a wooden bowl.

ABOVE

Three startlingly different styles of seating – a Le Corbusier recliner, an ebony and ivory throne and a roughly hewn tribal seat. Karel painted the picture, entitled 'Presence of the Void'.

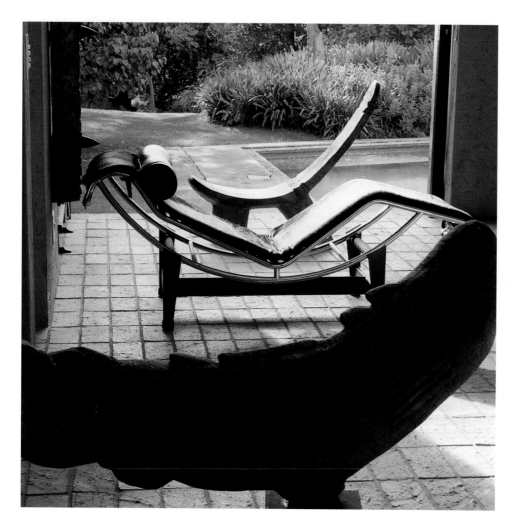

LEFT

Outside, a swimming
pool and restful
garden, and inside,
simple light-filled
spaces and studios.
In travelling the
world, Karel has
selected beautiful
objects from various
cultures, then
juxtaposed and
harmonized them
in both his art and
home. Two recliners
– African-style and
a Le Corbusier –
express the search
for cultural synthesis.

RIGHT

The mixing of
cultures that Karel
has created in his
collections is also
expressed in his art.
These pictures are
by Karel; the wooden
sculptures are
traditional African.

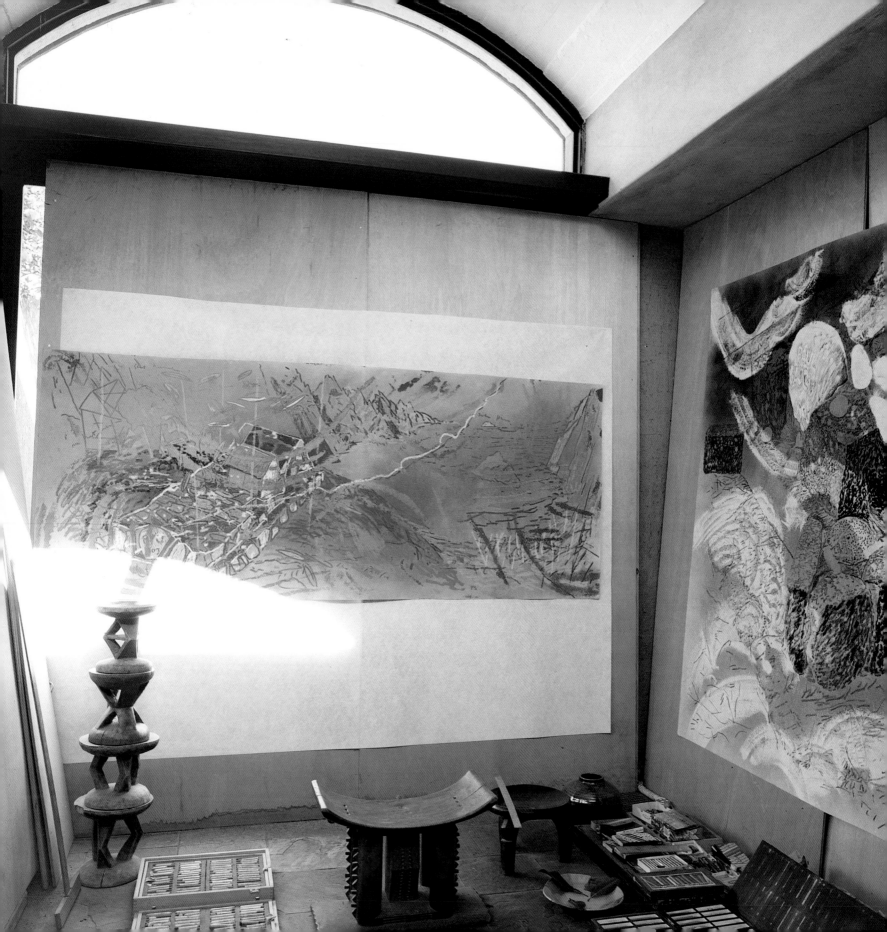

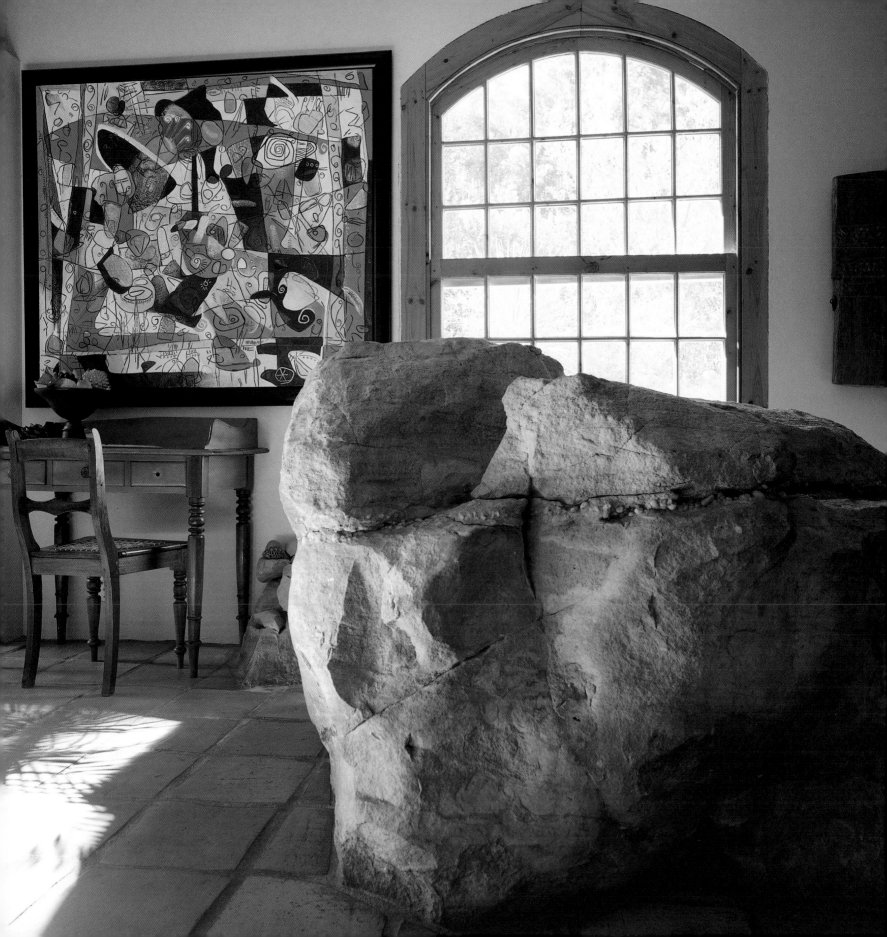

THE FORCE OF NATURE

Artist Robert Slingsby has been called a force of nature and on meeting him one understands why. He expresses himself forcefully, not only in his paintings, but also with his words. With near-manic enthusiasm, undeterred by the ironic wit of his wife Janis, he discourses about the many things he finds 'awesome' in art, archaeology and the mysteries of the natural world, such as the age of rocks, crop circles, pyramids, new cosmologies. Janis, a former genetic scientist, now acts as Robert's agent, taking care of his exhibitions at home and abroad.

Robert is also forceful in a physical sense. He has transformed a large chunk of natural space on the slopes of Table Mountain into a spacious elemental-looking house and studio set in a sprawling, rustic garden – all this with only one helper, his Zulu assistant, Fanie Sibia. 'If it's at all creative,' he explains, 'it's the result of an economy drive. We cut down every tree, placed every log and laid every tile.' The rocks were left where they stood and incorporated into both home and garden, so that there are literally pieces of Table Mountain inside the house as well as outside. Inside, these huge chunks of sandstone boulders, waist- and shoulder-high, and even bigger, give a rugged, almost heroic accent to the house.

Robert was, perhaps, less respectful of the trees, but that was because the Australian bluegums were not indigenous to the Cape. Furthermore, he says, 'because the logs were here, we decided we'd live in a log cabin'. Parts of the floor are made of circular yellow-wood stumps. For the walls and roof, he used a 'build-your-own-log-cabin' book, based on Scandinavian and Swiss models. But his mountain retreat has a strong local flavour; it doesn't shut out the cold but lets in the light and brings in the outside through huge corner windows.

Apart from some Indonesian wicker furniture, the interior is very African. A Balinese bench is covered with patterned fabric from Mali; there is a range of vernacular Cape Dutch furniture, weathered wooden stable doors set into the walls, a bushman's bag, African sculpture, crystals and stone tools, and pictures in the various styles Robert has painted. Many of these were inspired by the austere Richtersveld area, a rocky desert in the remote Northern Cape.

'I've always been a treasure-hunter,' Robert explains, surveying his home with its eclectic choice of furniture and *objets d'art*. And, one might add, something of an alchemist, who has succeeded in transforming parts of Table Mountain into his home.

LEFT **Table Mountain is ever present, both inside and outside the house. When confronted by boulders during construction, Robert literally built the house around them. The picture, by Robert, is called 'Fractals Africa'.** ABOVE **With mountains and woods behind, the Slingsbys' home is on the right and Robert's studio on the left. The log cabin house was built using bluegum trees growing on site. As they are not a protected species in South Africa, they made the ideal building material.**

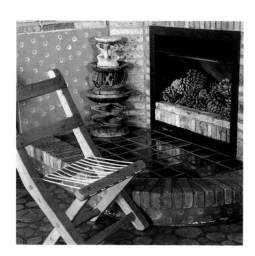

LEFT ABOVE

The log cabin is a feature of the whole house. The picture on the wall, by Robert, is called 'Interior-Exterior'.

LEFT BELOW

This leather-thonged folding chair made of lemon-wood is from the Cape's West Coast area, a remote part of the country that is a repository of tradition.

RIGHT

These wicker sofas, which are almost dwarfed by Robert's picture entitled 'Descent into Anarchy', are Indonesian, with the cushions covered in Mali prints. A traditional bed from Cameroun acts as a coffee table.

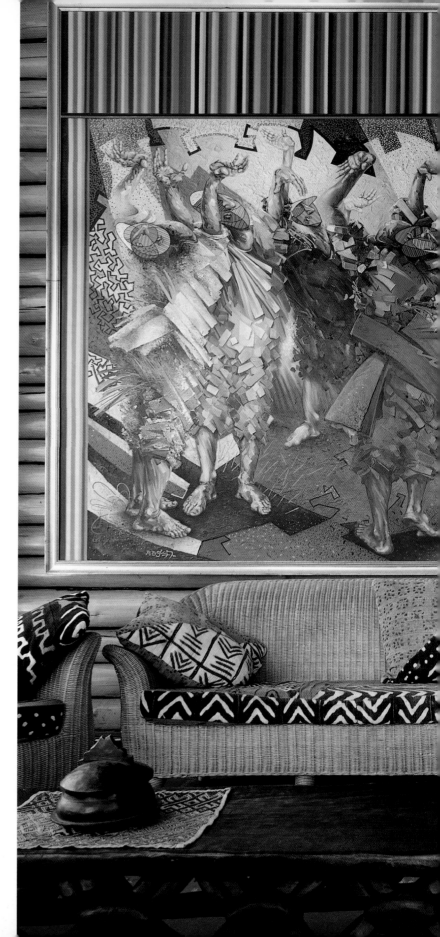

Friends teased
Robert over this
particular boulder,
saying that he was
getting too tired to
carry it away. It
dominates this part
of the kitchen, which
also features an old
Cape kitchen table
and fruitwood
chairs. The view from
the window looks
down the mountain
to Bokkemans *kloof*,
or ravine.

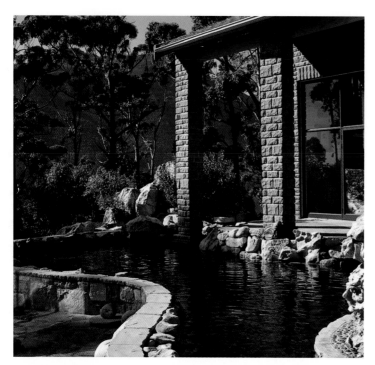

LEFT ABOVE

This view of the studio is from the log cabin house. Built from more conventional materials, the studio is spacious enough to accommodate Robert's large-scale pictures and Janis's office. Koi carp swim in the ponds between the house and studio.

LEFT BELOW

One of Robert's sculptures, which resembles a sundial, is made from dolomitic rock, which he found in the Richtersveld.

RIGHT

'White Dunes', painted by Robert, is the complementary backdrop for the old Cape furniture in the dining room.

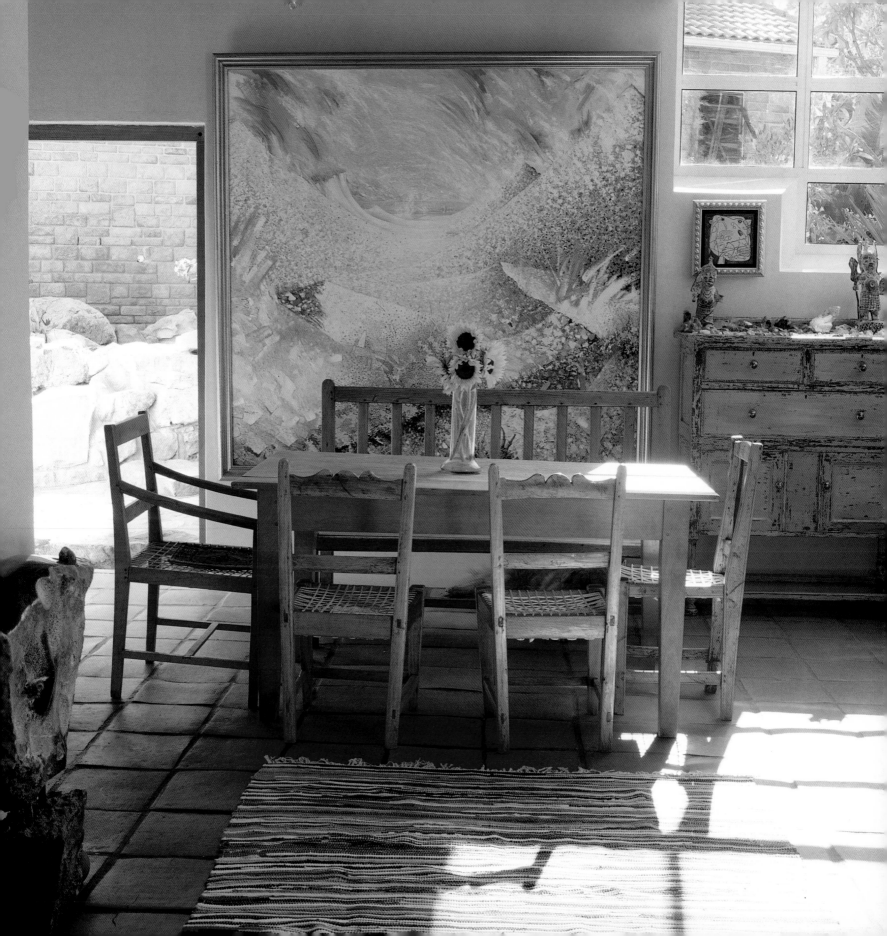

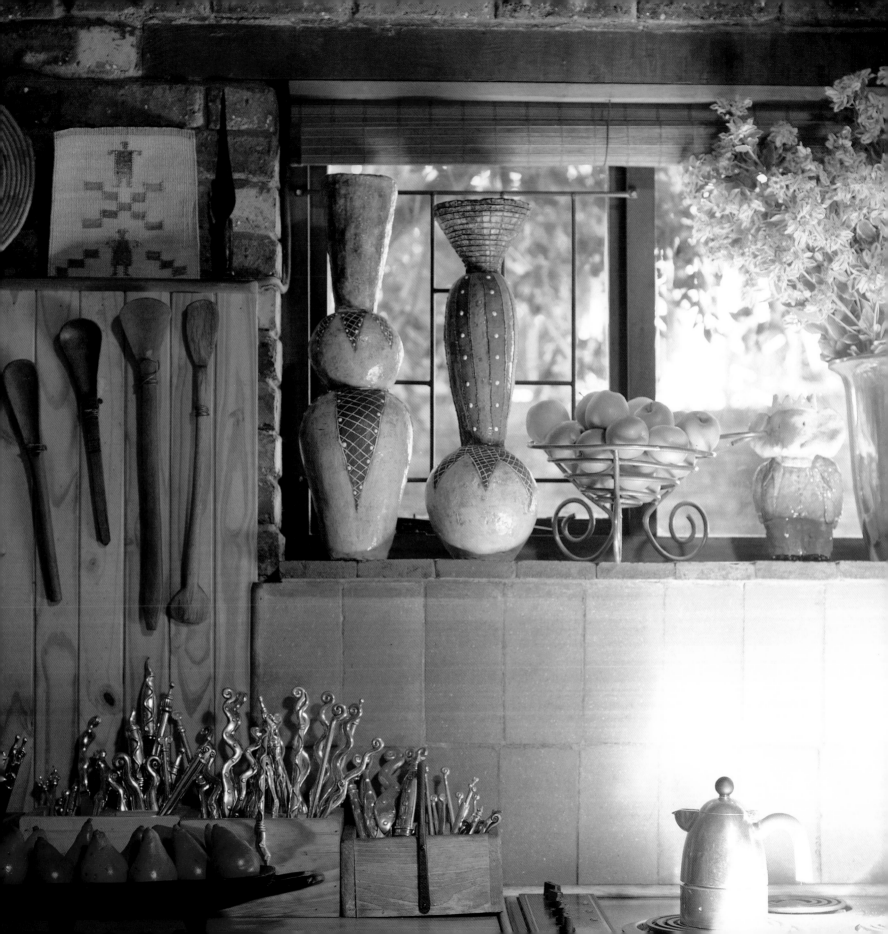

A RELAXING RETREAT

'While others have to go away for their weekend breaks, we feel that we are already away,' says Carrol Boyes, speaking of the seaside home that she and Barbara Jackson have made together. Both Barbara and Carrol are artists. Barbara is a successful ceramist, who also teaches at art workshops and takes on occasional curatorial assignments for African art around the world. Carrol makes cutlery as well as pieces in pewter and other metals. Her work is very well known at home and abroad, selling at Harrods and Heals in London, Giorgio on Rodeo Drive, Los Angeles, and Galeries Lafayette in Paris. To help keep up with the demand for their work, they each have a studio at home as well as in Cape Town, which is twenty minutes' drive away.

Between sea and mountain, Carrol and Barbara's world revolves around designing, shaping and making, but it is also made up of light, beaches and birds – they hang fruit in the trees for birds such as Cape bulbuls, mousebirds and white-eyes. 'To say that we're inspired by the sea would probably be nonsense,' says Barbara, 'but I suppose, in a way, we do feed off it.' They also feed off the objects in their home, which they built from scratch – laying floors, heaving bricks and building walls themselves – almost twenty years ago.

The house is made mainly of rugged brown bricks, which are wind- and weather-resistant – essential protection as the Cape of Storms, later renamed the Cape of Good Hope, is not far away. The furniture is simple: an Oregon pine table in the kitchen, surrounded by aluminium chairs, large comfortable sofas in the living room and a table that started life as a leather-thonged, Boer pioneer bed in the nineteenth century. It is now used to display a Zimbabwe thumb piano, Zulu headrests, a Nubian sword and colourful baskets made from telephone wire.

Although the house is crammed full of *objets d'art*, the views over the garden and sea prevent a feeling of overcrowding. Many of these possessions are their own work, but there is also an intriguing collection of art and artefacts from all over Africa as well as paintings by other well-known local artists, many of whom are friends. They have several pictures by William Kentridge, Bongi Bengu and Willie Bester; when celebrating his fortieth birthday here, Bester hung the large picture in their living room. In a home that is a relaxing retreat away from the city, it is this artistic stimulus, combined with the proximity to nature, that provides Barbara and Carrol with all the inspiration they need for their own creative work.

LEFT **Throughout their house, Barbara and Carrol's creations, combining the utilitarian and the decorative, stand side by side, as here in the kitchen. Barbara made the gourd-like pots, Carrol the ornate cutlery. Her metal spoons, in a variety of different shapes, but often curved, are a pleasing contrast to the wooden spoons made by craftsmen of the Shangaan tribe.** ABOVE **These salad servers, in a 'man and woman', design were made by one of Barbara's students.**

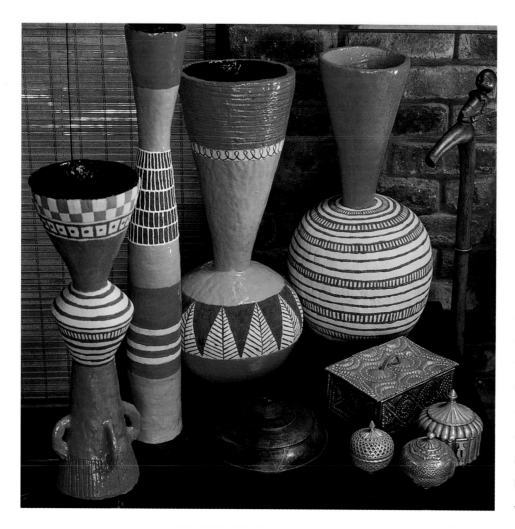

LEFT

This juxtaposition of tribal and modern features a Lozi ceremonial wooden staff with a group of Barbara's brightly coloured pots, showing the influence of tribal art.

RIGHT

Philippe Starck aluminium chairs are set around an early twentieth-century table made of Oregon pine. The centrepiece is a Zulu meat platter, the large picture on the wall by Debora Bell.

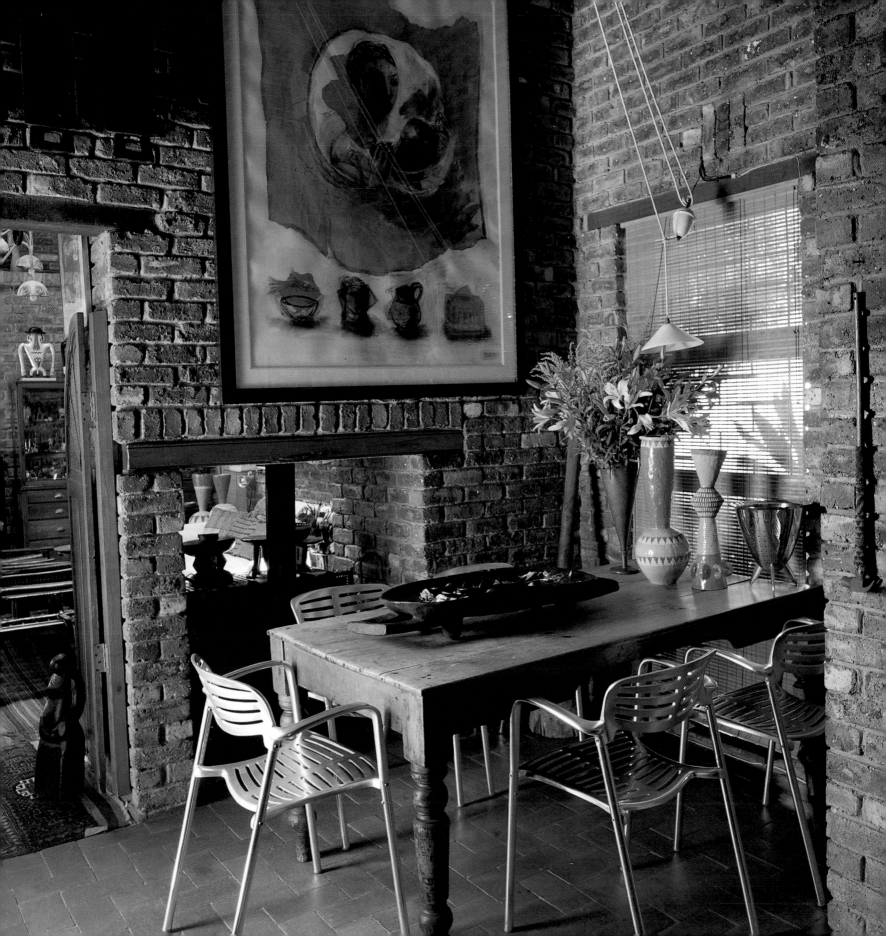

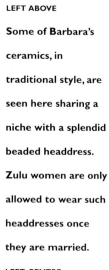

LEFT ABOVE

Some of Barbara's ceramics, in traditional style, are seen here sharing a niche with a splendid beaded headdress. Zulu women are only allowed to wear such headdresses once they are married.

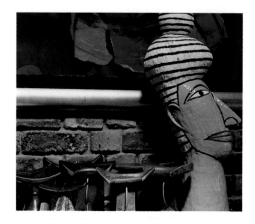

LEFT CENTRE

One of Barbara's exuberant turbanned heads in ceramic stands next to a group of carved tribal headrests, some of which are adorned with beads.

LEFT BELOW

Among the most eyecatching of the many tribal objects to be found in Barbara and Carrol's home is this musical instrument: a thumb piano from Zimbabwe.

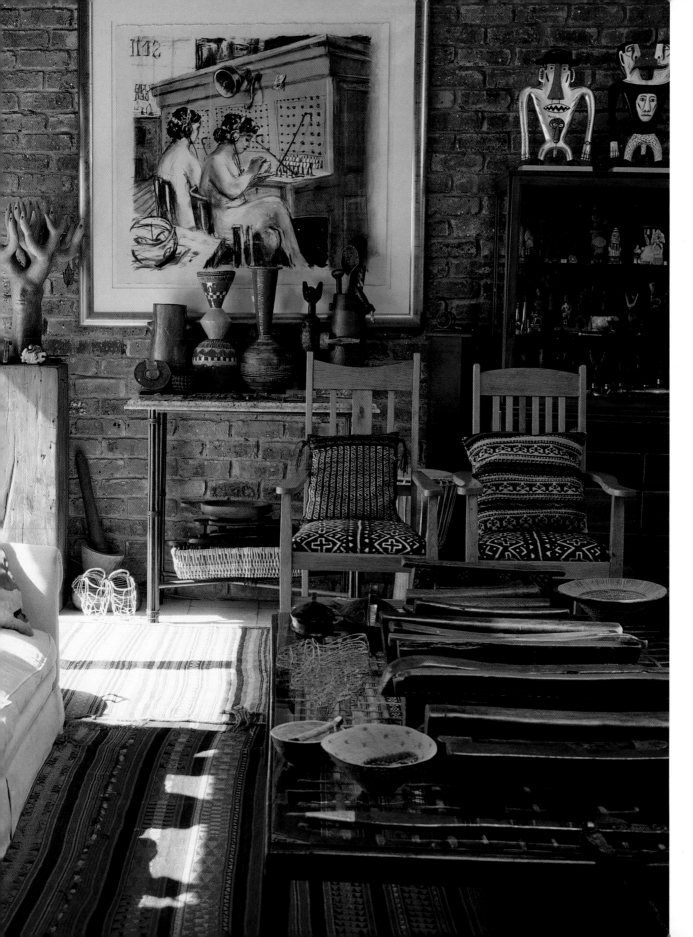

LEFT

An eclectic mix of objects co-exist quite happily in the sea-facing living room. There are works by well-known South African artists, such as William Kentridge and Norman Catherine. The table was originally a leather-thonged, Boer pioneer bed from the nineteenth century, stored in the covered wagons that crossed the country. Now it is covered with African art.

LEFT

This is another example of Carrol's pewterware. Her distinctive style has been admired and sold throughout the world. Instantly recognizable, each piece is a variation on her basic themes.

RIGHT

The temptation to laze about on this inviting terrace in the dappled shade must be very difficult to resist. Some of the country's most beautiful mountain scenery lies behind the house, and the view from this direction looks out over granite boulders and sandy beaches towards the sea.

NATURE

'That paradise on earth ... which the Beneficent Creator has enriched with his choicest wonders' was how the great botanist Linnaeus described South Africa in the eighteenth century. Whether you prefer safari, tropical, desert, coastal or mountain scenery, South Africa has it all. It is no wonder that nature plays such an important part in the country's life, culture and design.

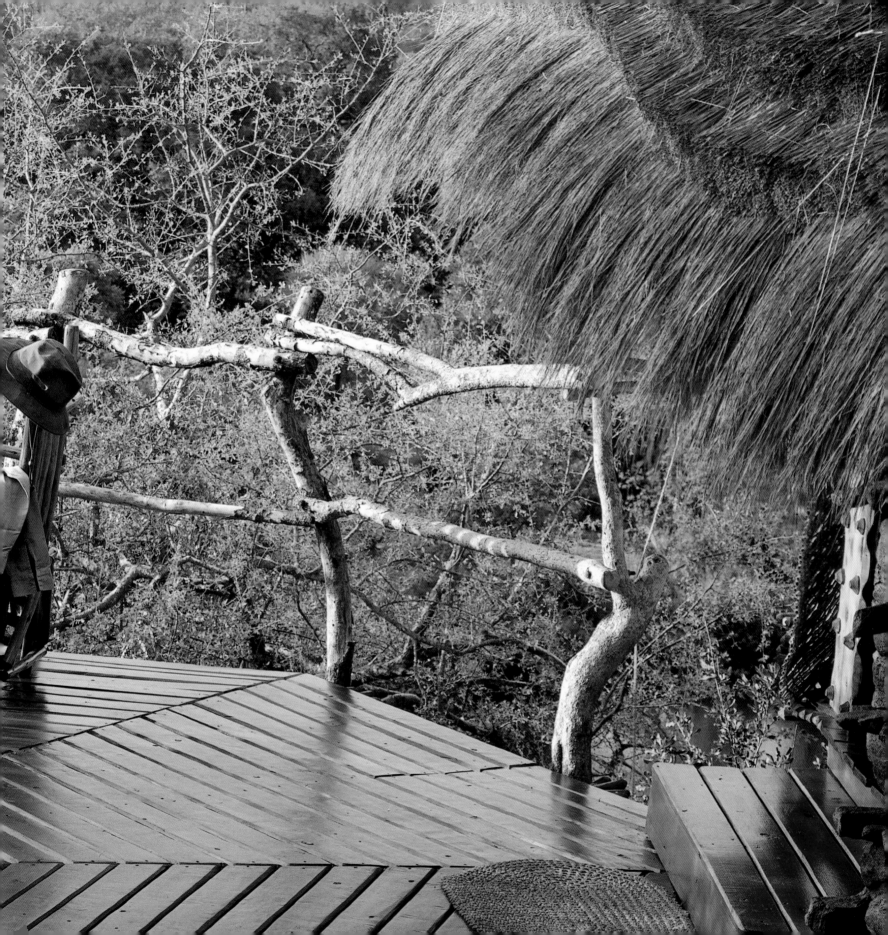

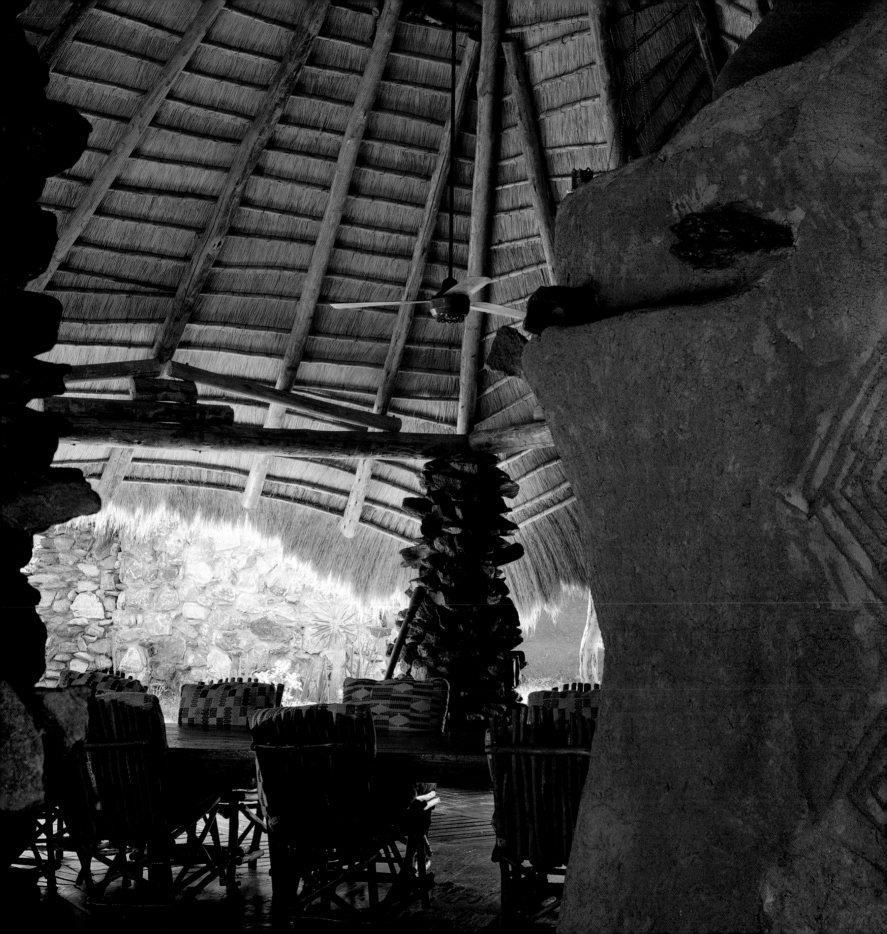

SAFARI STYLE

The architecture and design of safari camps have traditionally been colonial in style, evoking a world of white game hunters. In contrast, the camps at Makalali in Eastern Mpumalanga are decidedly Afrocentric: bush lodge architecture has been reinvented with a strong sense of place and tribal tradition.

A feeling for the site and the people who lived in the area was, from the outset, crucial to Makalali's owner, Charles Smith, an American with long-standing African connections, and to its ebullient architect, Silvio Rech, born in South Africa of Italian parents. Silvio obviously relished getting back to nature and setting up and training a work team of Shangaan tribespeople, at the same time drawing on their own craft traditions. While Makalali was being built, Silvio, his partner Lesley, also an architect, and their baby son 'were living on site, according to the principles of the Italian Renaissance'. But with wild animals interrupting progress, it must have seemed a long way from Florence: a giraffe had to be prodded out of a pool and when an elephant pushed over a tree, it was incorporated into the overall design.

Makalali is very much the result of a collective effort. It has an organic feel, of rootedness and belonging: its scattered structures, strung out along the banks of the Makhutswi river, seem to grow

out of the ground. In keeping with African traditions, the layouts are circular, with domes and cones everywhere, reminiscent of the termite heaps dotting the surrounding bushveld. The woodwork is rough-looking and the thatching shaggy. But while African motifs are incorporated into the design – mud, stone and knobbly effects, traceries based on Bushmen paintings – Makalali is a long way from the clichés of 'airport art'. Silvio has reworked and updated African designs, synthesizing them into a truly original style of his own.

At the camp, activities centre on game drives and on more relaxed animal viewing from the verandas overlooking the river; there are also hammocks in the trees. Living and sleeping quarters are set well apart from one another in four different camps and are designed to provide guests with a degree of isolation conducive to savouring that 'back-to-the-bush' feeling. One sleeps under mosquito nets and can take memorable showers sheltered in a private enclosure under the trees and sky. In contrast to these secluded hideaways, Makalali's communal areas – the pools, bars and stockaded *boma* dining enclosure – set a more sociable mood and encourage campfire camaraderie. It comes as no surprise to see an entry in the visitors' book that reads, 'Terrible … to have to leave.'

LEFT One of the Makalali camps, featuring Silvio Rech's Afro-baroque architecture.
ABOVE From high points, such as this look-out and the one featured on the previous page, there are wonderful views over the bush country. The best time to spot the animals is in the early mornings and evenings when they come out of the bush to drink in the grey-green waters of the Makhutswi river below.

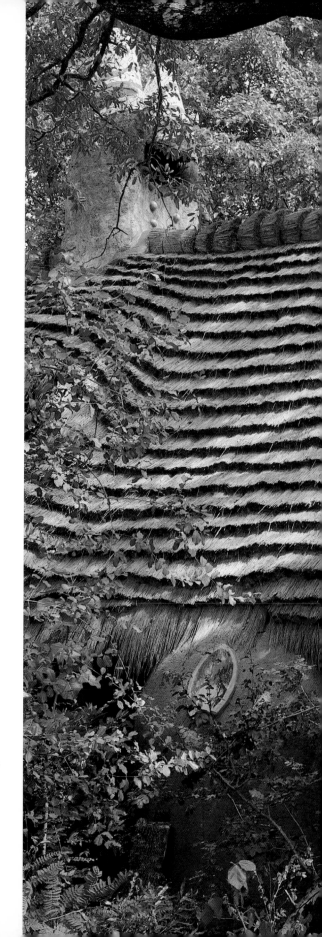

RIGHT AND FAR RIGHT

There is an overall organic quality to the camp buildings, which appear not so much as if they are built but growing among the trees. In places, the trees themselves are incorporated into the man-made structures. Felled ones are used in their twisting, natural state to form balustrades for balconies and stockade walls, demarcating various areas. The roof thatching has a stepped, shaggy outline, contributing to the elemental feel. Overt decorative touches, such as animal horns, are used sparingly.

ABOVE

The architecture and design of the Makalali camps are based on traditional styles, albeit a particularly free interpretation. The building materials used for the various structures are mud, wood and stone.

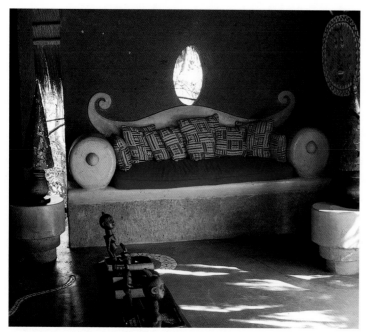

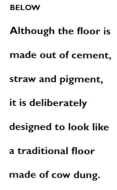

LEFT

Warm and earthy
colours predominate
throughout the
Makalali camps.
The back of this
throne-like seat
evokes buffalo horns.

BELOW

Although the floor is
made out of cement,
straw and pigment,
it is deliberately
designed to look like
a traditional floor
made of cow dung.

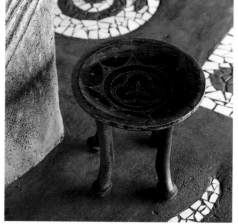

LEFT

Set against the
thatched roof of a
communal area in
one of the camps is
a patterned oxhide
Zulu shield. It is one
of the best-known
traditional designs in
South Africa.

RIGHT

The brown and
white mosaic-tiled
floors and patterned
walls were the work
of on-site local
craftsmen. The
ornate coffee table
was originally from
the Sudan.

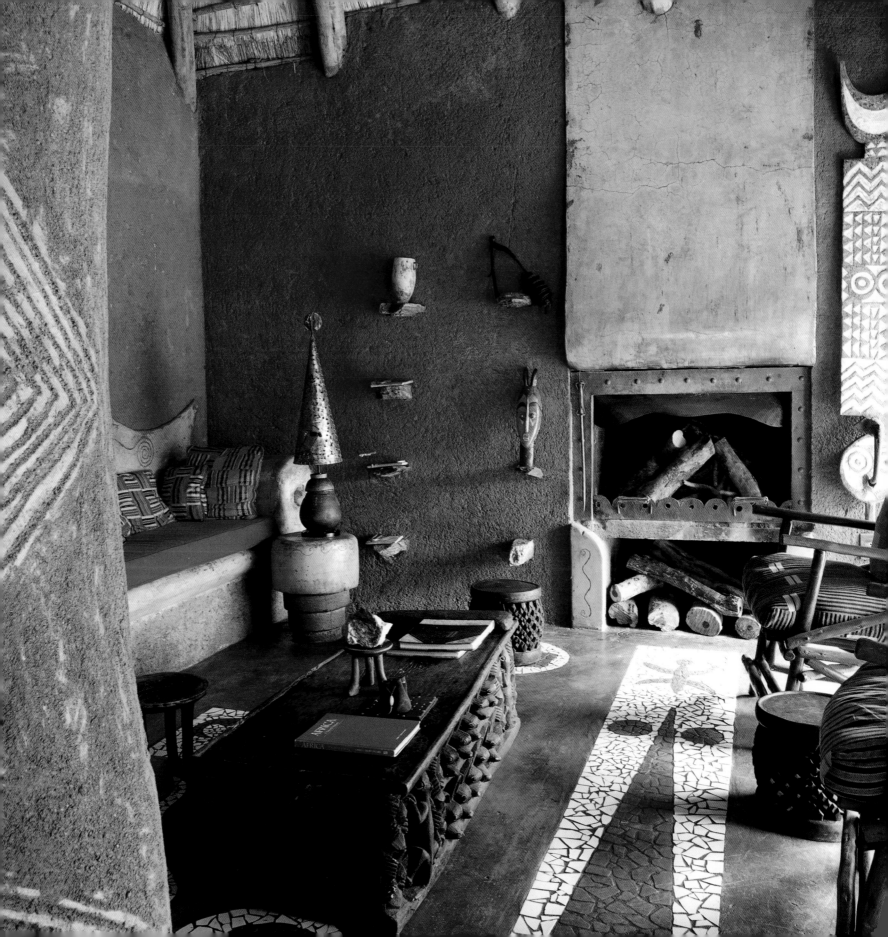

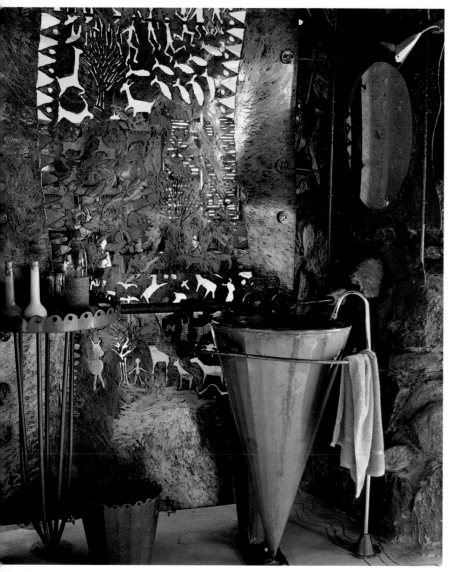

LEFT

This bathroom is separated from the bedroom by a screen of metal tracery. Depicting hunting scenes, the design was inspired by South Africa's most famous art form – the cave paintings of the Bushmen, or San. The screen and the cone washbasin were made by local Shangaan artisans.

RIGHT

Kente cloth is used for the bedspread and curtaining. The mosquito net is not only practical but decorative.

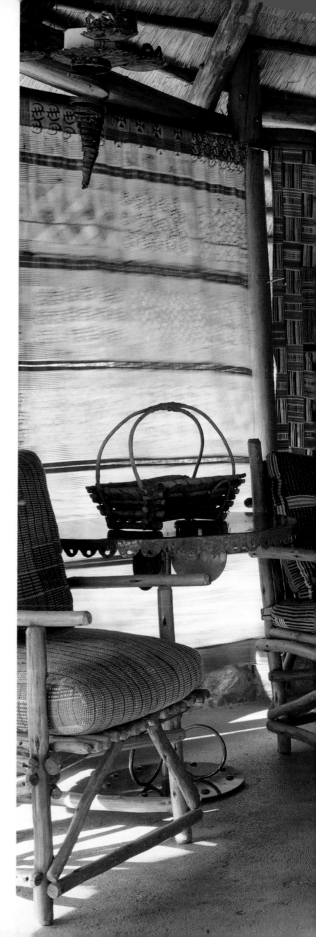

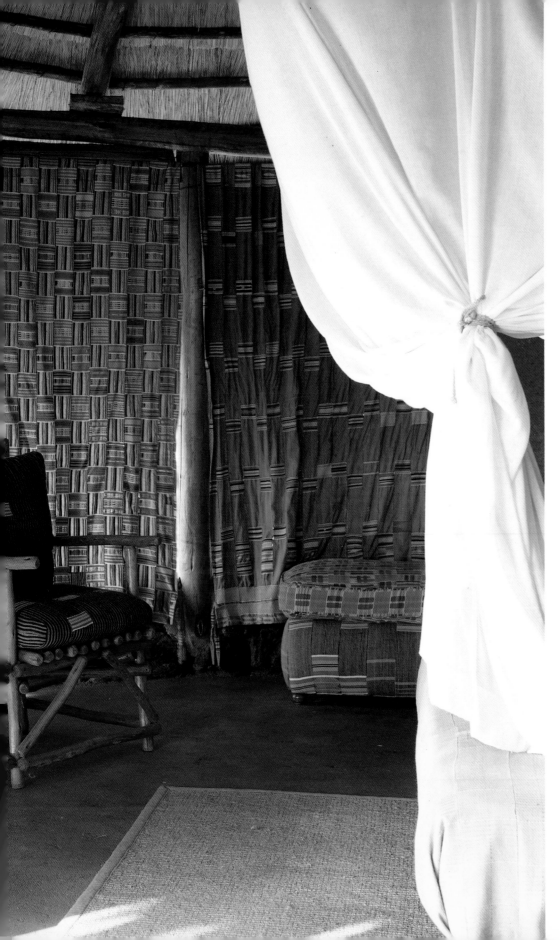

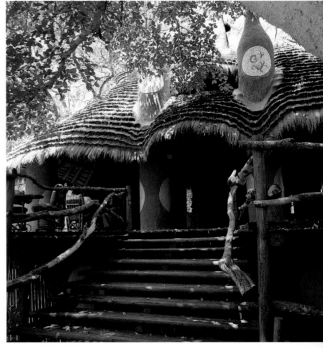

ABOVE

The communal areas

of Makalali are made

up of traditional

circular structures.

Their undulating

thatched roofs,

wooden pillars and

steps, and handrails

made of branches

make them seem

almost a part of the

natural landscape.

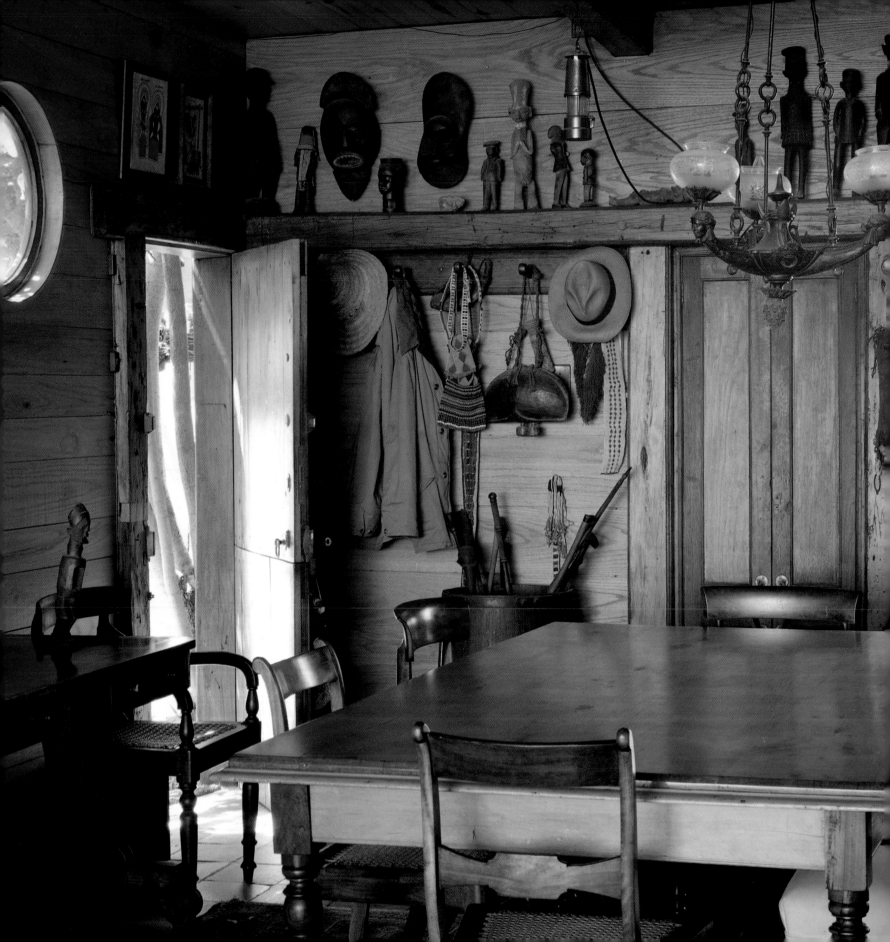

AN ARTIST'S COLONY

It is not unusual for places originally colonized by artists and writers, such as St Tropez in France and Clifton in South Africa, to be taken over by developers and then sold on to wealthy businessmen. Clifton's wooden bungalows by the sea no longer house a significant writers' colony, as in the days of Uys Krige and Jack Cope. In fact, many of the bungalows have been replaced by palatial marble apartments, complete with sun decks, in keeping with Clifton's status as the most expensive strip of property in Africa. But parts of the old, laid-back Clifton live on, for instance in the bungalow of Julian Mervish. Although a businessman, he has always lived like an artist.

Set just behind the glamorous beaches with the country's largest concentration of suntanning socialites, models, beach-batters and voyeurs, Julian's bungalow resembles Gauguin's Tahitian dream or Robinson Crusoe's hideaway – even the resident parrot manages to underline the far-away feel of his home. With his wife Jewel, who also has a sure eye and strong views when it comes to designing and decorating, Julian built a bungalow that looks rooted and organic, as if it had just grown out of the ground, dodging a tree here, a rock there, and incorporating others, so that the interior includes rounded humps of granite.

The upper floor has changing views of the ocean; the lower floor, where there is a sunken bath, is partly burrowed out of rock and also looks out to sea. A woody feel is sustained throughout the home; the walls incorporate pine and old yellow-wood beams from a farmhouse, even an old train door. The inside of the shower is panelled in wood, a church communion table from the Karoo hinterland serves as the dining table, and a wooden butcher's rack for storage and display hangs from the kitchen ceiling.

Above the fireplace there is a large frieze by Lippy Lipshitz, the Lithuanian-born, Cape Town-trained habitué of Montparnasse. Carved fifty years ago from stinkwood, it shows typical Cape Town 'street theatre' scenes: flower sellers, minstrels, a fisherman blowing a fish horn. Julian's art collection also includes sculptures and pictures by Moses Kottler and other well-known South African artists who were friends of his father, a cultural and community leader in Cape Town. From his father, Julian also inherited a strong interest in African art; on the walls, there are Bushmen, or San, beads, metalwork from Ghana, ceramics and woodcarvings and a humorous, oversize, Xhosa tobacco pipe from Umtata representing a traffic policeman on a motorcycle.

LEFT Vestiges of Clifton's artistic past live on in Julian Mervish's bungalow, with its rustic wooden walls and casual decor epitomizing laid-back living. The lamp is a survivor from the age of gas while the cupboard door from a colonial train harks back to the age of steam. The yellow-wood table is a collector's piece, as are the Cape dining chairs.
ABOVE Artefacts from a different past – that of traditional Africa.

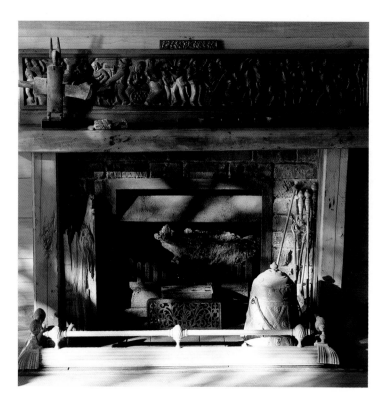

LEFT

A stinkwood frieze by the artist Lippy Lipshitz runs above the open fireplace in the living room. Carved fifty years ago, it depicts typical Cape Town street scenes. The wooden object on the left of the mantelpiece is a Dogon-style lock from West Africa.

RIGHT

Panelled walls, which echo the floorboards, are a neutral setting for this collage of various pictures. Representing a golden age in Cape Town's cultural life, the collage includes work by Lippy Lipshitz and portraits of Julian's father.

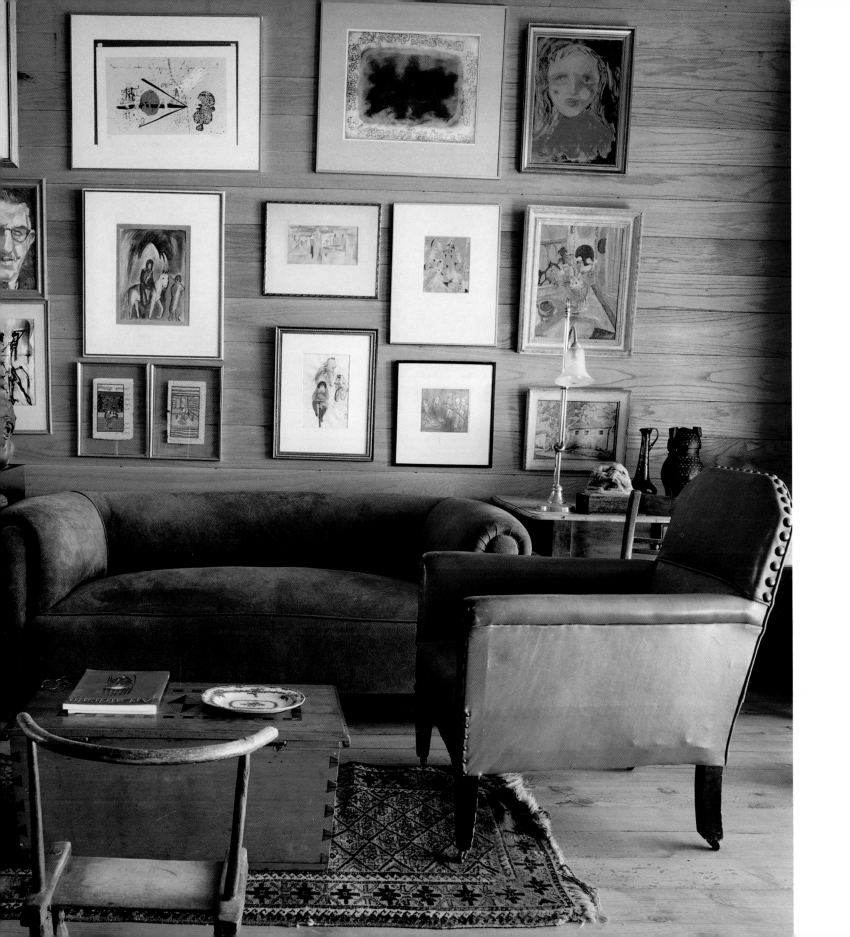

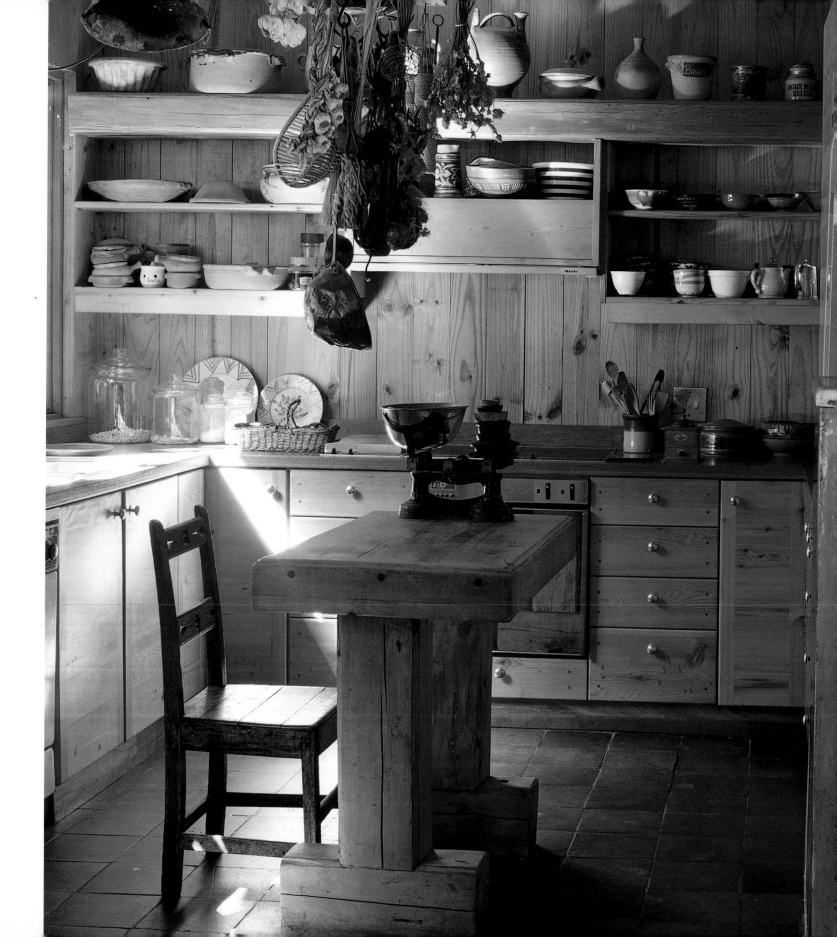

LEFT

The rather battered-
looking General
Electric fridge, with
the water cooler
on top, is a family
heirloom of sorts.
Inherited from
Julian's aunt, it is still
in full working order.
The other appliances
are modern but
encased in wood to
complement the
look of the kitchen.
A butcher's rack,
used for storage
and display, hangs
from the ceiling.

RIGHT

A tree, just visible
behind the glass on
the right, was
preserved as the
bungalow was built
around it. The tree
now grows up
through the ceiling
to the terrace above.

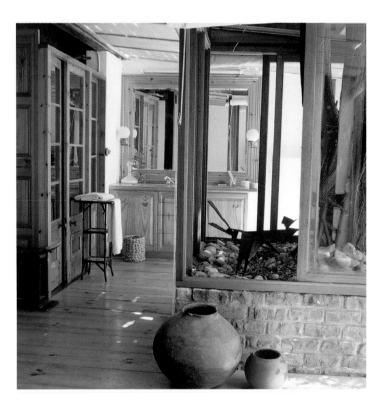

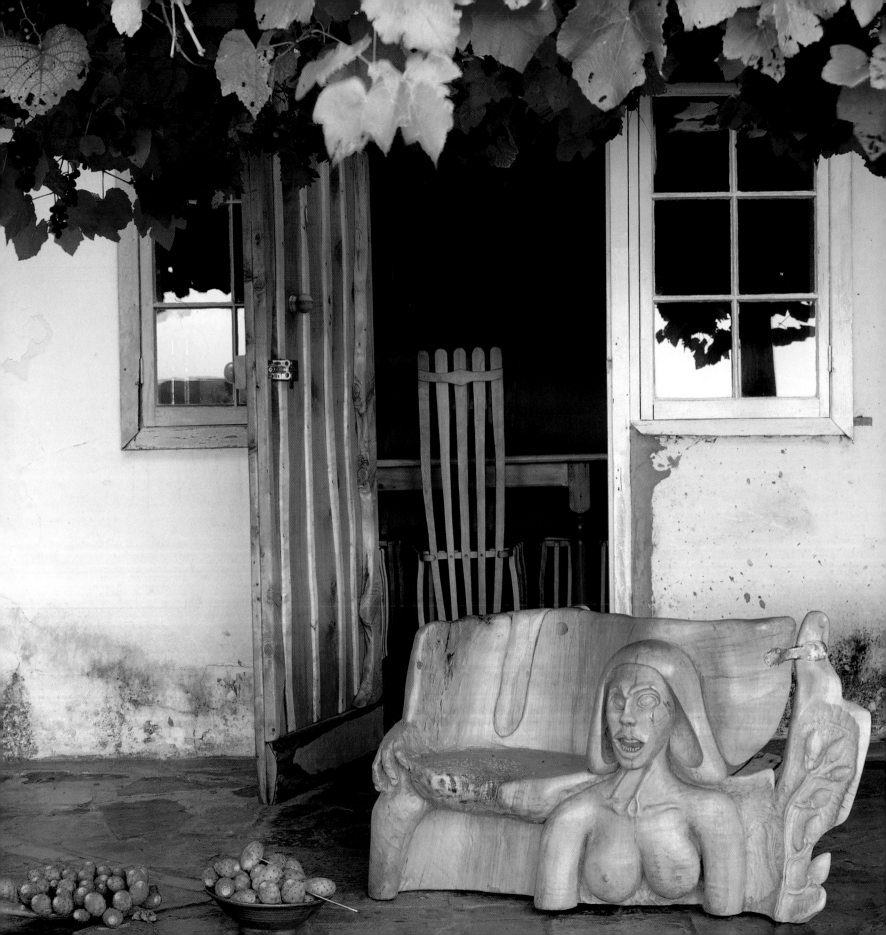

LIVING OFF THE LAND

After making a career as a printer and publisher in the Johannesburg-Pretoria area, Bruce Attwood left South Africa in the troubled 1980s to follow an artistic dream in Tuscany. On his return a few years later, he reinvented himself as a sculptor and designer, working mainly in wood, which had always held a fascination for him. At the same time, he set about reshaping his life and making a home that would be in complete harmony with its surroundings. Bruce had grown up speaking Zulu as well as English in the Estcourt region of Natal, and these close links with the tribal way of life prompted his desire to 'get back to nature, back to my roots and back to basics'. His dream was to live like a Bushman, in a cave, although he wanted to be able to see the sun rise and set from his bed.

Using a fifty-year-old outhouse for his basic framework, Bruce created a unique bed-and-breakfast guest house and home in the rural hinterland of Kwazulu-Natal. The original structure, which belonged to a farmer friend, consisted of two traditional rondavels, or thatched round huts, connected by a *stoep*, or veranda, with an overhead trellis. Perched on a kind of natural platform overlooking the Bushmans River, his home has panoramic views of the Drakensberg Mountains. Bruce built the walls from mud, dredging the river bed for building sand and cutting down trees such as yellow-wood, jacaranda and deodar to make the furniture and fittings. He claims that the organic-looking pieces he has made seemed to shape themselves, but he still ensured that his roughly hewn chairs were as comfortable as possible by taking moulds from the outline the human form makes in sand.

Bruce is a great believer in living off the land, foraging and recycling. Much of his food is based on seasonal plants and berries, and he has recycled all manner of things. The lids of a discarded sewage system have been turned into floor tiles; he has salvaged pieces of leather from a shoe factory to cover wooden doors, creating a patchwork effect; made curtains from fibre cloth normally used for protecting seedlings; and bought inexpensive glass plates from a chain store to convert into candelabra-style light fittings.

Bruce's home lies in the middle of a network of dirt roads leading to remote little villages where the traditional tribal way of life is, for the time being, preserved. Completely in tune with this very natural environment and without being at all fey – he is far too practical for that – Bruce is remaking his life and sharing it with others who happen to come his way.

LEFT Bruce Attwood's life changed fundamentally when he started carving wood. After making this 'sofa', one of his earliest pieces, he moved on to designing furniture, like the slatted, high-backed chair seen through the open door, and then remodelled the farm building, transforming it into a guest house and home. ABOVE A clenched fist made of metal makes a graphic door knocker.

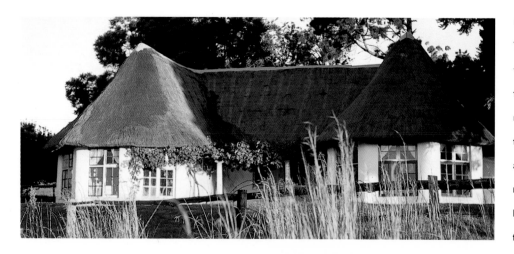

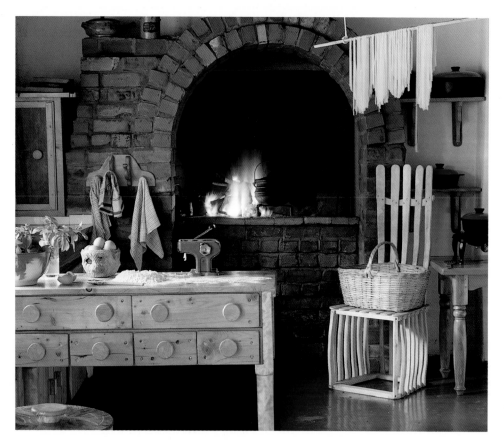

LEFT ABOVE

The exterior of the guest house features a *stoep* and rondavels. The views from the house are spectacular.

LEFT BELOW

Most of the furnishings in the house, including those in the kitchen, were made by Bruce from local materials.

RIGHT

The high-backed, slatted chairs were made by Bruce with body measurements as well as rustic design in mind. The candle chandelier suspended from the thatched roof is made from wood and inexpensive glass plates; the lampstand has been textured in recycled leather.

UNDERSTATED STYLE

When Ina Brandt decided to build a new house on the hilly outskirts of Pretoria a few years ago, she resolved to 'get away from the colonial, copycat traditions based on English, American, Spanish and Greek architectural styles'. So, she made a list of everything she wanted her house to be and gave the detailed brief that resulted to her architect and builder. The house, she believed, would 'be a reflection of Africa and also of the last decade of the twentieth century'.

From some of her windows, Ina has distant views of the Union Buildings. But the domes and colonnades of this imposing colonial complex designed by Sir Herbert Baker and Ina's house are worlds apart. Instead of presenting a *bella figura* to the world, her home from the outside is unobtrusive and understated. Screened

from the street, it is built around a garden area in such a way as to make the most of the changing light throughout the day: the biggest windows are north-facing, and the orientation of the house is designed so that the light is captured at different points as the sun moves across the sky. Surprisingly, this is rather unusual in South African homes where owners seem either to take the country's sunny climate completely for granted or forget altogether that they live in the southern hemisphere.

Ina is very environmentally aware; she relies on solar energy and uses water as a cooling device, almost Arab-style, within the house. She is particularly fond of the indigenous plants in her garden which also have a practical role – some attract birds while others keep snakes and mosquitoes away.

The house, like the garden, has a weathered homeliness, with thatched roofs and clay-like walls built from four kinds of sand mixed with cement. Much of the character of the house comes from the texturing of the walls, which was carried out by the sculptors Tieneke Meijer and Henriette Ngako. In the living room and kitchen area, which looks out over the main garden on one side and an enclosed courtyard adorned with earthy, African textures and colours on the other, there is an eclectic range of furniture and objects: a church bench from the Cape, an orchestral double bass, earthenware jars from Mozambique, folk art from Soweto and wire sculpture.

Ina describes herself as a 'putter-together' who has incorporated Karoo-Afrikaner, African and international hi-tech elements into the way she lives. By having confidence in her own ideas from the beginning, she has managed to create a house that is of its time and place and also widely admired.

LEFT In the garden area, screened from the street, several seating and dining areas are set against walls that have been carefully textured in earthy colours. **ABOVE** Ina Brandt's post-box, outside her door, distinguishes her house from others in the conventional and prosperous neighbourhood of Pretoria where she lives. It is in the shape of a baobab, the bulbous primeval-looking tree that grows in the northern parts of South Africa, where Ina was born.

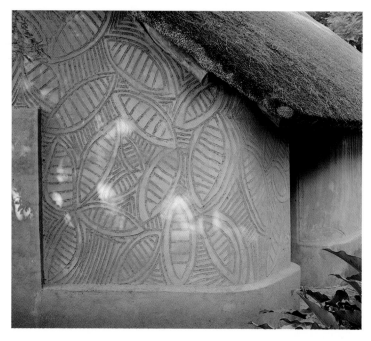

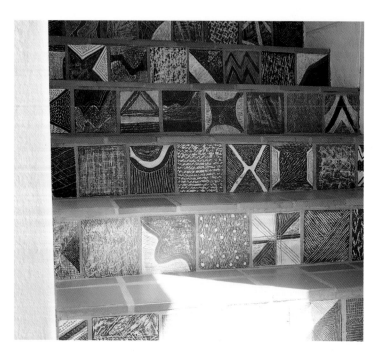

LEFT, ABOVE AND BELOW

Inside as well as outside the house, interesting patterns and textures have been applied to the walls, staircases and various other surfaces. In creating this look, Ina has had invaluable help from the artists Tieneke Meijer – she also moulded the lizard illustrated in the Introduction – and Henriette Ngako, who made many of the African-style pots. Particular inspiration was drawn from the traditional designs of the Ndebele people, whose ancestral homelands are near Pretoria, and the Sotho people from Lesotho.

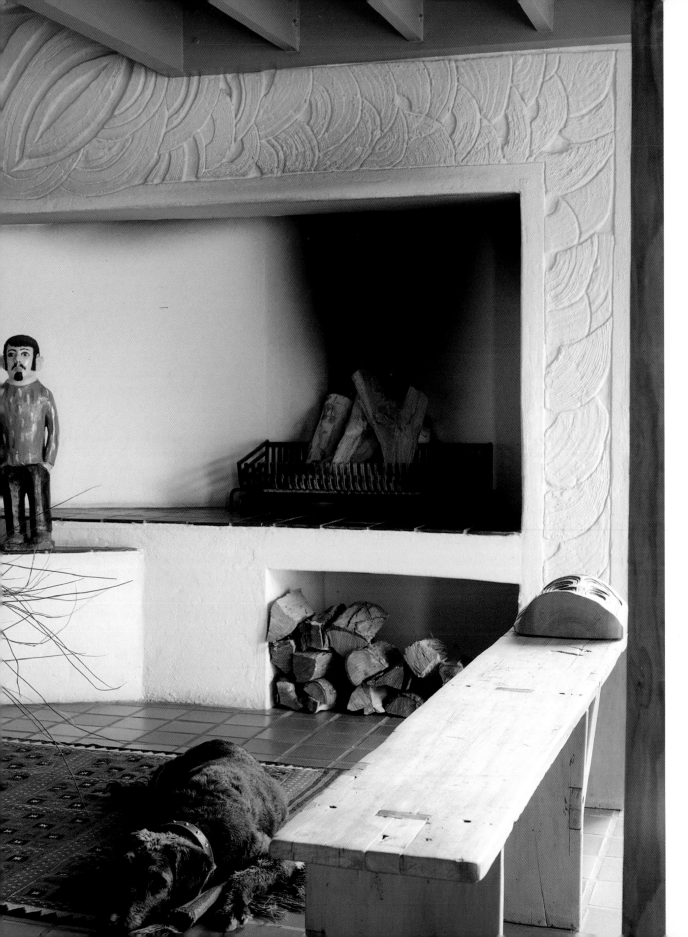

LEFT

Kawal, the dog, lies next to a former church bench in front of the open fireplace, its lintel textured in Sotho-inspired patterns. Throughout her home, Ina has placed great emphasis on the fireplaces, the use of solar energy and sun-traps, as well as fountains, pools and other cooling systems – she loves the soothing sound of water in her home. A firm believer in making the most of natural resources, she finds that most South Africans do not make enough of one of their greatest and most abundant assets – that of sunlight.

GUIDE

Rather than attempting to cover a country five times the size of Great Britain, or more than twice the size of France, this guide sets out to help readers get their bearings in and around Cape Town, an attractive and convenient base for a visit to South Africa.

Cape Town is one of the world's great cities, spreading out below Table Mountain and hugging the coastline of a peninsula that juts out between two oceans. The views of the mountains and sea are dramatic and ever-changing. Along the coast there are fishing villages, surfers' colonies and seemingly endless beaches; the mountains are equally varied, with countless walks and climbs to experience.

Cape Town is also a garden city, full of the distinctive flowers and plants of the so-called Cape Floral Kingdom, although the Cape region has a Mediterranean feel, with olive groves, cypresses and celebrated vineyards. The cityscape of old Cape Town – its Castle and other historic buildings – has much to offer urban amblers in search of the past. But above all, it is a city of young people and a magnet for artists, film-makers, designers, journalists and other creative types from South Africa and abroad. Unsurprisingly, the cultural life in the city is buzzing, offering something for everybody.

Telephone codes

The national code for South Africa is 27; the local code for Cape Town is 021; for Johannesburg 011; for Durban 031.

Accommodation

In recent years, there has been a proliferation of small 'charm' hotels, guest houses and bed and breakfast accommodation in Cape Town. Particularly useful is the 'Country Places Collection', produced by **The Portfolio Collection**, tel 011-880 3414 fax 011-788 4802. **Captour Accommodation**, tel 418 5214, is also helpful. Accommodation is available in the city itself, on the coast and in the leafy suburbs below Table Mountain, as well as further inland.

City Centre

Cape Heritage Hotel

90 Bree Street
tel 24 46 46
One of the city's newest hotels, but part of a heritage-conscious inner city development.

Close to the City Centre

Mayville House

21 Belvedere Avenue
tel 461 9400
Situated in Orangezicht, an old hillside suburb below Table Mountain.

Mount Nelson Hotel

tel 419 6677
fax 419 8955
Built in 1899, this classic colonial hotel has a celebrity guest list that stretches back as far as Rudyard Kipling. Refurbished by Graham Viney, whose own home is featured on pages 22–5, it is now part of the Orient Express group. Complete with large grounds and a pool, the hotel is very expensive but if you can't afford to stay there, go for drinks and the atmosphere or, better still, for afternoon tea and a never-ending supply of scones, cream tea and nostalgic tinkling on the piano.

No. 1 Chesterfield

1 Chesterfield Road
tel 461 7383
fax 461 4688

Situated in Orangezicht, this bed and breakfast overlooks the entire city and Table Bay with the Hottentots Holland mountains in the distance. The rooms are decorated in different South African styles.

Villa Belmonte

tel 462 1576
fax 462 1579
An ornate Italianate villa in Orangezicht, with views out over the city and the sea.

Waterfront

Table Bay Hotel

tel 406 5000
fax 406 5686
A recent luxurious addition to the ever-expanding Waterfront area.

Victoria and Alfred Hotel

tel 419 6677
fax 419 8955
This is the centrepiece of the extremely lively leisure area. Some rooms have over-the-water views of Table Mountain.

Coastal

The Bay Hotel

tel 438 4444

Sleekly modern luxury hotel looking out over the sea at Camps Bay, a ten-minute drive from the city centre.

Clifton House

tel 438 2308

Bed and breakfast hotel with five suites and a small swimming pool. Situated close to the long, palm-fringed beach of Camps Bay and the trendier beaches at Clifton.

Winchester Mansions

tel 434 2351

fax 434 0215

Old-fashioned but refurbished hotel in Sea Point, which has broad beach-front promenades and a large public swimming pool.

Southern Suburbs

The Alphen Hotel

Alphen Drive, Constantia

tel 794 5011

fax 794 5710

An old Cape Dutch manor house in large grounds. Antiques and a great atmosphere.

Constantia Uitsig

Spaanschemat River Road, Constantia

tel 794 6500

fax 794 7605

Cottage accommodation in the middle of the Constantia vineyards, a few steps away from two of the best restaurants in the country: Constantia Uitsig and La Colombe.

Rodenburg Guest House

8 Myrtle Road, Rondebosch

tel 689 4852

fax 689 2065

Family-run spacious Victorian house, with garden, situated near to a suburban railway station.

Steenberg Country Hotel

Constantia

tel 21 713 2222

fax 21 713 2221

Upmarket hotel dating from 1682, with Cape Dutch-style rooms.

Vineyard Hotel

Colinton Road, Newlands

tel 683 3044

fax 683 3365

One of the country's oldest hotels, associated with Lady Anne Barnard and other historic figures, now thoroughly modernized.

Restaurants, Cafés and Bars

Africa Café

213 Lower Main Road, Observatory

tel 47 95 53

African food, from all over the continent

Bertha's

1 Wharf Road, Simon's Town

tel 786 2138

fax 786 2286

Overlooking the harbour, Bertha's is very reasonably priced and has a good atmosphere.

Biesmillah

Corner of Whale and Pentz streets in BoKaap

Serves Cape Muslim food but no alcohol.

Blues

Victoria Road, Camps Bay

tel 438 2040

Trendy restaurant, Californian in style.
There are lovely views over the beach
at lunchtime.

Brass Bell

Kalk Bay Station, Kalk Bay

tel 788 5456

Restaurant, bar and music, next to the
sea with a view over False Bay.

Café Paradiso

Kloof Street, corner of Malan Street

tel 23 86 53

Several of the outside tables have
fantastic views of Table Mountain.
Go for the 'weigh your own plate'
mezze buffet.

Company Tea Garden

Located in the Gardens between
Queen Victoria Street and Government
Avenue

Perfect for an impromptu meal in the
city centre. Cape Malay curry and
standard tea-room fare in a great
setting, under the trees.

NAMIBIA

SOUTH AFRICA

| 0 | 100 | 200 | 300 | Kilometres |

| 0 | 100 | 200 | Miles |

Stellenbosch

CAPE TOWN

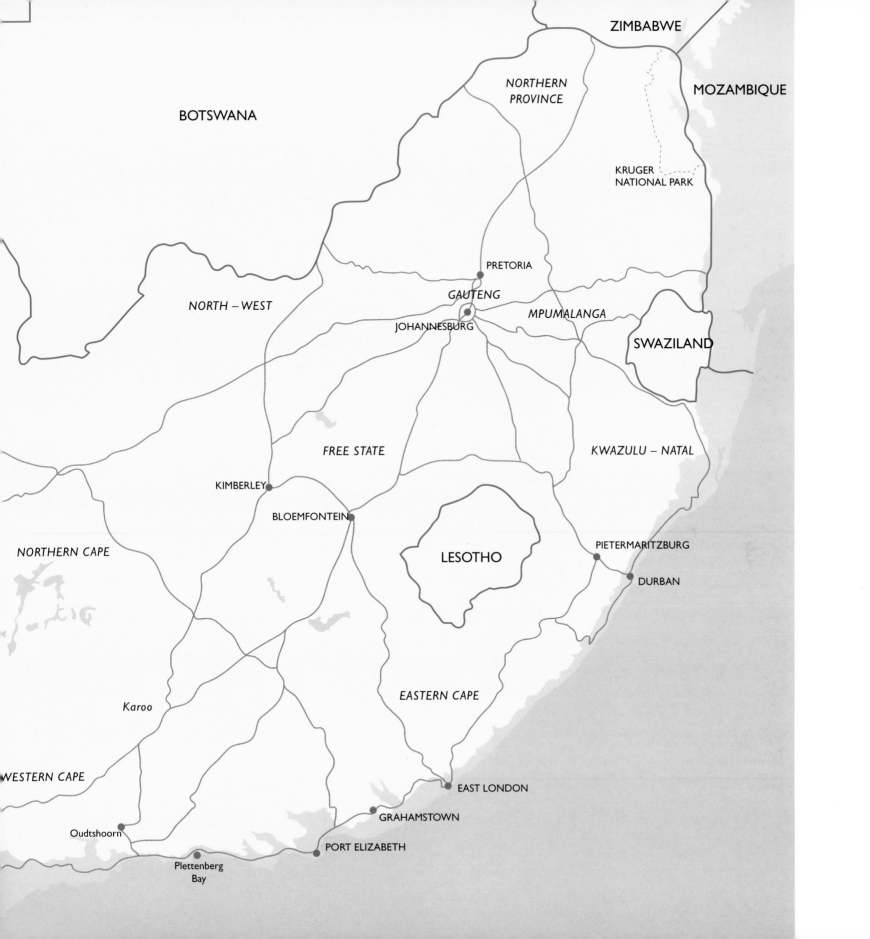

Constantia Uitsig

Spaanschemat River Road, Constantia

tel 794 4480

Classic cuisine, lovely setting, especially at lunchtime, with views over the vineyards.

Fish on the Rocks

Hout Bay harbour

Like Snoekies, this casual fish and chip shop serves fresh fish and has harbour and mountain views.

Floris Smit Huijs

55 Church Street

tel 23 3414

Elegant food and decor in an old city-centre town house.

The Galley

On the Beach, Fish Hoek

tel 782 3354

fax 782 3567

A very good seafood menu. Extremely good value and with wonderful views.

Jewel Tavern

Vanguard Road, near Yacht Club, Duncan Docks

tel 448 1977

Chinese seaman's club that has recently been 'invaded' by Capetonians. Inexpensive Chinese cooking.

Kaapse Tafel

90 Victoria Street

tel 23 16 51

Serves traditional Cape dishes such as *bobotie* and *bredies*.

Kimberley Hotel

48 Roeland Street

Turn-of-the-century decor and a lot of character, although it can be a little rough and ready at times.

L'Aubergine

39 Barnet Street

tel 45 49 09

fax 461 3781

Central location. Highly rated by the local French community and others.

La Colombe

tel 794 2390

Positioned back to back with

Constantia Uitsig restaurant. Features the inventive cuisine of French chef Frank Dangereux.

La Med

situated between Camps Bay and Clifton

tel 438 7193

Popular hang-out for surfers and hang-gliders.

Muizenberg Station Restaurant

Laid-back restaurant with beautiful views over the long surfing beach.

Panama Jack's

Near Yacht Club, Duncan Docks

Laid-back restaurant serving seafood. Views of boats in the docks.

Perseverance Tavern

83 Buitekant Street

The oldest pub in town with lots of character.

Rozenhof

18 Kloof Street

tel 24 19 68

Serves some local specialities. The dining area is a series of intimate rooms.

Rustica

Buitengracht Street
tel 23 5474
Italian-based restaurant. Good food and ambience.

San Marco

92 Main Street, Sea Point
tel 49 27 58
Long-established Italian restaurant where the fish dishes are highly recommended. The calamari are particularly good.

Snoekies

Hout Bay harbour
Rivals Fish on the Rocks as the best fish and chip shop in the area.

Wangthai

31 Heerengracht, Foreshore
Delicious Thai food.

Shopping

The Waterfront is paradise for the 'shop till you drop' crowd. It has nearly everything you might want, including a branch of **African Image**, owned by Michael Heuermann and Tracy Maltbie, and selling exciting old and new South African arts and crafts. (Michael and Katherine Heuermann's home is featured on pages 134–9; Tracy and Peter Maltbie's home on pages 126–9.) You will also find **Exclusive Books**, **Vaughan Johnson's** first-rate wine shop, cafés and restaurants, cinema complexes, open-air music, boat cruises, an aquarium and maritime museum. And there are still seals in the harbour! (**African Image** is in the Table Bay Hotel mall, tel 419 0382, and **African Heritage** is shop 102, Victoria Wharf, tel 21 6610.)

Other markets, scattered throughout the Cape Town area, extend from the central station to Alphen Common in the wealthy suburb of Constantia. The **Montebelo Design Centre** is at 31 Newlands Avenue, tel/fax 021 686 6445.

The most exclusive shopping mall area is in **Claremont**, which has recently been extended. The more adventurous could try the **Khayelitsha Craft Market** in the Khayelitsha African township, tel 361 5246 fax 887 8397.

A lively street to saunter along is Kloof Street with its close-up views of Table Mountain. Fashionable haunts include **Melissa's** for groceries and **Café Paradiso**.

For more of a cross-section Cape Town experience, take a slow walk up Long Street, with its lovely, somewhat weatherbeaten Victorian buildings and assortment of sights, shops and merchandise, mostly second-hand. At the upper end of the street, at number 211, is **Clark's Antiquarian and Africana Bookshop** and a cluster of other bookshops. More select dealers in antiques, arts and crafts – African, European and eclectic – are centred round **Church Street**. Colin Sayer's **The Collector** is at 48 Church Street, tel 423 1483, and sells wonderful pieces of tribal art. (Colin and Sue Sayer's

home is featured on pages 104–9.)
Gilles de Moyencourt, a French dealer
with an eye for bygones, is at number
54, tel 424 0344. Another leading
Church Street dealer is **Peter Visser
Antiques**. **Peter Visser Interiors** is at
63 Loop Street. **African Image** (see
page 202) has a branch on the corner
of Church and Burg Streets, tel 23 8385.

The **Beezy Bailey Art Factory and
Shop** is at 4 Buiten Street, tel 423 4195
fax 423 4196. (Beezy and Nicky Bailey's
home is featured on pages 142-9.)
Nearby is the open-air market in
Greenmarket Square, surrounded by
Art Deco high-rise buildings and, on one
side, the **Old Town House**. This building
looks as if it has been transplanted
from eighteenth-century Amsterdam.
It houses a collection of Dutch old
master paintings, including work by
Frans Hals. Although free and central,
the museum is often deserted. **Steven
and Juliette de Combes**, whose
home appears on pages 114–21,
are collectors and dealers of African
art. Appointments necessary, tel/fax
780 1823 email: decombes@mweb.co.za.

Things to Do and See

In the city
The heart of the city is a must-see area
but it is only accessible on foot. The
Dutch built the old garden three
hundred and fifty years ago to produce
fresh food for the sailors en route to
the Indies. Various buildings are
grouped around the garden, including
Parliament, the **President's Chambers**,
the **National Library**, **Museum** and
Art Gallery, **St George's Cathedral**
and the **Old Synagogue**, as well as
other cultural institutions.

Another historic area, a few blocks
south, centres on the seventeenth-
century Dutch **Castle**, complete with
bell-tower and moats. It is full of antique
pictures, furniture and memorabilia.
Nearby is the Edwardian **City Hall**, the
new **Civic Centre** and the **Nico Malan**
theatre, venue for opera and concerts.

Mountains and Sea
Like Rio and Hong Kong, Cape
Town makes the most of its location
– mountains rising sheer from the sea.

Walk up or around **Table Mountain**, or
take the cable car. Drive up **Signal Hill**.
There are smallish 'social' beaches at
Clifton or vast sandy expanses for
solitude and long walks at **Noordhoek**
and **Muizenberg**. Dramatic roads carved
into cliffsides take one to **Cape Point**,
described by Sir Francis Drake in
1580 as 'the most stately thing and
the fairest Cape we saw in the whole
circumference of the earth'. Along the
coast are **Simonstown**, the former
imperial naval base, fishing villages at
Kalk Bay and **Hout Bay**, and the penguin
colony at **Boulders Beach**. **Robben
Island**, where Nelson Mandela and other
political prisoners were held, is now a
major tourist attraction.

Vineyards and Historic Houses
Inland from Cape Town, in the direction
of the Hottentots Holland Mountains,
are the mellow charms of the winelands
and the old gabled estates. Historic
towns include **Stellenbosch** with its
lovely main street and fascinating
museum. **Franschhoek**, which translates
as the 'French corner', was originally
settled by French Huguenots. French

genes are still in evidence and the village is now home to a number of good restaurants. Two of the best are **Le Quartier Francais**, 16 Huguenot Road, tel 876 2151, and **La Petite Ferme**, Franschhoek Pass, tel 876 3016.

Very well worth a visit for furnishings, textiles and woodwork with an African flavour is the high-class interior decorating shop **La Grange**, 13 Daniel Hugo Street, Franschhoek, tel 76 21 55.

Excellent tours of the winelands can be organized by **Vineyard Ventures**, tel 434 8888 fax 434 9999.

Boschendal, tel 874 1252, is one of the grandest historic homes open to the public in this part of the Cape. It provides an idyllic setting for picnics and drinking wine. Reservations are essential. Even grander is **Vergelegen**, tel 874 1334 fax 847 1608. A Cape governor's architectural attempt, built around 1700, to rival the splendours of Versailles, it offers a history-laden house and garden as well as restaurants and wine-tasting.

Further westwards from Cape Town stretches the famed coastal road, the **Garden Route**. **Hermanus**, a chic resort, becomes the capital of whale-watching every October. It even employs an official whale-crier who shouts out sightings! Several hours' drive further along the Garden Route is **Plettenberg Bay**, another fashionable resort. On its outskirts is the **Plettenberg Park** hotel, tel 04457-39 067 fax 04457-39 092, which is featured on pages 86–9.

North from Cape Town, the road crosses the semi-desert **Namaqualand** where, every spring, the desert bursts into bloom, aflame with flowers.

Another road, the N1 northeast from Cape Town in the direction of Kimberley and Johannesburg, takes one across the arid, atmospheric Karoo. In this 'middle of nowhere' expanse is a Victorian resort built at the beginning of the twentieth century because of the region's healthy desert air. Still offering old world but comfortable accommodation is the **Lord Milner Hotel**, tel 023-551 3011

fax 023-551 3020. An even more flavourful alternative is the **Bergplaas Guest House**, tel 023-358 2134. Close to the Touws River, this farm sleeps up to thirty guests.

There are two other magical stopovers in completely different styles and settings. The **Antbear Fernhurst Farm**, near Estcourt in Kwazulu-Natal, tel/fax 0363-33 61 36, is a bed and breakfast and the home of Bruce Attwood, featured on pages 188–91. **Makalali Private Game Reserve**, Mpumalanga, is near the Kruger National Park, tel 011-784 7077 fax 011-784 7667, and featured on pages 174–81.

ACKNOWLEDGMENTS

The authors wish to offer thanks to all those who welcomed them into their homes and express their gratitude for the extra time the owners have taken to discuss the details of their homes.

Desmond Colborne: My thanks to all the subjects of this book for their generous co-operation, Karel Nel in particular. The Satour office in Paris was helpful with the Guide. How do I thank my wife, Marianne, when her contribution to this book was greater than mine?

Commissioning editor: Suzannah Gough

Managing editor: Richard Atkinson

Editor: Helen Ridge

Art editor: Karen Bowen

Map illustration: Tony Seddon

Production: Oliver Jeffreys

First published in 1999

by Conran Octopus Limited

2–4 Heron Quays

London E14 4JP

a part of Octopus Publishing Group

A catalogue record for this book is available from the British Library.

ISBN 1 84091 047 X

Printed in China